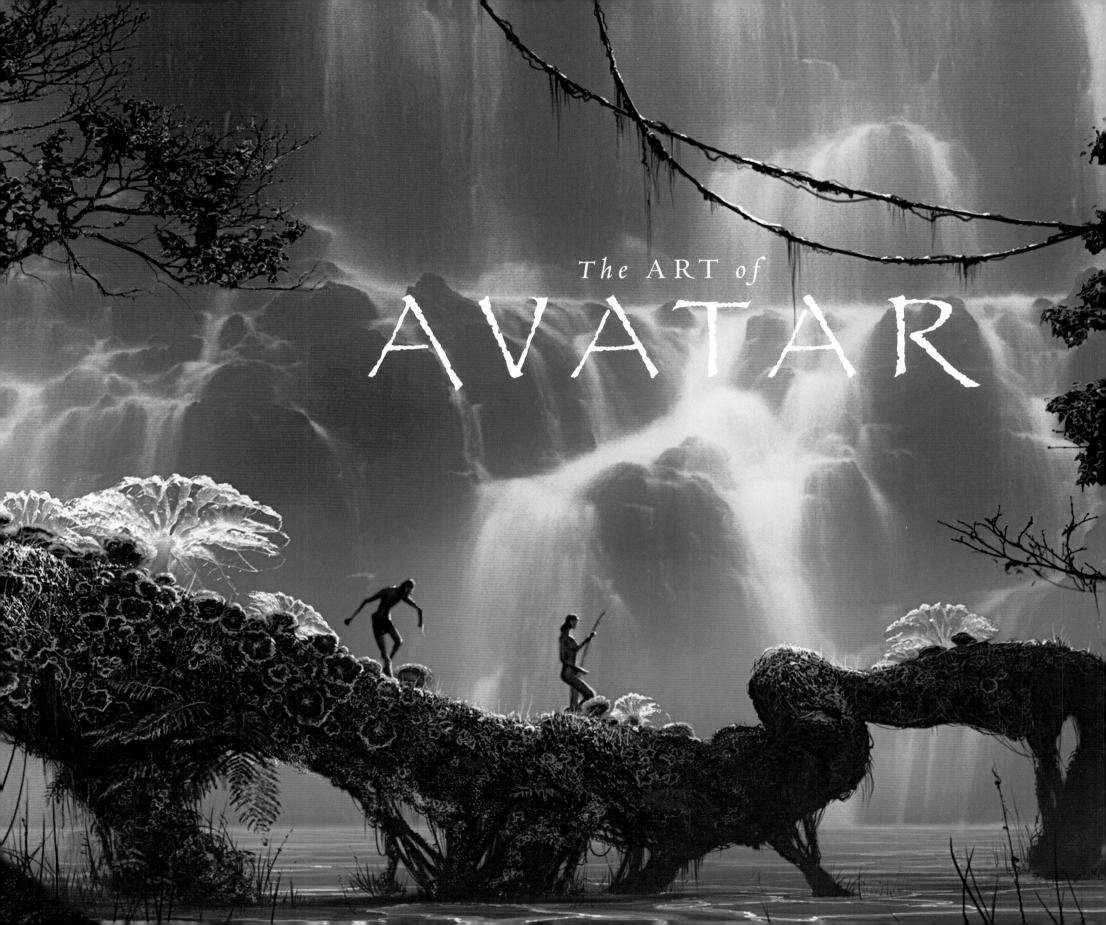

The ART of
AVATAR

The ART of
AVATAR

JAMES CAMERON'S *Epic Adventure*

Preface by PETER JACKSON

Foreword by JON LANDAU

Epilogue by JAMES CAMERON

By LISA FITZPATRICK

Abrams, New York

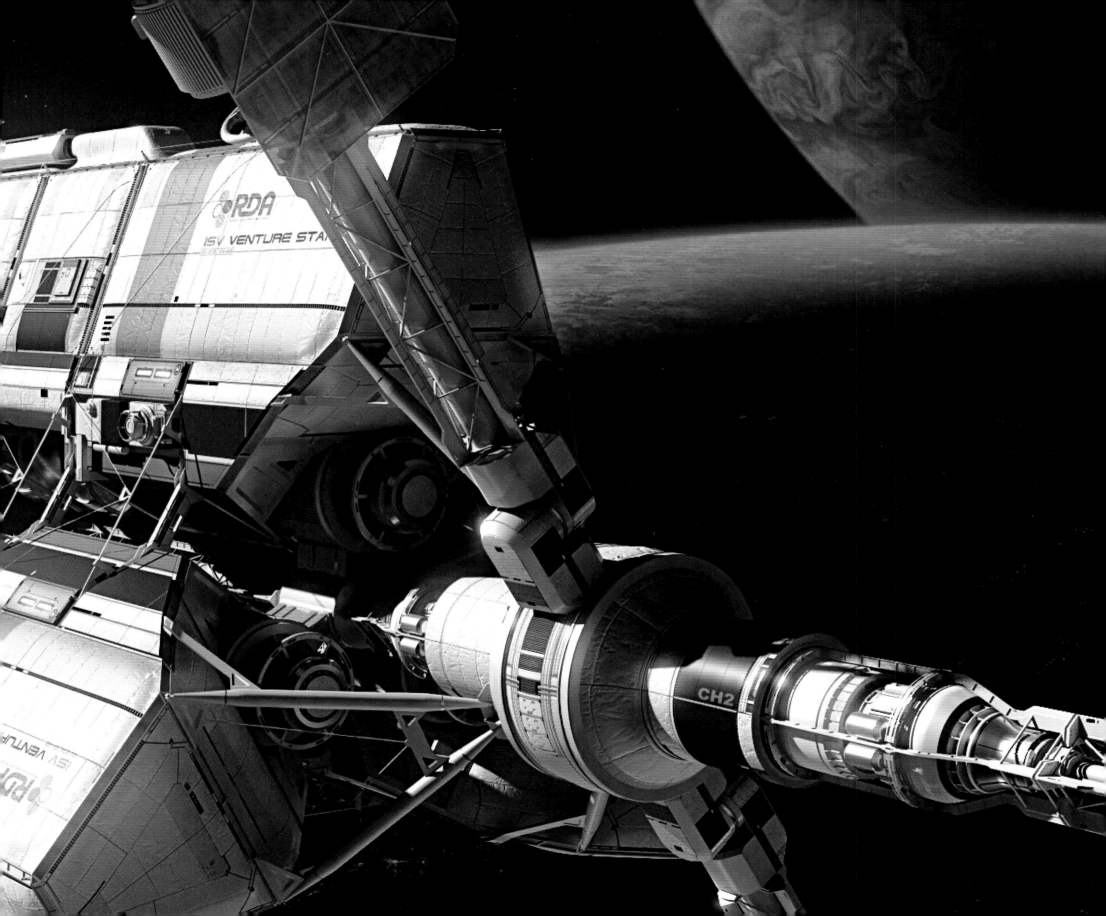

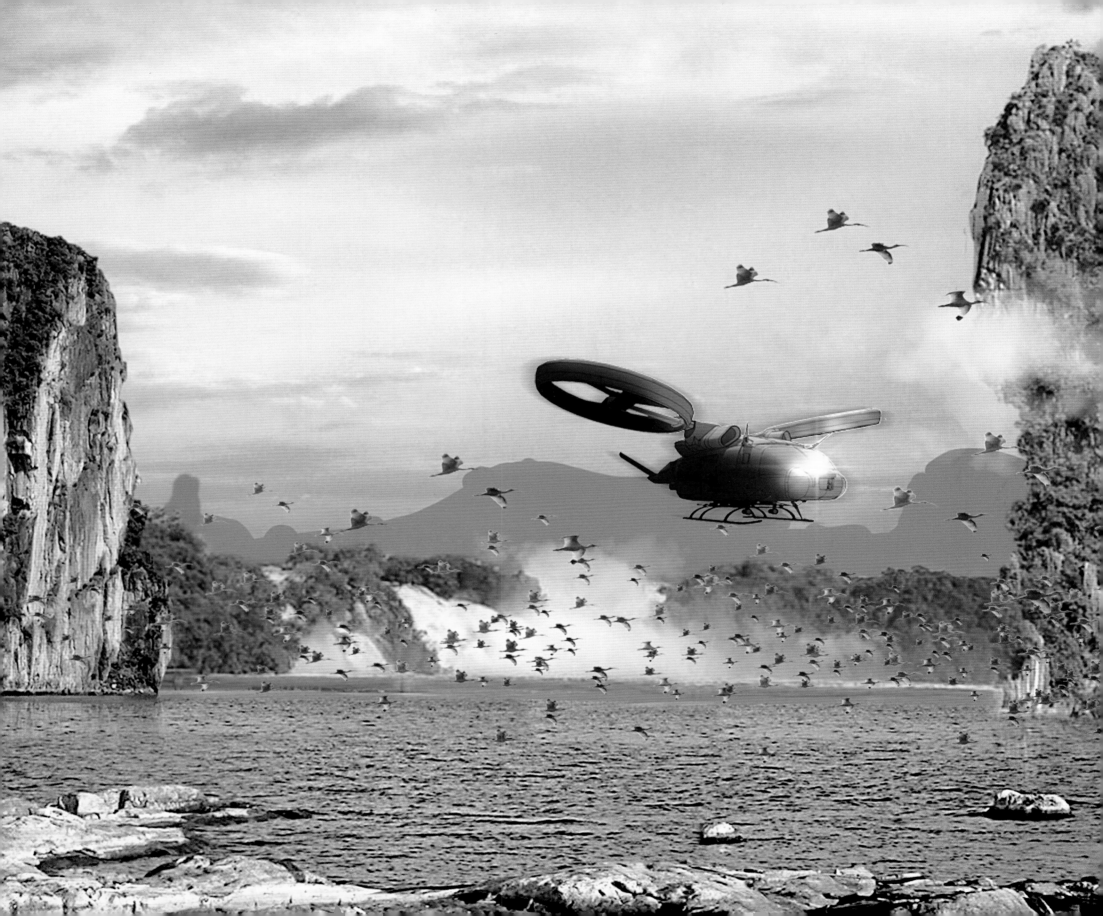

Suspension of Disbelief
Peter Jackson

"The suspension of disbelief." That phrase has long been used as a way of describing the necessary relationship between filmmaker and the audience. It's a quaint, slightly cynical concept, in which both participants admit that "we know this is a lot of nonsense, but let's forget about that for a couple of hours and allow ourselves to have some fun." The suspension of disbelief is an unspoken contract that has served the needs of moviegoers and moviemakers for over one hundred years.

But occasionally a movie comes along that takes us by the scruff of the neck and propels us headlong into an experience so strong and profound that such agreements are rendered instantly redundant. These are the movies that live with us our entire lives and, some would argue, shape our lives—films that touch both heart and mind and compel us to surrender completely to the power of the experience. This has happened to me maybe ten or twelve times in my life and doubtless, for each of us, the list of these watershed movies is unique and particular to our life experience. One of the great strengths of cinema is its diversity; there are films to suit all tastes, films that connect on many different levels, films that appeal to different age groups and cultures, and films that speak very powerfully to specific audiences. However, every once in a while we will see a movie that transcends cultural barriers, genre, and taste—a film that lives on in the minds of the audience, years after the fact, a film with a story, characters, and dialogue so memorable that it creates its own mythology. The image of an ocean liner splitting in half, a man falling away from the camera and plummeting into the sea, a box of long-stemmed roses flying apart to reveal a sawed-off shotgun, a watery tentacle snaking across a room, a playground atomizing in a nuclear blast, a woman and a man standing on the bow of ship, faces to the sun, arms outstretched— these are the images that stay with us long after the lights have come up. These are the stories we remember and treasure and relive over and over again. Stories that, for many of us, become defining moments in our lives.

During the twelve years since Jim Cameron made one of the most extraordinary films of all time, the phenomenon that was *Titanic*, we have seen him working with new technologies to make 3-D documentaries, in which he explores the undersea environments of some of the world's deepest oceans. We had no idea at the time that we were, in fact, witnessing the nascent development of Jim's next feature film, but in retrospect, that's exactly what was happening. Jim was preparing for *Avatar*—building and developing groundbreaking 3-D technology that could enable him to capture, on film, images that had thus far only existed in his imagination; images that, until now, were too complex and too difficult to render on film in a 3-D universe. In terms of cinema, *Avatar* represents a giant leap forward in the world of filmmaking. Jim Cameron has created a mind-boggling, beautiful, dangerous, alternative reality that has never before been seen on screen. As an audience, we find ourselves immersed in the 3-D landscape of Pandora, an alien planet inhabited by strange, graceful creatures and terrifying monsters. The jungles of Pandora glow with bioluminescent plant life; it is an environment that is as frightening as it is beautiful, and it is home to the Na'vi, an indigenous alien race who come into conflict with humans from Earth wielding futuristic weaponry.

Avatar is a fascinating mix of drama and science. Everything in the film has been designed and built with the utmost care and attention to detail—not just the costumes, but even the *buttons* on the costumes. Not just the trees of Pandora, but the *leaves* on those trees and the tiny insects crawling on the leaves. This is a world with an entire ecosystem, where animal and plant life has established itself in forms both familiar and wondrous, where there are gases in the atmosphere and minerals in the ground. It is a world that has evolved over time and that abides by its own internal laws of nature and logic. But at its heart, *Avatar* is a story that speaks to a universal truth about our place in the world, and the things we value and the things we choose to destroy. It forces us to confront the issue of who we are and what we want, and to acknowledge the simple truth that, as a species, we are bound to a common fate, and so the future of humanity is in our hands. The message of this film is: Character is destiny.

Most filmmakers are quickly categorized by critics and commentators as being "actor's directors," or "technical directors," perhaps implying strength in one area and deficiencies in another. Jim Cameron is neither. He is simply a master of his craft, a brilliant visual storyteller, and a visionary and iconoclast. Jim Cameron has never settled for what cinema is now—for Jim the point has always been what it can become and what we can reach for, how we can push the boundaries and move the art form forward.

Not long ago, books featuring "The Art of . . ." used to be fun to look at because they showed what the filmmakers hoped to put on screen before the reality of technical restrictions kicked in. I'm referring to the rubber puppets, badly made models, and rear-screen projection that made us realize just how big the gap was between imagination and the practical limitations of the day. Those times have all but gone, and now practically anything that can be designed and illustrated can be realized on screen. Jim Cameron has patiently waited for this day; finally we get to share the images and landscapes that have fueled his creative imagination these past few years . . . and it is a rare privilege.

Jim and the talented artists and designers whose work is featured in *The Art of Avatar* are not expecting you to suspend your disbelief when you turn the pages of this book. They ask for no favors. As the creators of this world they know: Seeing is believing.

And you will, I promise.

Foreword
Jon Landau

When we chose to embark on this film in 2005, I felt like a NASA engineer in 1961 when it was announced they were heading for the moon—full of inspiration, passion, and all the promise of a new filmmaking frontier. Our moon in this case was Pandora and the world of *Avatar*.

Jim Cameron had written *Avatar* a decade earlier, but at the time the tools did not exist to tell the story at the level that he envisioned. However, with a technological wave of change upon us, we saw an opportunity to maximize these emerging digital tools and use them—at long last—to bring Jim Cameron's fantastical tale to life.

Whatever outstanding technical challenges we did not yet have answers to (and there were many), we hoped we could solve along the way. As it turns out, once again this open-mindedness, this naiveté, was perhaps both our greatest strength and biggest weakness. We dove headlong into this production.

We began with various existing technologies, such as Giant Studio's performance capture system, AutoDesk's MotionBuilder software, and Glenn Derry's hardware, and combined them to make them work together in ways they never had before—all to bring to fruition the virtual production process that Rob Legato (our visual effects supervisor from *Titanic*) had initially pitched to us.

We searched out the best of the best and ended up with a phenomenal team of technicians and artists who were committed to realizing the vision of this film and the process of the production. Some were newer to the business (Nolan Murtha, Dan Neufeldt, and Craig Shoji), while others (including Ryan Church, Wayne Barlowe, James Clyne, and Richard Taylor) were seasoned filmmaking veterans—and responsible for some of the great iconic imagery of our industry in recent years. But none of them joined this film simply because Cameron asked them to. They came because of the story.

As filmmakers, we have a responsibility to bring provocative messages and relevant images to the cinema. At best, movies contain themes that transcend their genre; with *Avatar* it would be fair to say that Jim wrote a script that includes many familiar and relevant themes, all set against the background of an original, even visionary universe on a scale that has not been tackled since the pre-CG era. But technology alone was not the answer to exposing audiences to this world; it is the artist behind the technology that makes the images of this book, and ultimately the movie, so remarkable.

Jim's script offered rich, compelling, and immersive visual possibilities and challenges. Rick Carter, for example—whose sole collaborators over the last twenty years had been Steven Spielberg and Bob Zemeckis—remarked that he was astounded at the amount of artistic depth he found within the script. Rob Stromberg, Seth Engstrom, Yuri Bartoli, Neville Page, TyRuben Ellingson, Ben Procter, Jordu Schell, Christopher Swift, Joseph Pepe, Scott Patton,

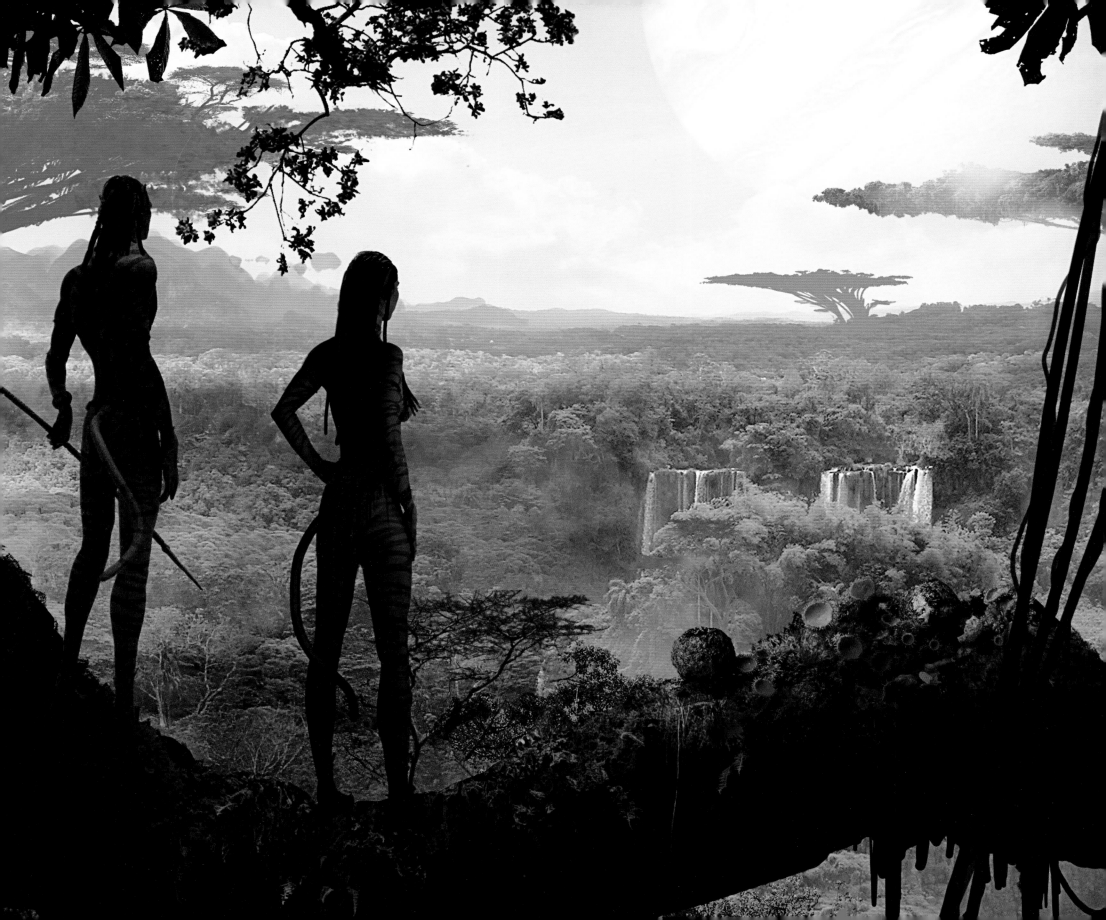

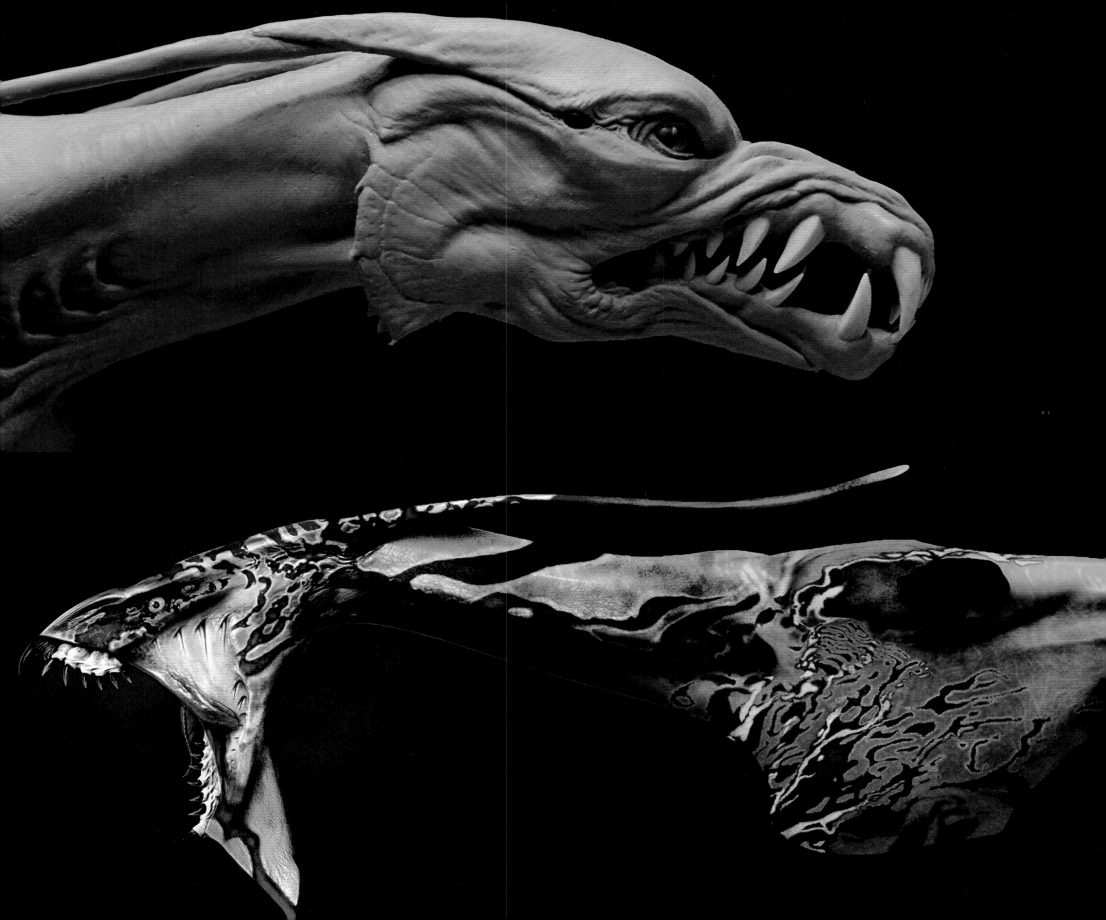

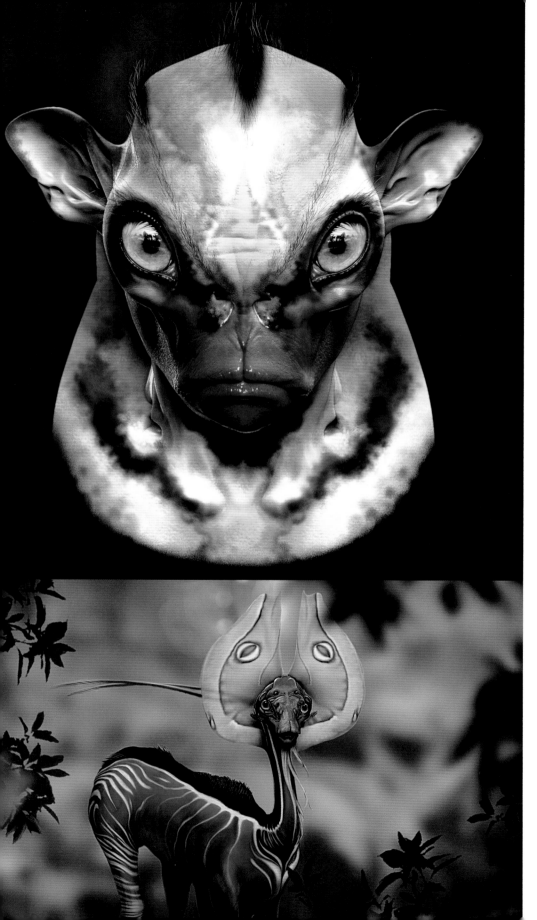

John Rosengrant, and many others who came on board had very similar feelings about the script and eagerly lent their extraordinary artistic talents to bring the words on the page to life.

In a business that can, at times, become very tired and too commercial, these artists approached *Avatar* without a sense of ego. The storyline presented a filmmaking opportunity so engrossing and epic in scope that, without hesitation, many joined out of passion, inspiration, and what some have described as the opportunity of a lifetime. Foregoing other opportunities, many (such as animation director Richie Baneham) stayed on over the course of the several years required to bring this larger-than-life production to the big screen. What has been exciting for me personally was to see that each of these artists brought a sense of meaning and purpose to everything they created. Oftentimes what they created was so much more than what had been handed to them on the page. They dug deeper. Weta is a terrific example of this.

When first looking for a visual effects partner, we sought out a team that would embrace the movie with the same enthusiasm we possessed. We wanted a company with the vision and the ability to realize this film on a photographic level that would enable the audience to engage with the characters in a whole new way. Our goal, ultimately, was to change the moviegoing experience. When people leave the theater, we don't want them to say, "I saw a movie"; we want them to say, "I experienced a movie." Peter Jackson, Joe Letteri, Eileen Moran, Andy Jones, Steve Rosenbaum, Eric Saindon, Guy Williams, and the teams at Weta Digital and Weta Workshop understood this ambition and so much more. They brought not just artistry but also a great commitment to what Academy Award–winner and Weta partner Richard Taylor likened to "a whole new level of spectacular entertainment."

Ultimately, this book is about celebrating the artists who came together to realize the imaginative world of Pandora. I, myself, do not possess the skills to create these images. My role in this process was to act as a sounding board and provide insight based on my previous experience of having worked with Jim. I would try to motivate the artists to push their own creative boundaries. I would encourage them to keep in mind something Jim has an amazing ability to do: Use touchstones familiar to the average viewer to create art that, in turn, becomes mass entertainment. And finally I would say that his movies are about "relatable" human emotions set on big scales; they are stories of the common man set against extraordinary backdrops.

Regardless of the box-office performance of the film, our hope and expectation is that it will transform the cinema-going experience into one that is much more immersive and intellectually engaging. We hope that the result of our journey inspires filmmakers of the future to avoid creating stories merely to utilize technology, but rather have them propel technology to tell stories that could not otherwise be told. With this in mind, I believe there are a host of tales that have been locked up or limited by what technology could not yet do. Hopefully this film is a small crack in the next door.

Introduction

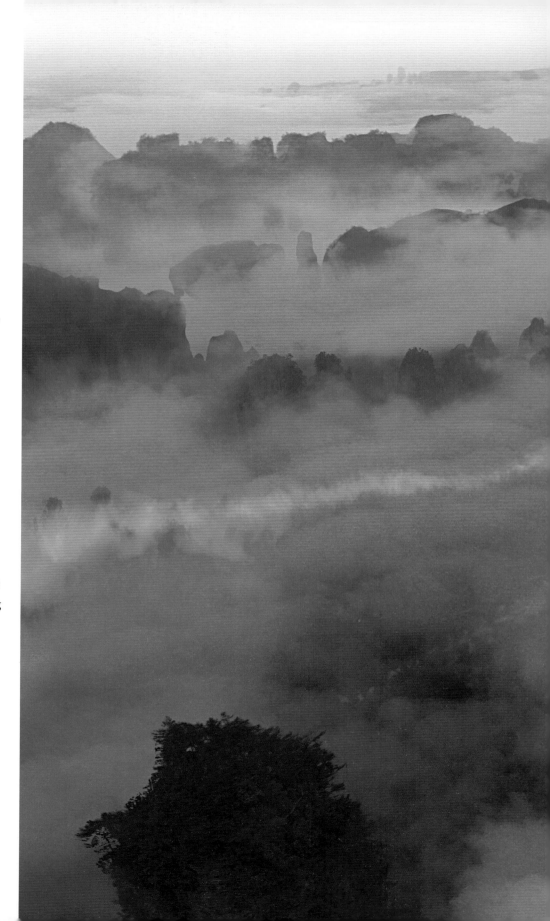

"I think we made the wheel rounder," recounts lead visual-effects designer and seasoned film veteran Robert Stromberg about his time on *Avatar*. To say this endeavor was ambitious would be a remarkable understatement by any measure—certainly by FOX's standards, causing one executive to proclaim to Jon Landau, "I don't know who's crazier for letting you take this on, us or you!" More than four years in the making, *Avatar* employed an accomplished team of artisans that at times swelled to more than one hundred and twenty illustrators, designers, sculptors, and visual effects artists.

At its core, this film is a visual odyssey from the familiar to the fantastic to the phantasmagorical. But the truly high art brought forth in *Avatar*, above all other innovations, is the transportive experience itself; all efforts at visualization were designed, ultimately, to serve this photorealistic, dramatic film-going experience. While technological advances are the enabling factor, the film's success is earned by the technology passing unnoticed, as the viewer becomes fully immersed in the world of Pandora and its epic landscapes. Believability is essential in order for the filmmaker to achieve this. The first phase of conception, design, and development of this credible world is the subject of this book, including all the characters, creatures, vehicles, and environments originally conceived and envisioned by James Cameron himself.

Director, screenwriter, and editor, as well as accomplished illustrator, Cameron is the architect of every facet of this film, from the co-creation of the new camera system to the immersive shooting techniques and the conception and realization of the cast of characters that make up the fantastical world of Pandora. This is a Cameron movie from beginning to end, and he surrounded himself with an accomplished team of artisans who could assist him in bringing these ideas to life. When reflecting upon the nearly two-year sketch-paint-and-design phase, Stromberg remarked, "Jim said to me, 'Let's take our time and get this right.'"

Cameron called this team the "brain bar" and he asked them to take chances, to take risks, and to be bold in their creative decision-making process. "Jim would then be able to 'filter' their work because he knew what he wanted, but without the artists stretching themselves we would never have gotten to where we've gotten," Landau reflects. Lead vehicle designer TyRuben Ellingson echoes the widely held sentiments of the entire team in saying, "Jim is simple when it comes to how he collaborates. He wants the very best you have. Period. And he will address it as such and say 'you can do better, dig deeper.' His string of knowledge and depth of capacity can be taxing—you have to play your best game every day, but that collaboration felt evolutionary to me in regards to my own capacity."

Creative opportunity was never sacrificed on the altar of process—quite the opposite. This film production thrived on a culture of exploration, innovation, and a tenacious earnestness to produce the best work possible—thus attracting some of the more renowned progressive

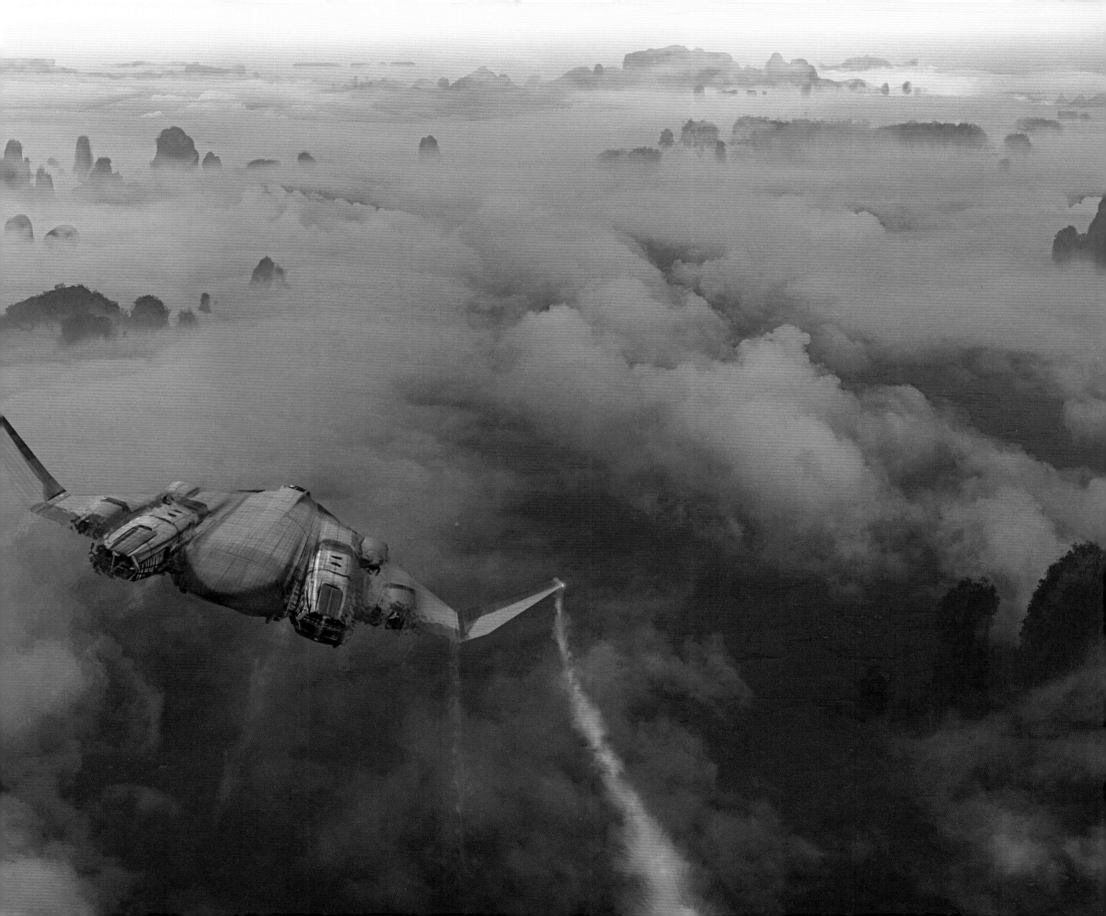

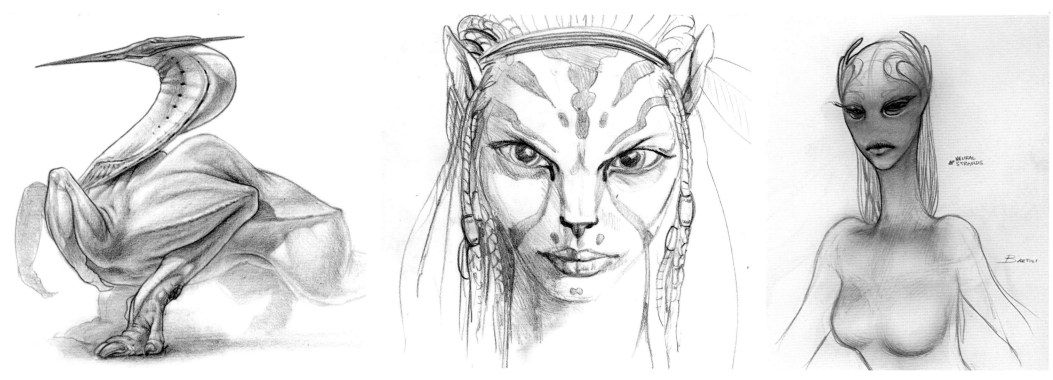

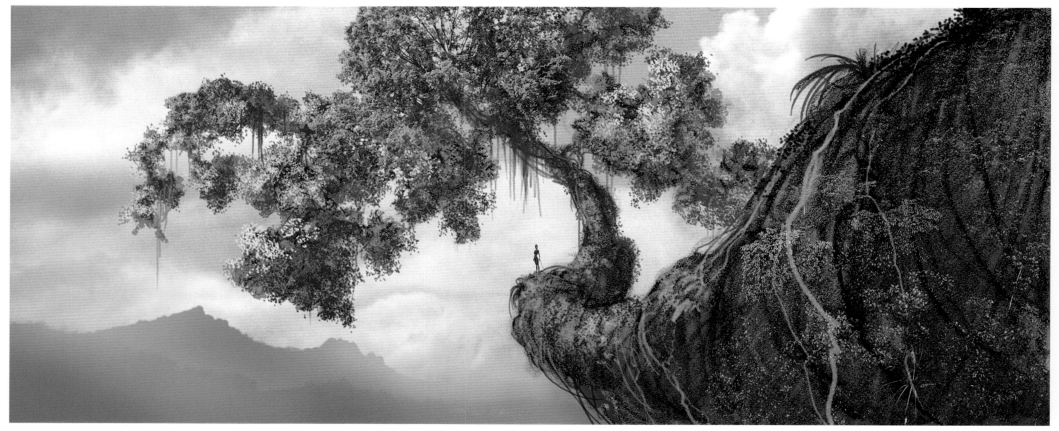

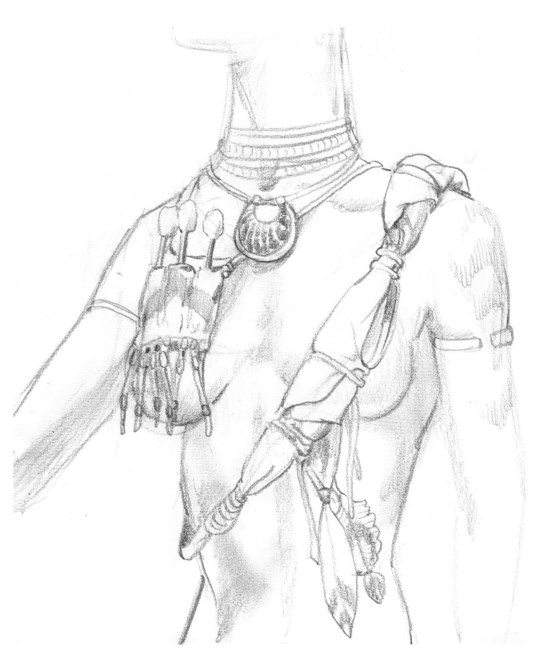

sketch of Neytiri's patterned face, opposite center), sharing with artists everything from drawings on cocktail napkins to, in the case of the *Venture Star*, an eleven-page document on how the ship functioned, complete with light-speed calculations, pod dynamics, engine thermodynamics, architectural plans, and more. He could have rested well knowing he had achieved a level and scope of innovation rarely seen in Hollywood: He had invented an entire world for the big screen, replete with alien character, culture, beauty, tragedy, revelation, conflict, and purpose. But he has offered up a visual dimension even more unique and arresting—a phantasmagorical and largely hidden network no less essential to the Pandoran life force than our Earth's air: bioluminescence.

Over the course of the last twenty years, for the sheer pleasure of exploration (and the chance to produce a documentary or two), James Cameron has spent a good deal of time navigating through the depths of our world's oceans; he has traveled through cavernous, lightless environments spanning hundreds of miles, witnessing firsthand thriving swarms of bioluminescent life forms floating, glowing, and pulsating along. "Hearing his tales from the ocean depths was like listening to a terrestrial astronaut," recounts Neville Page, creature designer on *Avatar*. Cameron wrote these visions directly into his script: *a glowing phantasmagorical forest, purple moss reacts to pressure, rings of green light, ripples on the pond expand outward from each footfall, exploding rings of light where his feet touch down. Dreamlike, surreal beauty.* Stromberg, concept designer Dylan Cole, and others took on the challenge of interpreting these vivid depictions of this planet at night, uncovering the most effective combination of purples, cyans, and hot pink accents, which formed the signature color palette for *Avatar*. These bioluminescent light patterns were woven into all the living creatures on Pandora, including the planet herself. One goal of this effort was to inspire the audience to see these light patterns as a living network, a nervous system of sorts, that connects everyone and everything to one another.

Life in the depths of our oceans—we know it exists deep beneath the surface and is natural to our Earth, but at the same time, to many, it may still feel quite foreign. Cameron drew upon this theme of "otherness" and "sameness" in the process of realizing the detail of life on Pandora. All the design efforts needed to begin with a grounded, believable look and feel; the illustrators frequently referenced Earth-based environments and identifiable creatures—the rhino for the Hammerhead, the panther for the Thanator, and the Clydesdale for the Direhorse. Cole offers the following reflections: "I knew that we had to walk this very fine line between too alien and too Earth-like. The audience needs to be able to identify with the characters' environments and believe where they are, yet their look still needs to be alien and compelling enough for a film such as this." It's all in how the concept designers combine these polarities to create a look that not only resonates with viewers as authentically Earth-based but also sufficiently stretches the collective imagination to make for engrossing entertainment. There are many considerations that go into the design process, whether it's a creature, a locale, a Na'vi, or an avatar. Succeeding at that believability is at the root of the full expression of this film, and it all begins—and some might argue it also ends—with the loose sketch.

thinkers in the film industry today, including Rob Legato, Rick Carter, Robert Stromberg, Ryan Church, Ben Procter, Neville Page, and many others. Ellingson recounts: "The through line for me of all that I witnessed on *Avatar* was this intermingling of concept, execution, and story dynamic, and the simultaneous practical use of the story beats of the action in the design process. It was very hybridized." The results of this work are indeed in the realm of the fantastic—from the Hammerhead to the Woodsprites and from the AMP Suit to the Well of Souls. Cameron himself jump-started most of the initial designs for the film (see his Na'vi clothing sketch, above, and a

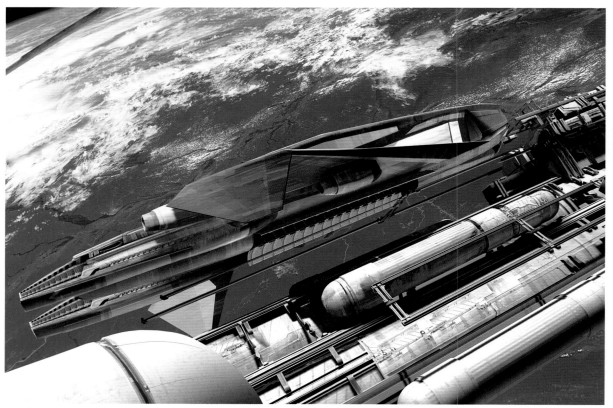

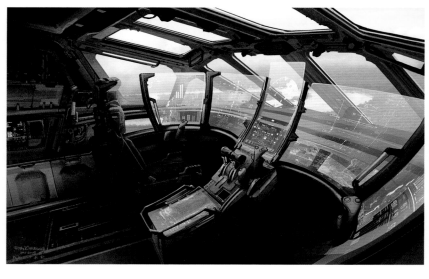

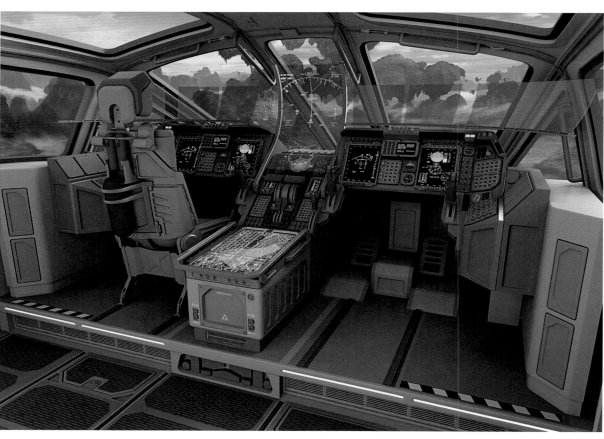

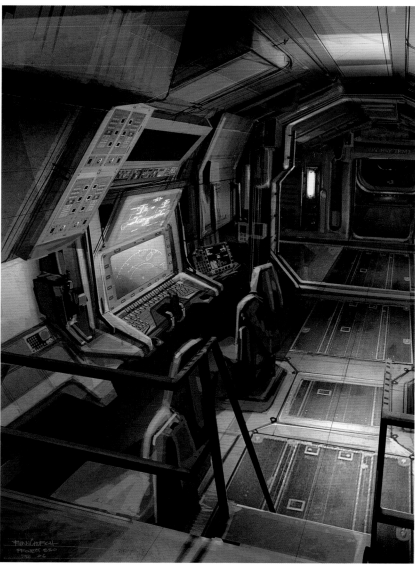

THE VALKYRIE SHUTTLE "I love the fact that I got to work with a director that *did* want to know what kind of bolts were holding these fusion engines on and if it's gonna vector," recounts senior illustrator Ryan Church of his collaboration with James Cameron. A member of an advisory board to NASA, Cameron really "knows his birds," says Church (himself a fan of aviation since he was young). He was thrilled to be chosen to spearhead the shuttle's creation, and he designed the entire shuttle—"my signature contribution"—from scratch. "A lot of what I did was draw things out. It may take longer, but it's also more satisfying." This vehicle, in particular, took some time to finalize. Conceptually, it was very realistic and well conceived, but there were many specifics the script called for that the Valkyrie shuttle had to perform: First it had to detach from the *ISV*; then it had to re-enter exo-atmospherically, coming down to land like our space shuttle. All the various technical requirements for this had to be taken into consideration.

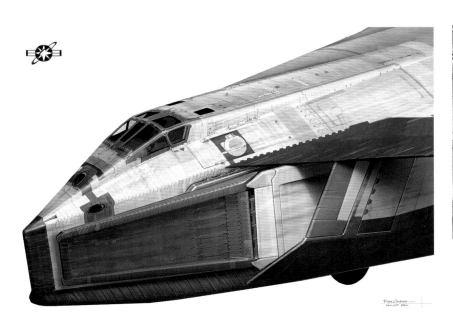

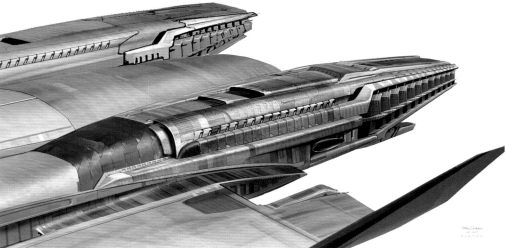

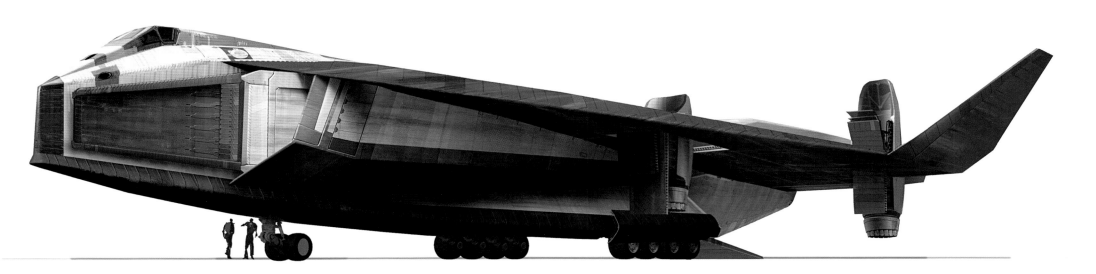

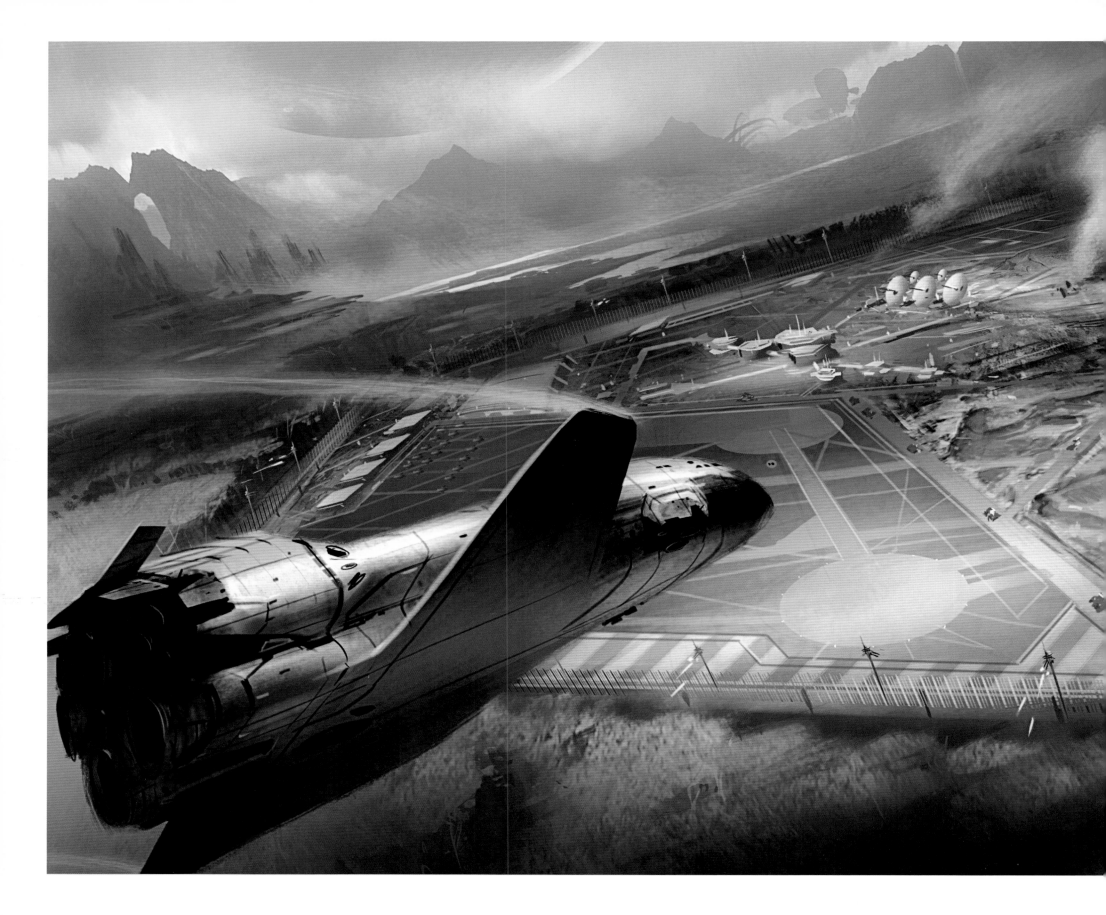

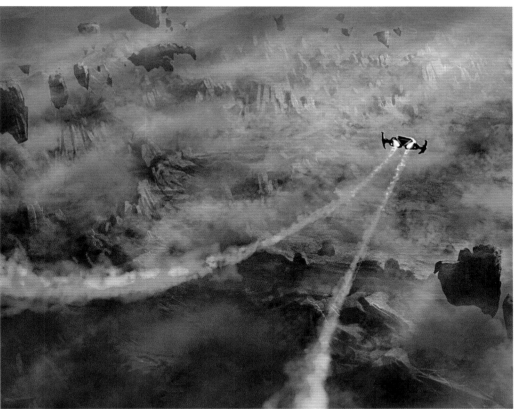

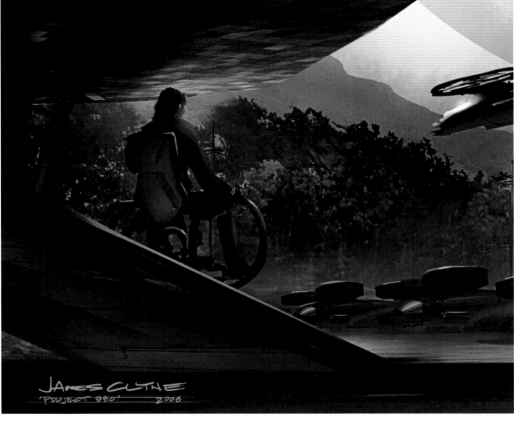

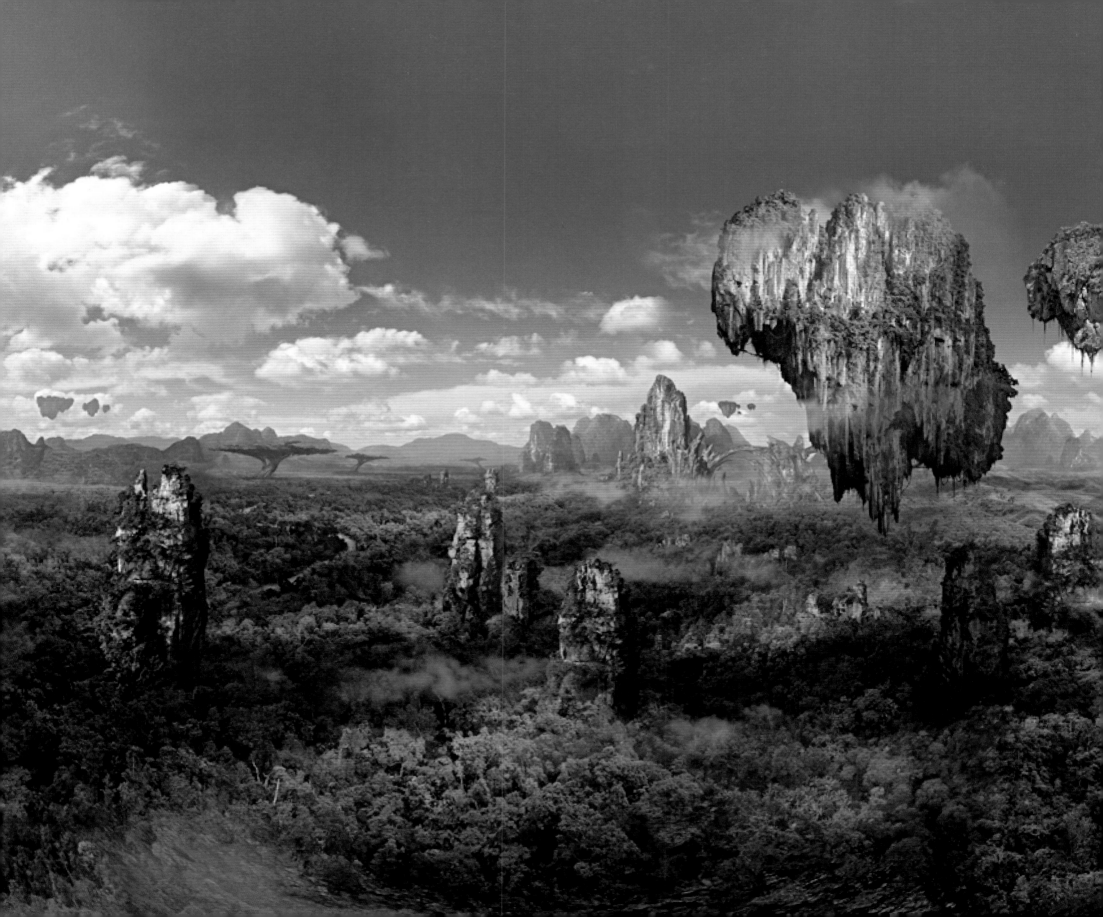

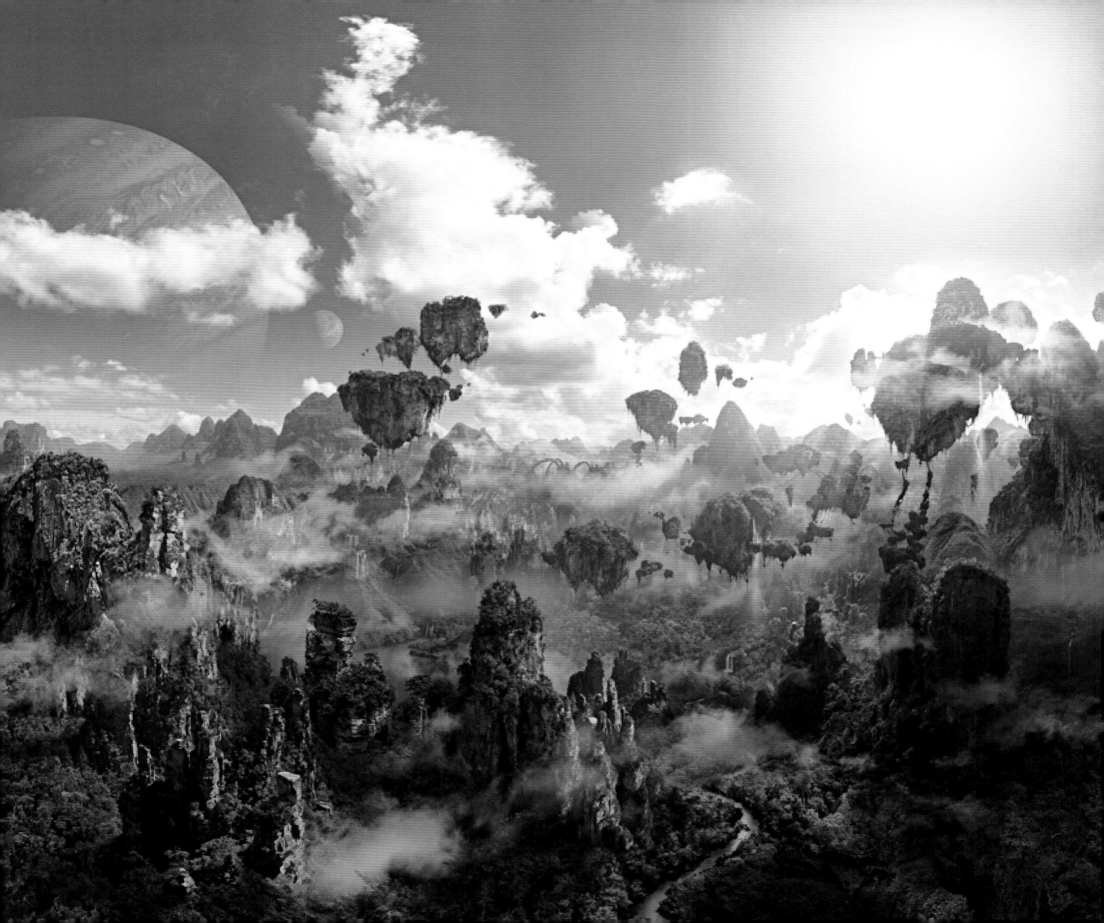

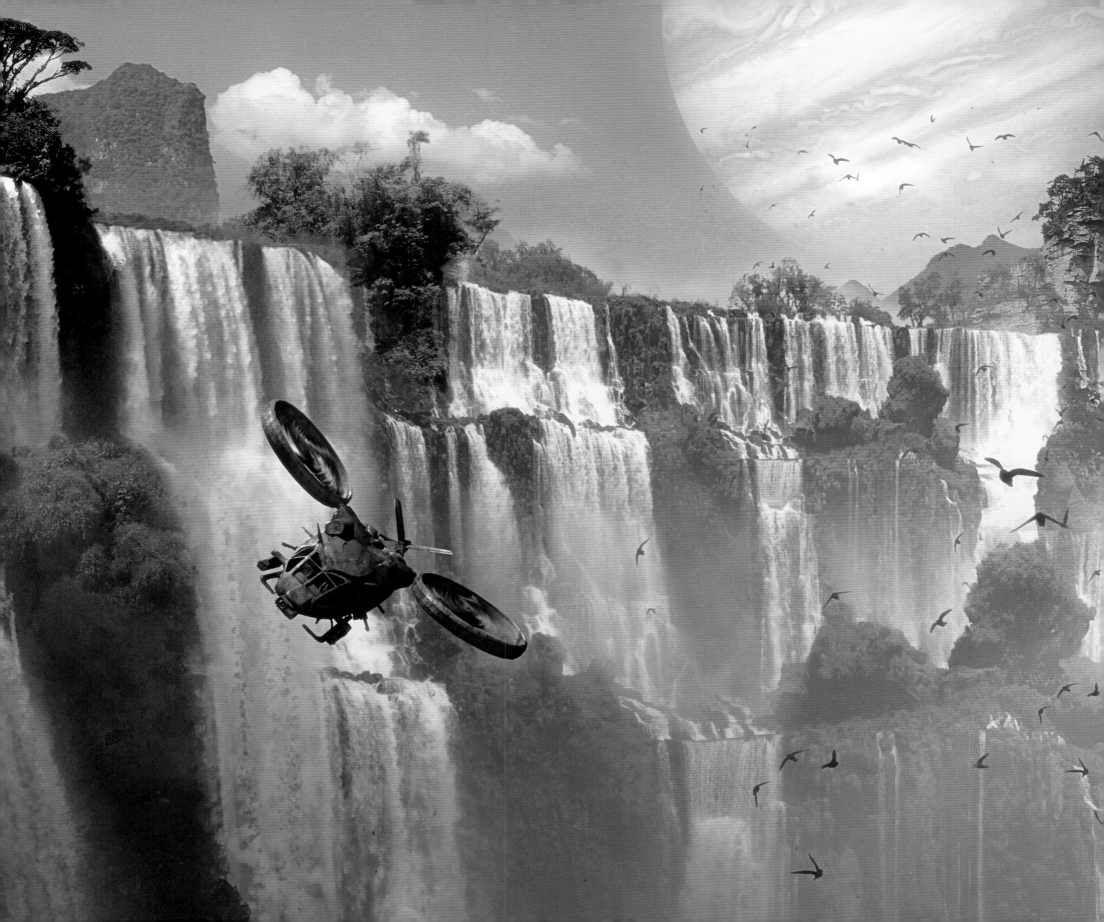

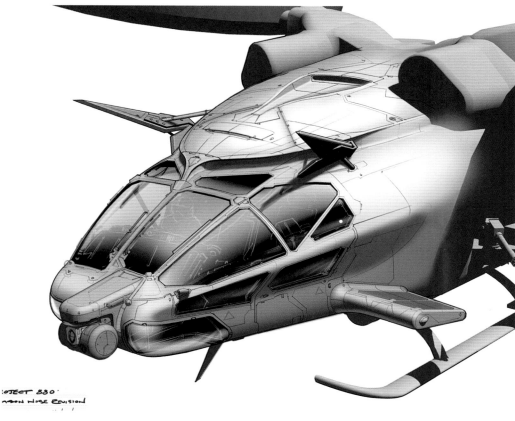

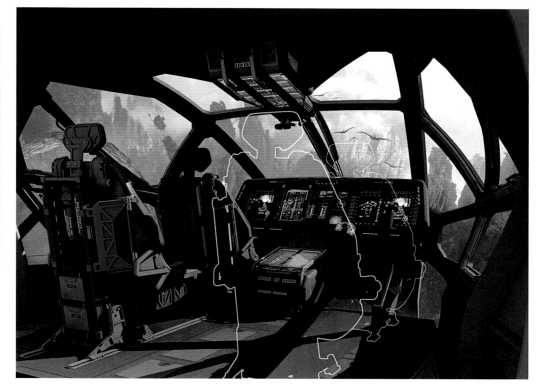

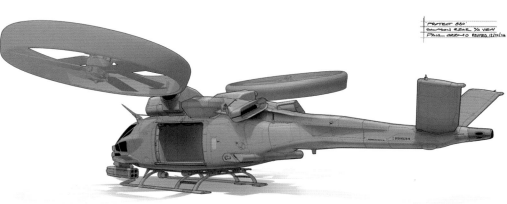

'OJECT 880'
NOSE REVISION

'PROJECT 880'
SAMSON REAR 3/4 VIEW
PAUL OZZIMO REVISED 12/12/06

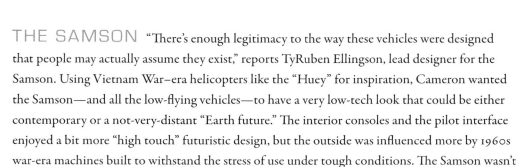

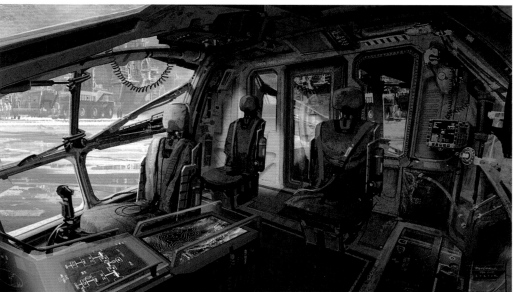

THE SAMSON "There's enough legitimacy to the way these vehicles were designed that people may actually assume they exist," reports TyRuben Ellingson, lead designer for the Samson. Using Vietnam War–era helicopters like the "Huey" for inspiration, Cameron wanted the Samson—and all the low-flying vehicles—to have a very low-tech look that could be either contemporary or a not-very-distant "Earth future." The interior consoles and the pilot interface enjoyed a bit more "high touch" futuristic design, but the outside was influenced more by 1960s war-era machines built to withstand the stress of use under tough conditions. The Samson wasn't designed to travel at intergalactic light speed. Like the Huey, it was conceived of more as a transport vehicle—deliberately utilitarian in mood. Many scenes in the film and a good deal of dialogue between the main characters take place on the Samson in flight between the more familiar, human-based Hell's Gate and the Na'vi territory of the alien forest. Knowing that once the audience "flies off the compound" they will be immersed in the much more forbidding, unfamiliar, and esoteric environs of floating mountains and fantastical plants, Cameron wanted this machine to be very grounded and devoid of "excess filigree."

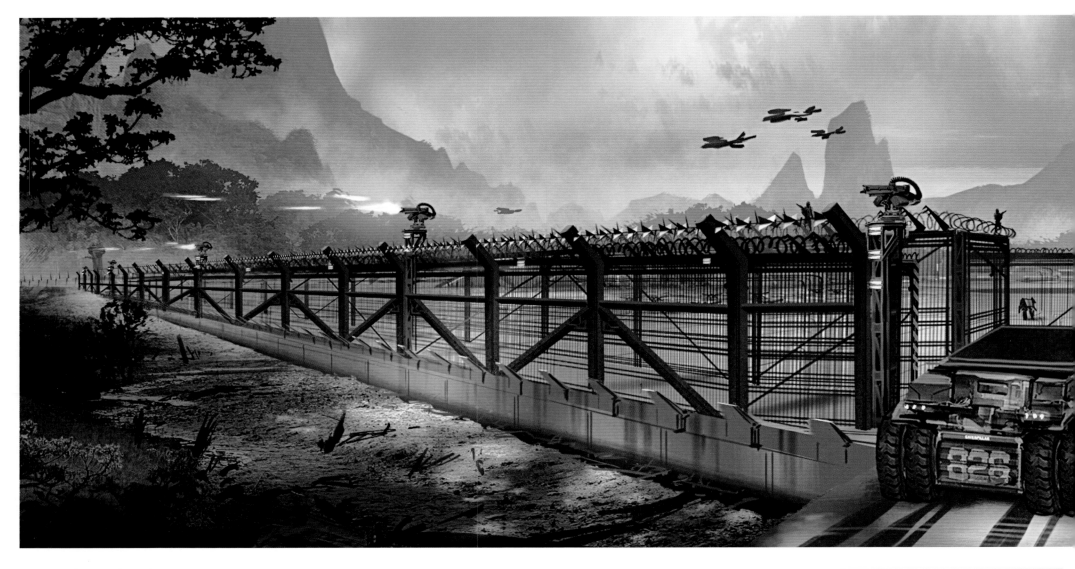

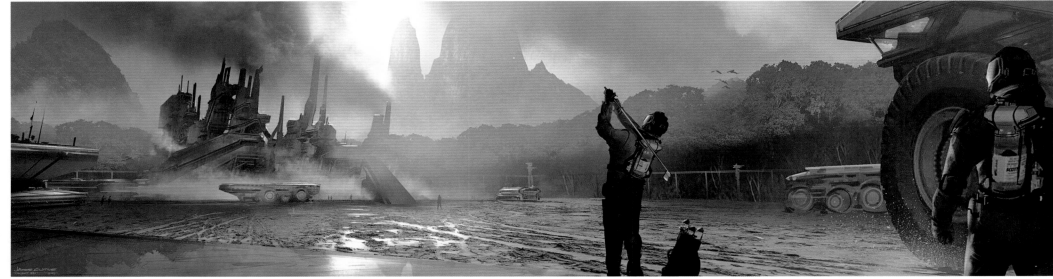

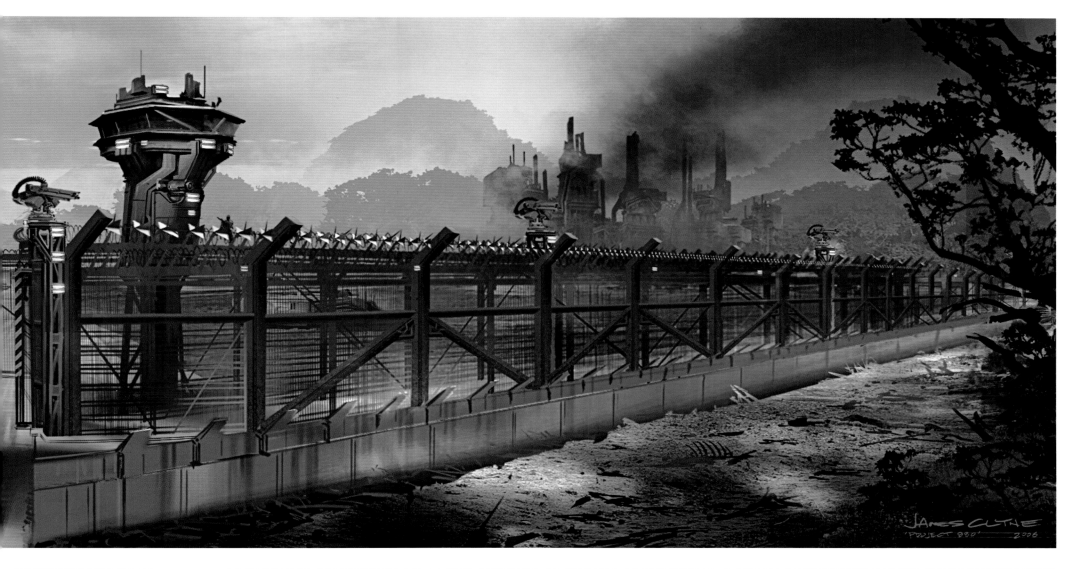

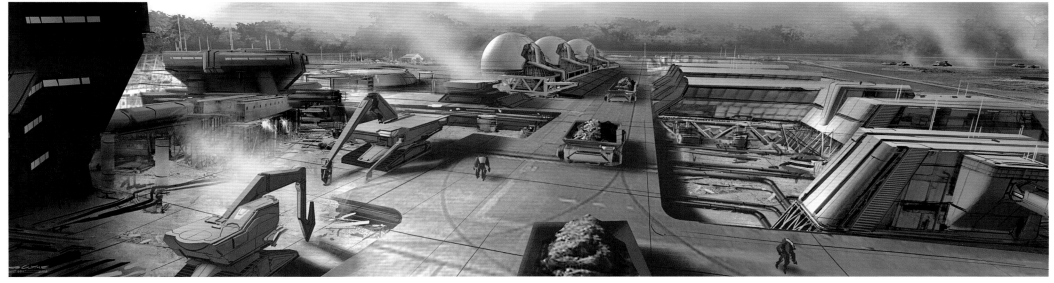

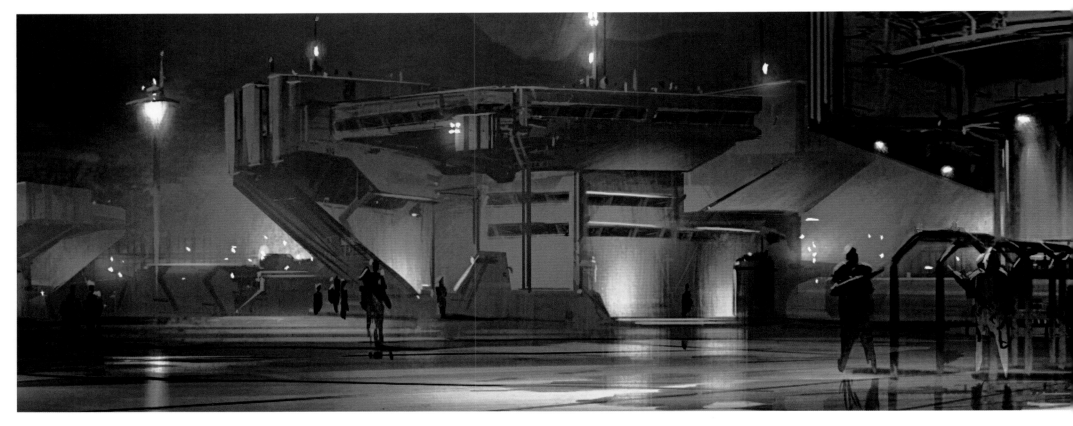

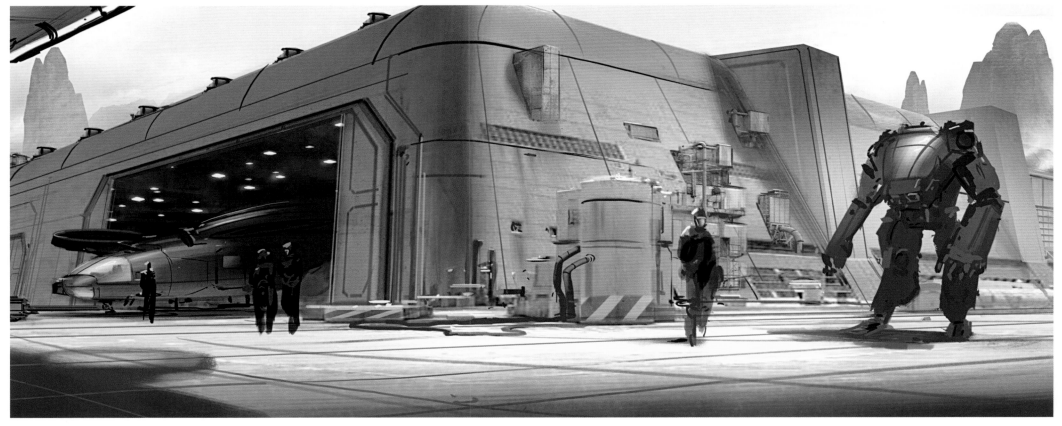

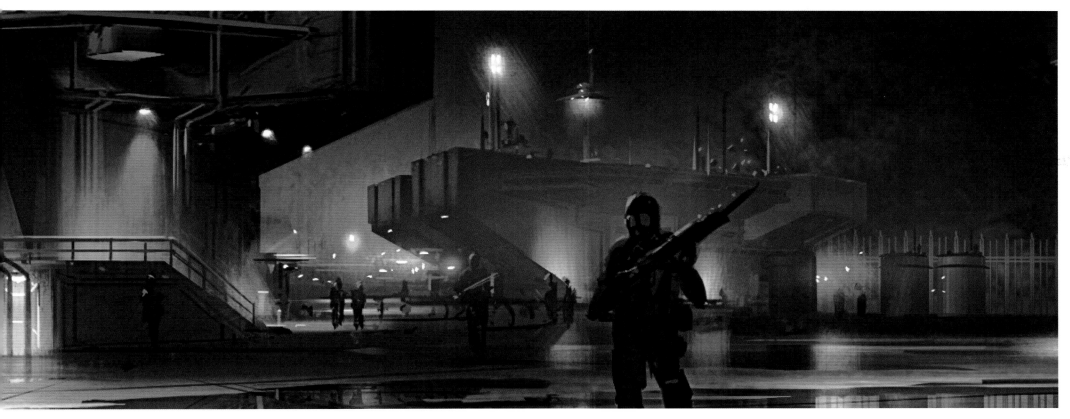

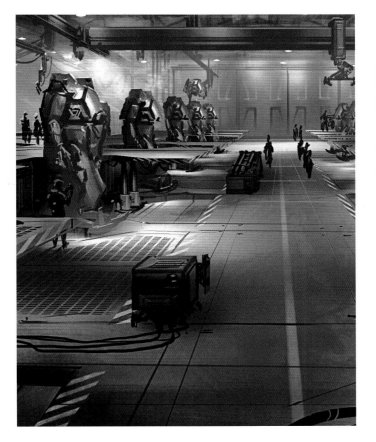

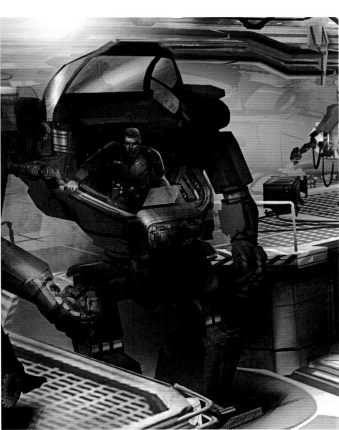

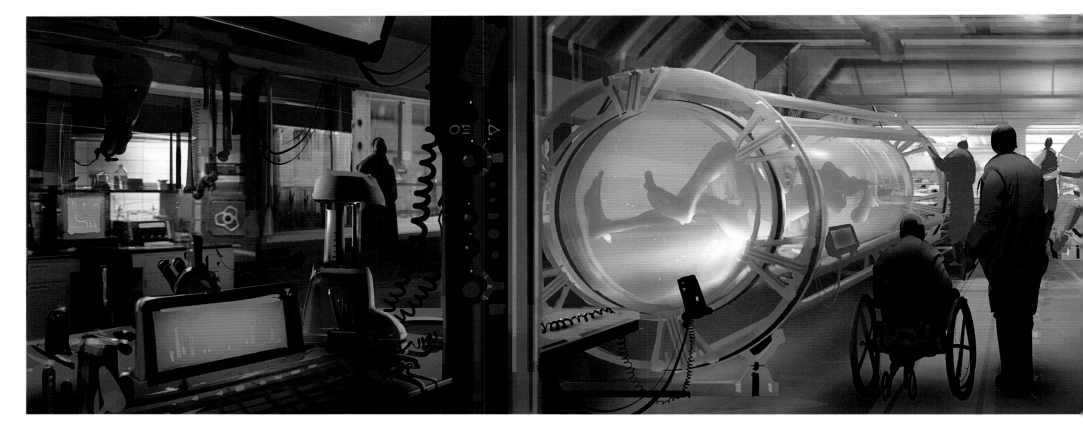

THE BIOLAB The avatar amnio tanks were the most significant prop of the Biolab, as well as the most challenging apparatus designed by Weta Workshop for their live-action sets. In following the tank's specs provided by vehicle designer Ben Procter (Procter's 3-D model is opposite bottom), Weta found a company in the United States that could produce both the plastic and metal components for these complex units. To produce the container, the plastic needed to be "rolled" and then shipped over to New Zealand for assembly. In the film, these oversized, clear-looking "tubes" are where the avatar bodies develop and mature. The script required that they fit on the *ISV*, and then be unloaded, transported to, and installed in the research center at Hell's Gate. Overall, the team had to build five tanks.

Unlike the very low-tech, Vietnam War–era look of the vehicles and the military strongholds in Hell's Gate, the design directive for the research centers called for a more sleek and modular—but realistic—appearance. The physical sets were built from the ground up using computer models, custom wood kits, aluminum, and reinforced glass. Procter was also involved with these sets, and when he first showed his designs to Cameron, he was reminded that his vehicle maps and plans would be closely scrutinized. "'I believe that that is what drives Jim to be a critic of our work,' Rick Carter would tell us again and again," recounts Procter, "because unless the created world made sense to him, it was irrelevant that anything we designed may appear 'cool.'"

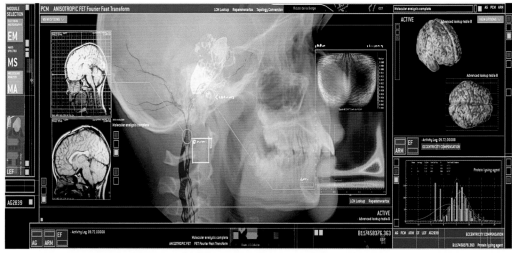

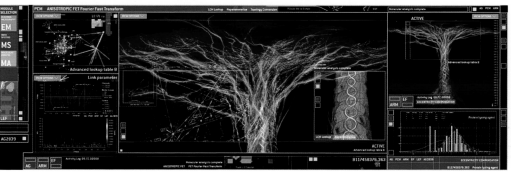

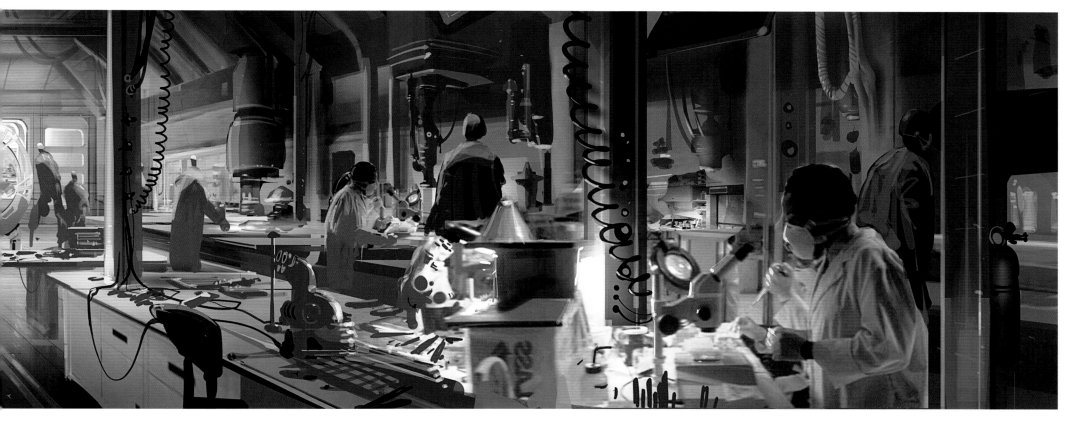

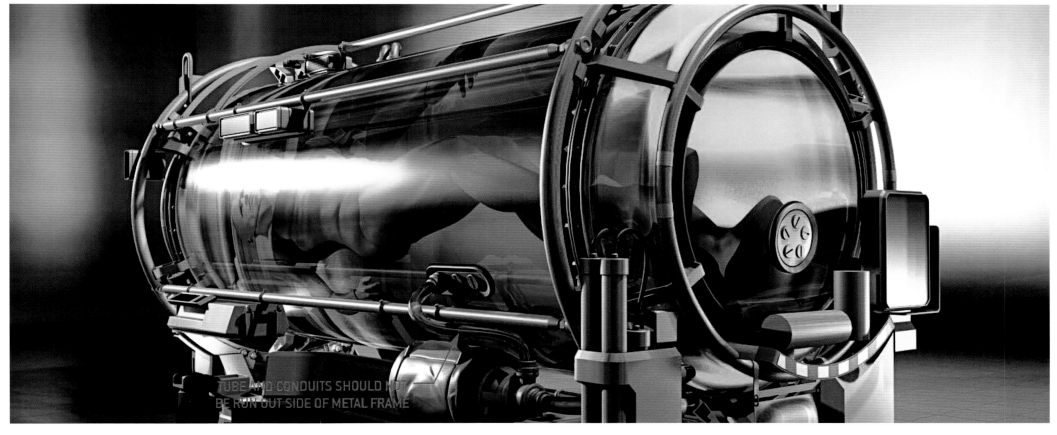

TUBE AND CONDUITS SHOULD NOT
BE RUN OUT SIDE OF METAL FRAME

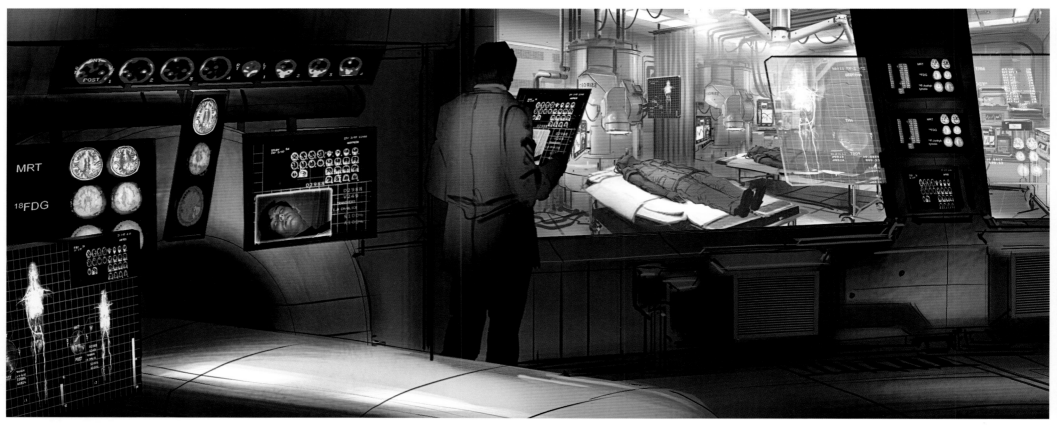

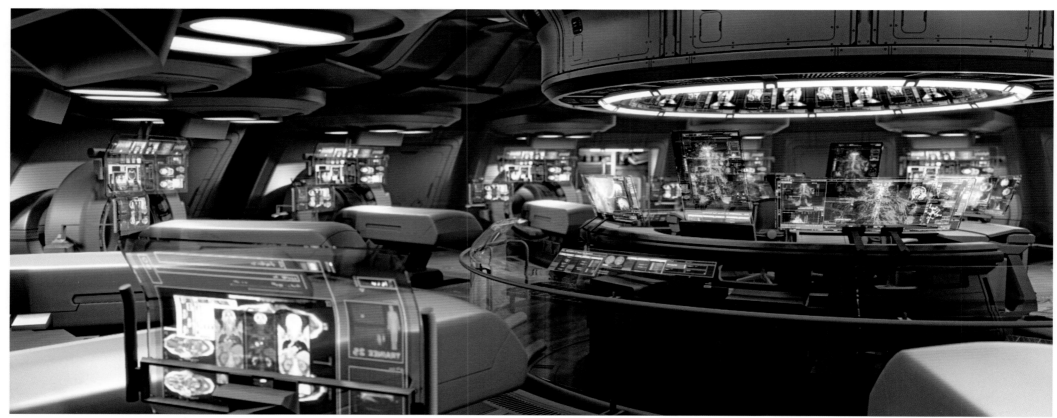

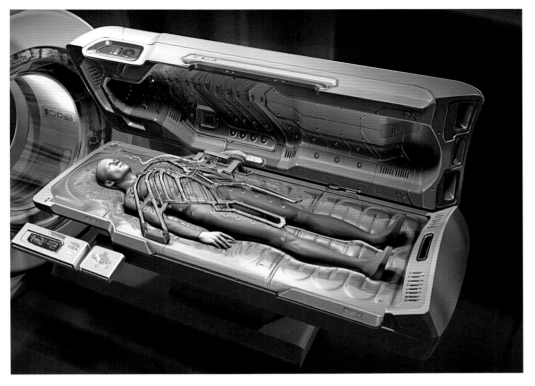

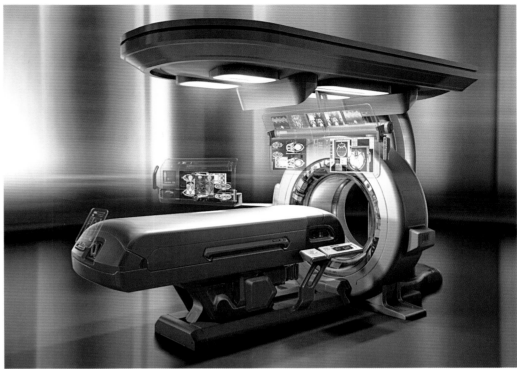

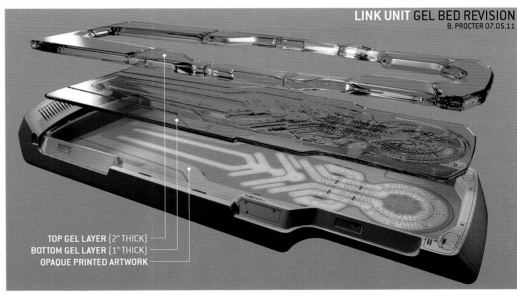

LINK UNIT GEL BED REVISION
B. PROCTER 07.05.11

TOP GEL LAYER (2" THICK)
BOTTOM GEL LAYER (1" THICK)
OPAQUE PRINTED ARTWORK

THE LINK *Two ghostly networks of light merging* is how the script describes the computer model showing what Jake's electro-magnetic field looks like when linking with his avatar. Deliberately coffin-like in their design, the link units may look surprisingly simple, but they proved to be immensely difficult to produce for the live-action set in New Zealand. There was a vast array of details that needed to be catered to for the many close-ups of Jake entering and exiting. Not only did the units have to appear to function in general, they had to slide at different speeds, stop on cue, open precisely, and have an internal glow. This glow also needed to transmit through a gelatinous material that had been transported to the set from Los Angeles. Illustrator James Clyne was largely responsible for the concepts that fill up the various screens in the link room with data; he said he produced thousands of displays that he sourced from studies of EKG systems and medical graphics. Seth Engstrom produced many of the early concept drawings for the link—similar to the lower left image above by Yuri Bartoli.

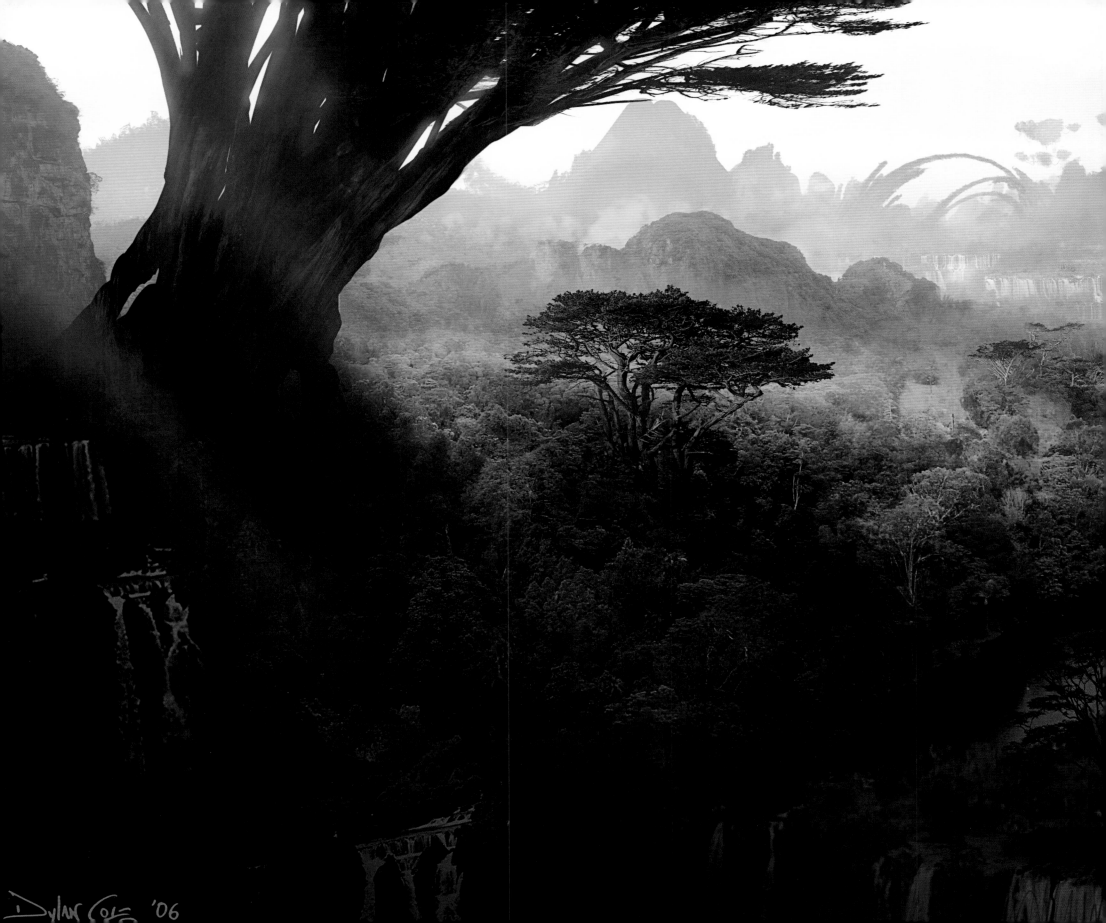

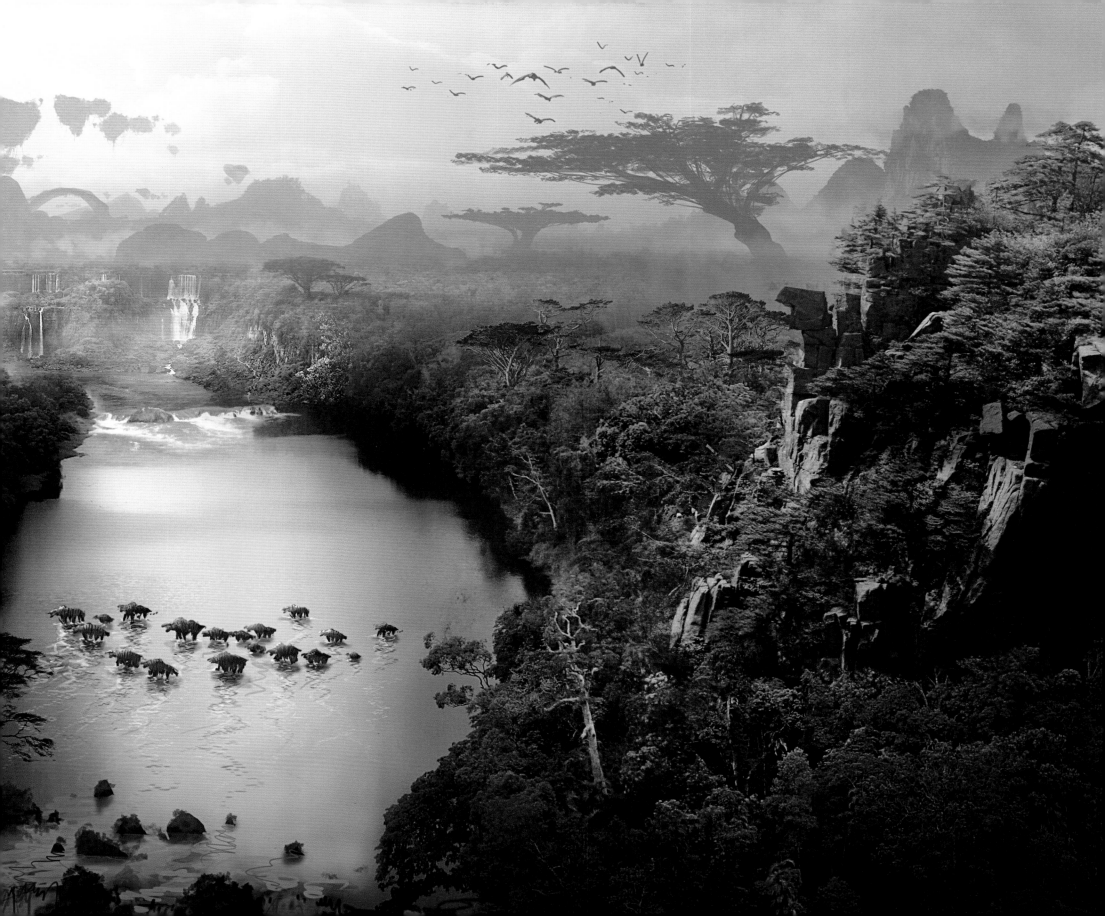

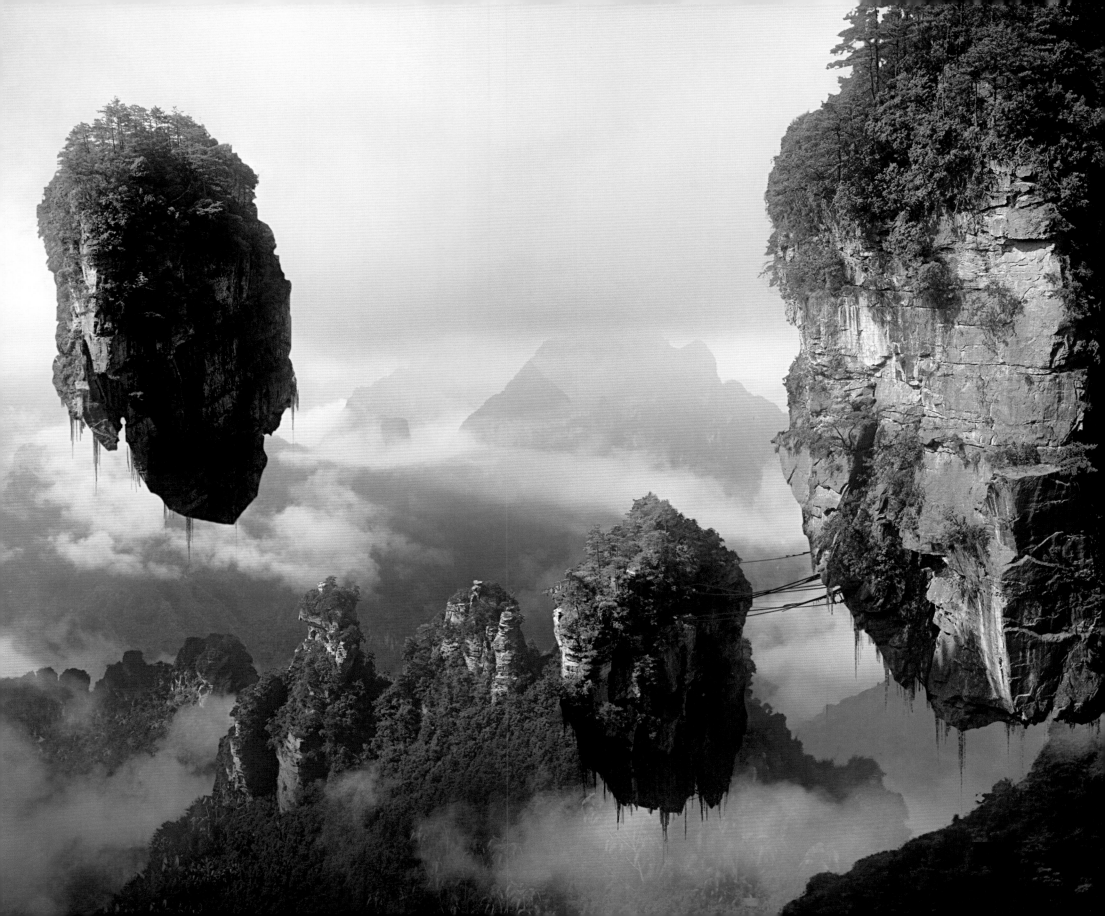

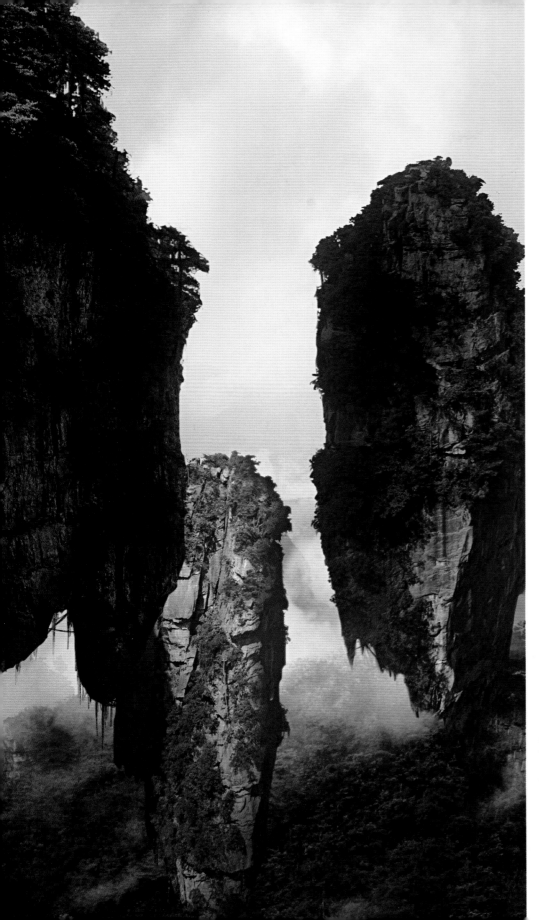

FLOATING MOUNTAINS

The Pandoran landscape is meant to communicate a vibrant, pristine, untouched, and fantastical world, one that contains the newly prized unobtanium that humans have come to mine. The Earth views, in stark contrast, depict a world in a state of ruination. Its resources depleted, the air unbreathable, its look is gritty, oppressive, monochromatic, and dark.

Rob Stromberg's panoramic painting on the next page was one of the first created for Cameron and served for months as a kind of signature look for the team of illustrators that later joined the film. From the perspective of "world building," the success of this painting lay largely in the balance between the familiar and the alien . . . always a challenging ambition for filmmakers, which, if achieved, enables the environments they create to appear not only plausible, but—at their best—real. His constant refrain with the artists was that all the fantastical elements in the Pandoran world must have a feeling of legitimacy and a reason for being—they should never be just eye candy. This dynamic approach resulted in a level of detail and precision not commonly found on a Hollywood production.

On one occasion, a request from Cameron to "show me more rocks" led intrepid young designer Steve Messing to leave the production and fly off to China for two weeks to capture images, via hot air balloon, of the karst rock formations in the Guilin region. Made of limestone with craggy, cubic edges, and monstrously sized, this mountain range (shot in early morning, noon, and evening light) possessed many of the qualities called for in the script. The image to the left is a flattened version of a full 3-D stereoscopic matte-painting test conducted by Stromberg, utilizing crops from Messing's Guilin photos. Within the software, this image of floating unobtanium can rotate 360 degrees. His source photography served as reference for all the floating mountain views, as well as the Beanstalk, the Rookery, and the backdrop for the final battle scenes. The panoramic of the Pandoran landscape on pages 20–21 is a "dome" image, which was inserted directly into the 3-D software as a background. Note the compressed edges of both lower corners—these stretch to fill the spheric three-dimensional space.

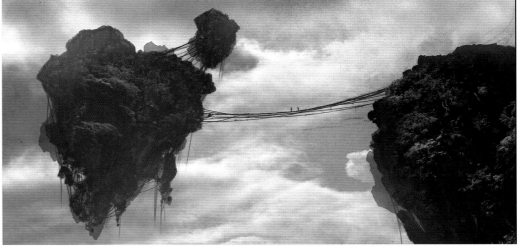

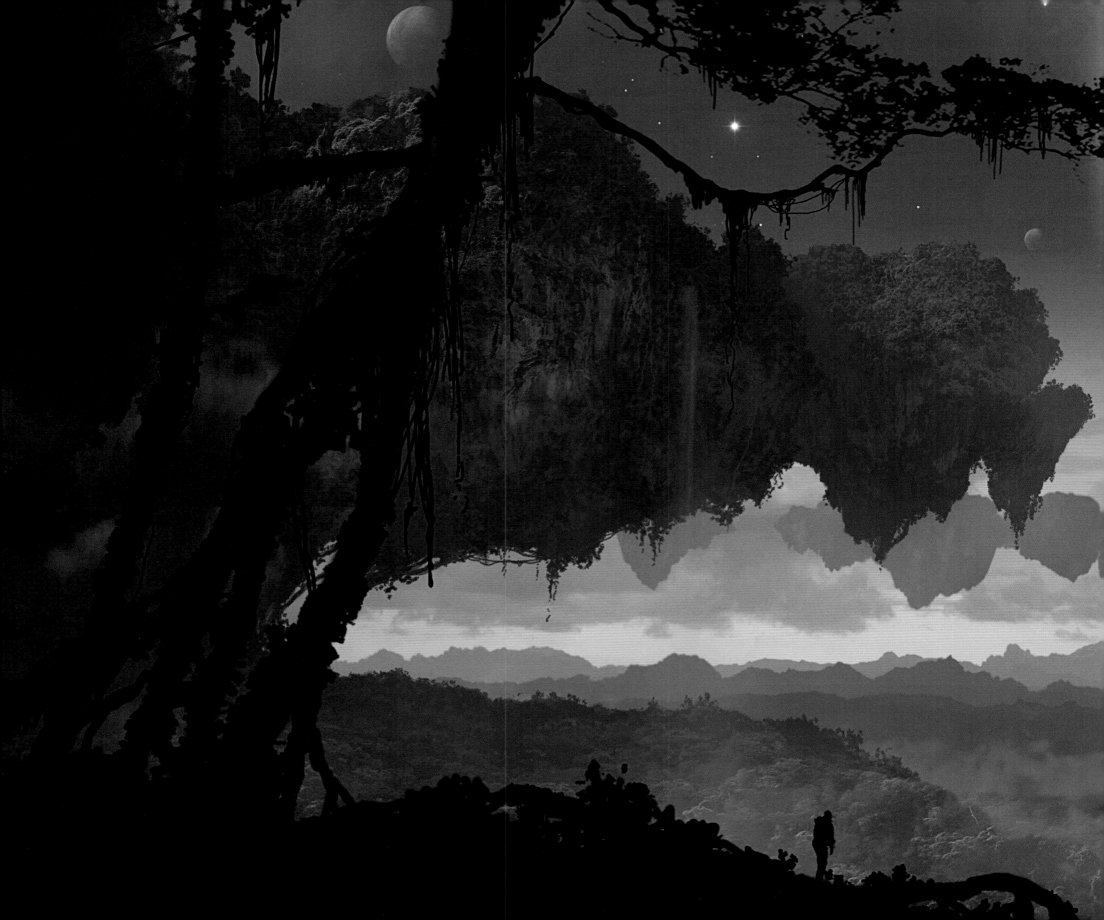

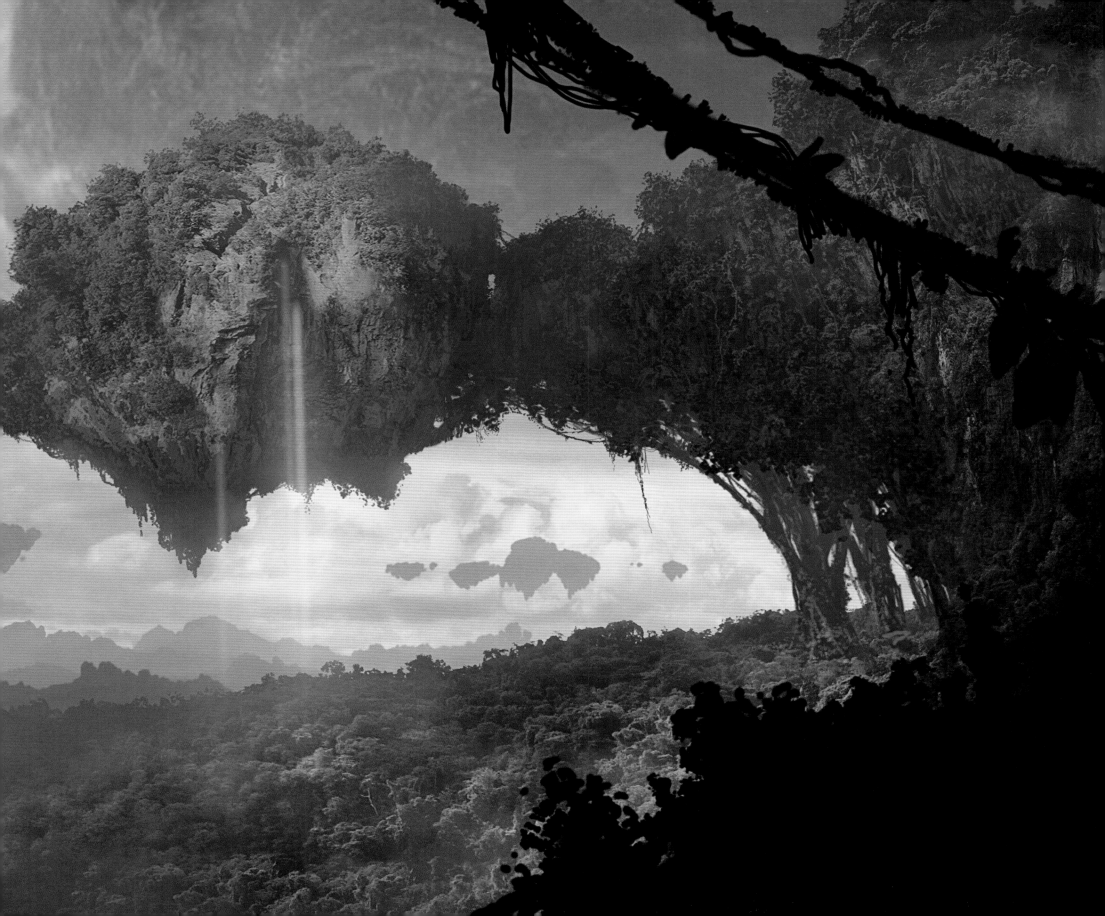

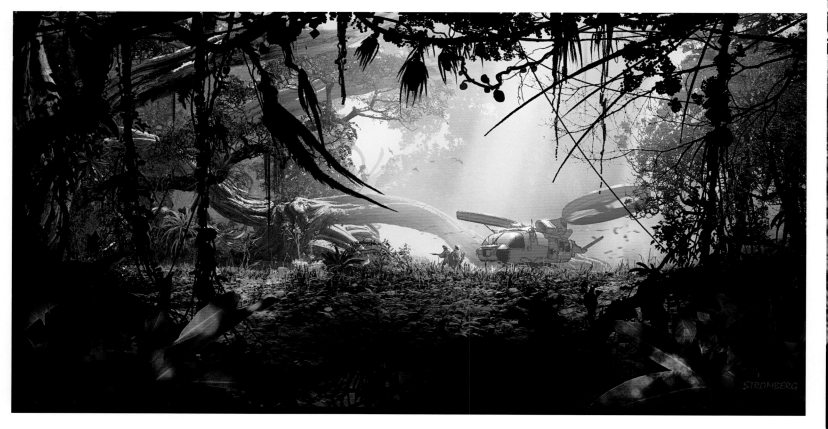

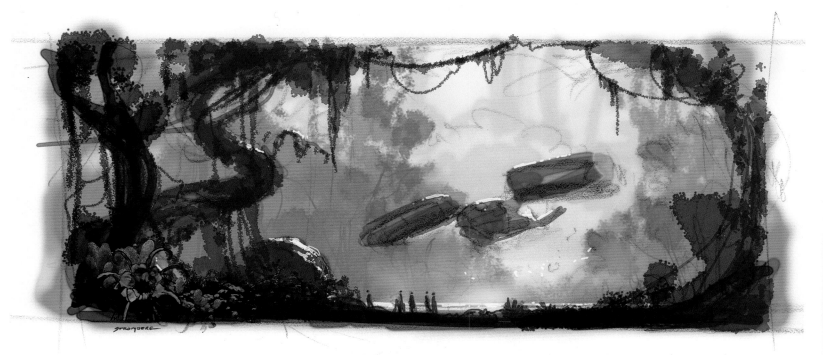

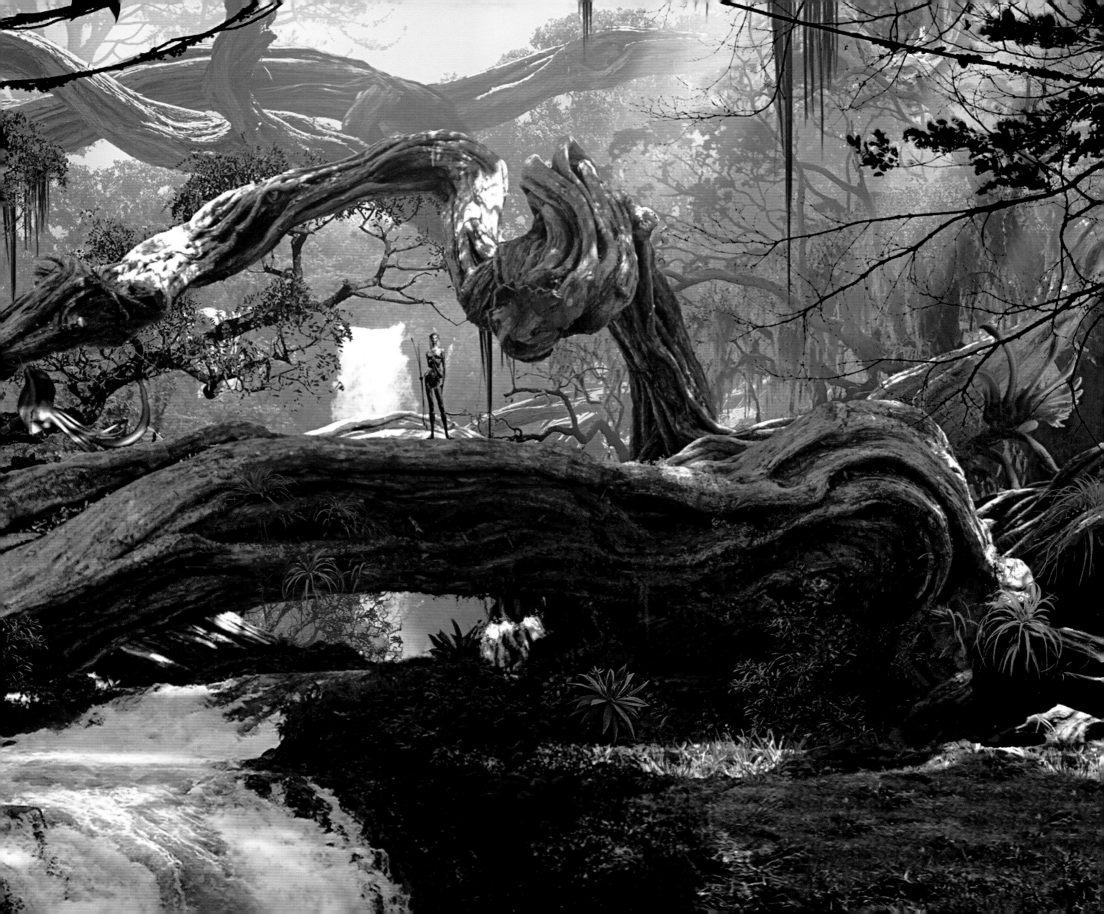

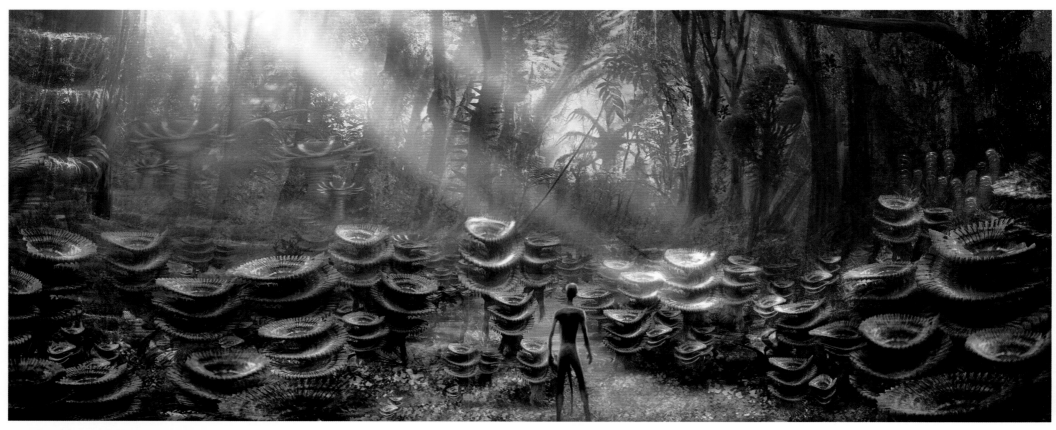
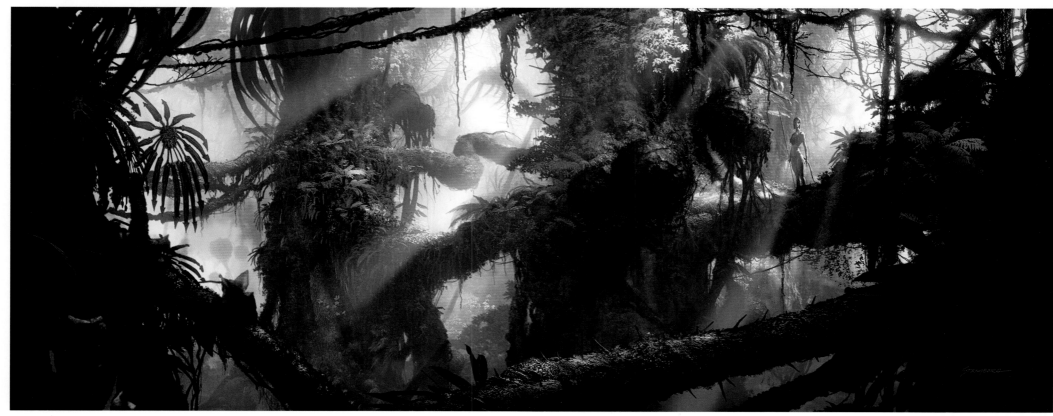

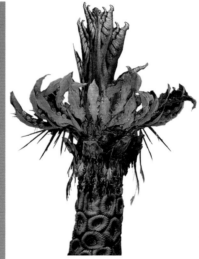

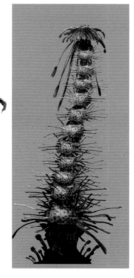

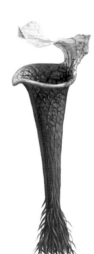

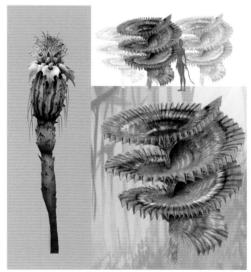

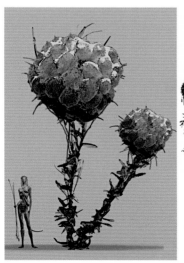

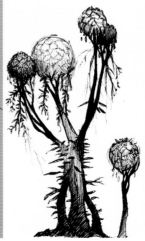

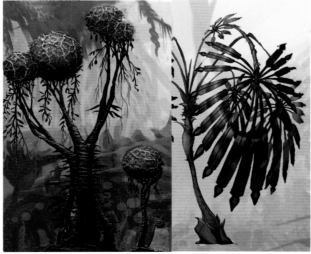

Warbonnet Fern

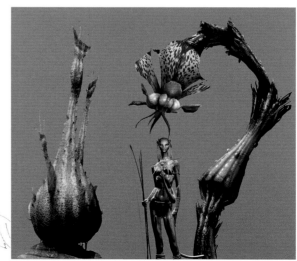

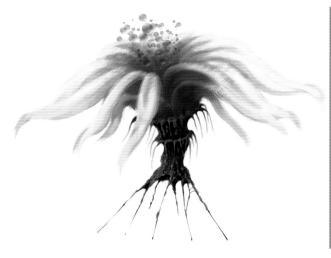
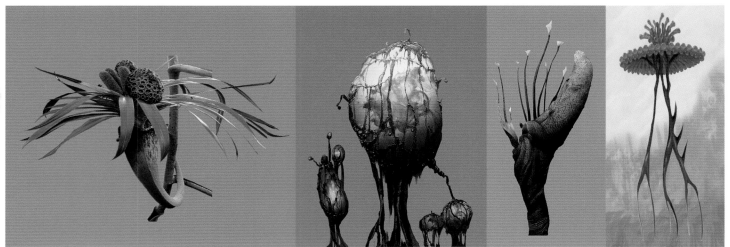
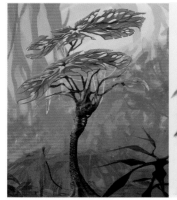

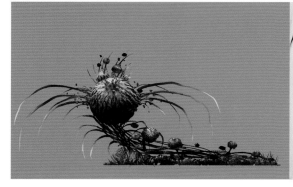

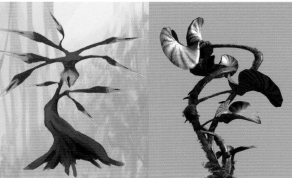
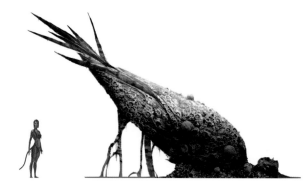
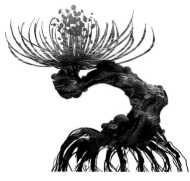
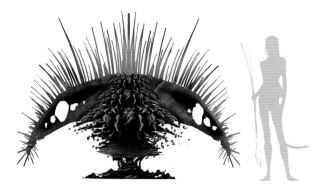
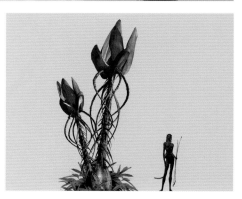

THE HAMMERHEAD This beast features a rapid-flaring threat display, in which an explosion of color fans out from the solid-bone transverse projections on its ten-foot-long head. Early 2-D explorations, at best, only hint at the thundering grandeur called for in the script. First explored in large paintings, the final, approved color and patterning are represented by the image at right by Yuri Bartoli, who also created the pencil sketch below. Creature designers often employ a more subdued, camouflage-type color palette; the bright, flamboyant themes found in all of *Avatar*'s creatures are a unique departure.

"Jim had a very specific goal. He knew he wanted a bony mass up front because this creature was going to hammer its way through the forest," says Neville Page about the aptly named Hammerhead. Cameron also wanted this Pandoran herbivore to be more bull-like, kicking up dust and stomping at the dirt. Andrew Jones and Dave Clayton (both animation directors at Weta Digital) were largely responsible for infusing it with bull-like movements. Clayton suggests that even though such a lumbering, thick-limbed creature would most likely just trot off, the initial scene with Avatar Jake called for the Hammerhead to flee, so a gallop was thought to be more effective. Jones describes: "We needed to find ways of showing the story beats with the characters that we had been given, so we experimented with different attitudes of a creature that might, at first glance, have a more limited range of native expression." Jones and Clayton developed the language for translating the creatures of the film from their 2-D and 3-D model world into their fully animated phase.

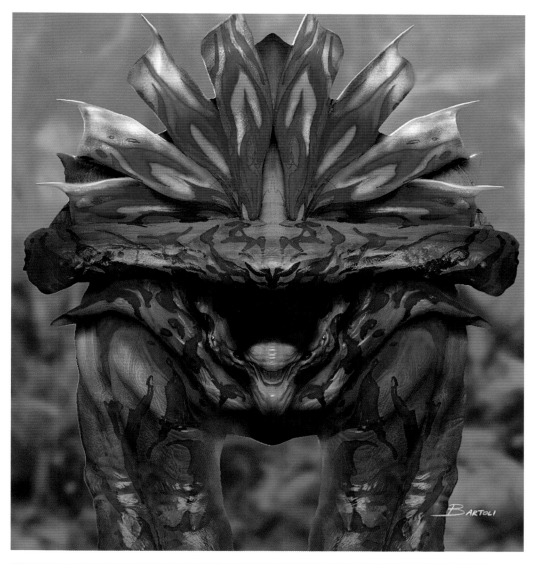

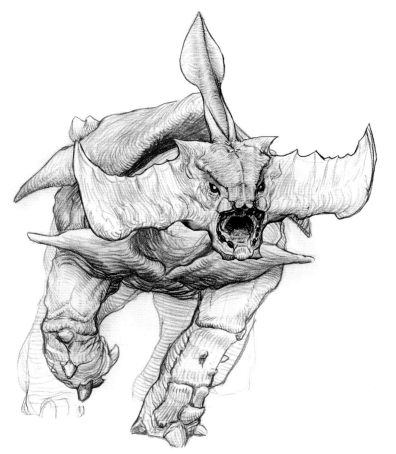

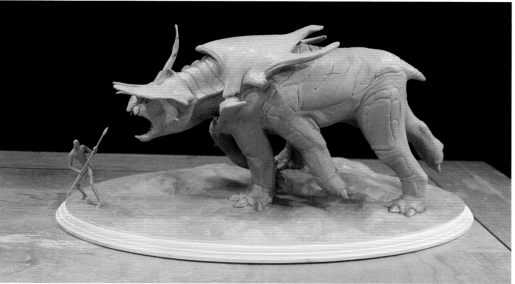

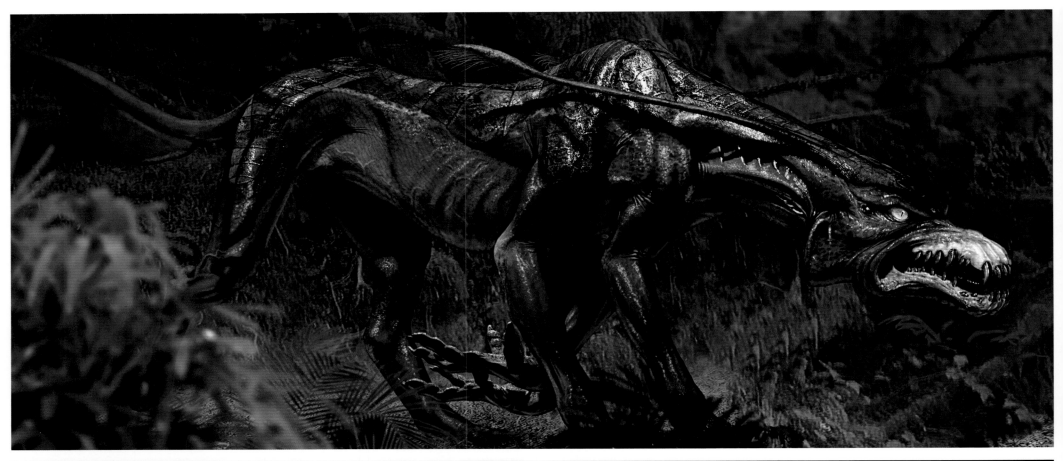
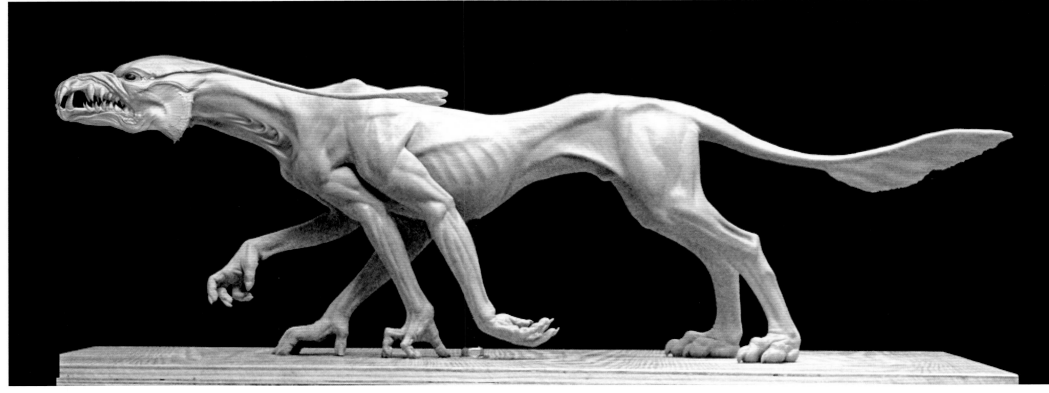

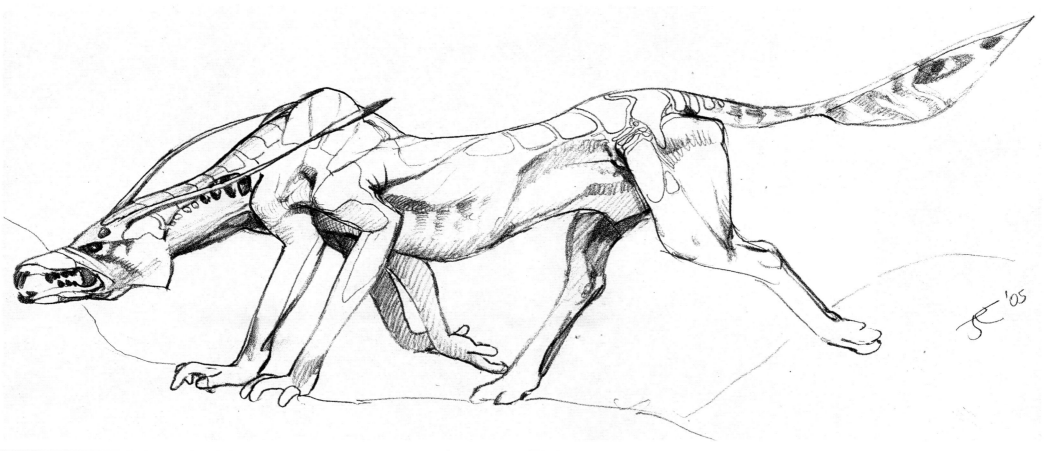

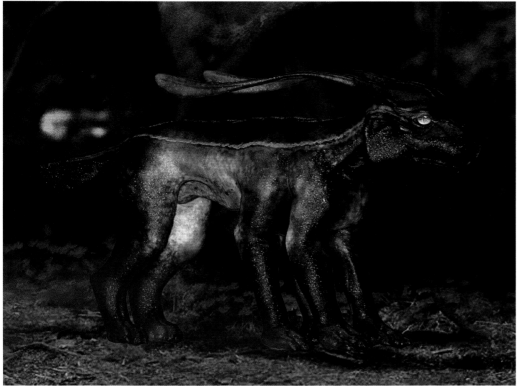

THE VIPERWOLF

As with the rest of the world of Pandora, James Cameron was clear about what this creature needed to be—down to the final detail. The Viperwolf, channeling the dreadful canine apparitions of twentieth-century painter Francis Bacon, is a loathsome predator. Its hairless, six-limbed, mink-like body has shiny black skin banded with vermillion and thin lines of iridescent blue. It can slither through the forest underbrush, run like a dog, climb like a monkey, and hunt in the trees as well as on the ground. Using this as the artists' launching point, every line, every proportion, and every color value and skin texture were explored over the course of many months until finally the precise details of the creature were fully revealed. This discovery process, like most on the production, could be compared with the resurrection of an old memory or a vision of a place once visited. By design, an environment was created where the team was allowed the opportunity to explore various design directions in great detail. Rob Stromberg describes the experience: "It was like a big jigsaw puzzle, trying to figure out what combination works. We spent more than a year and a half assembling and disassembling, trying and failing until we finally arrived at a place where we resolved what the puzzle—this world and its creatures, including the Viperwolf—looks like." The next phase was motion, and the Viperwolf was the first of the hexapedal animals to be put to the test. Recounts creature designer Neville Page, "Honestly we didn't know what to expect from the motion studies, but after seeing the Viperwolf in action we all agreed we could move forward. Not only was it working, it was looking really, really cool."

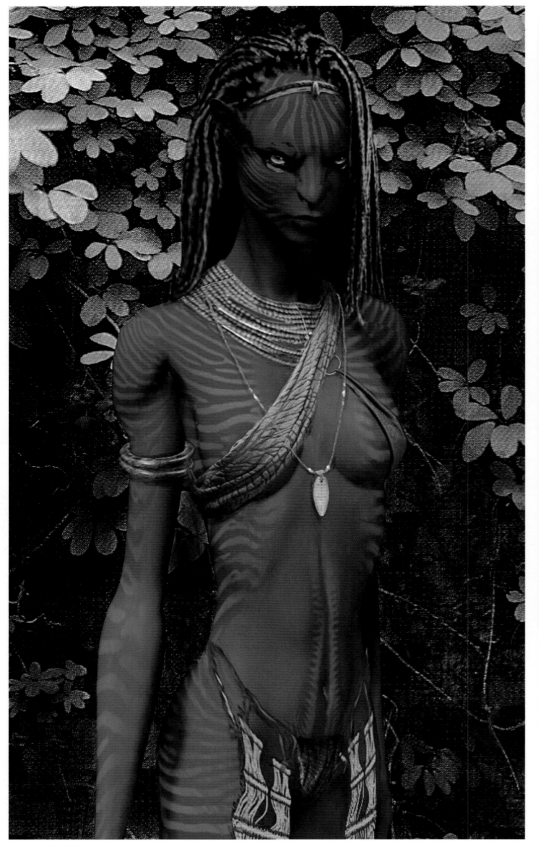
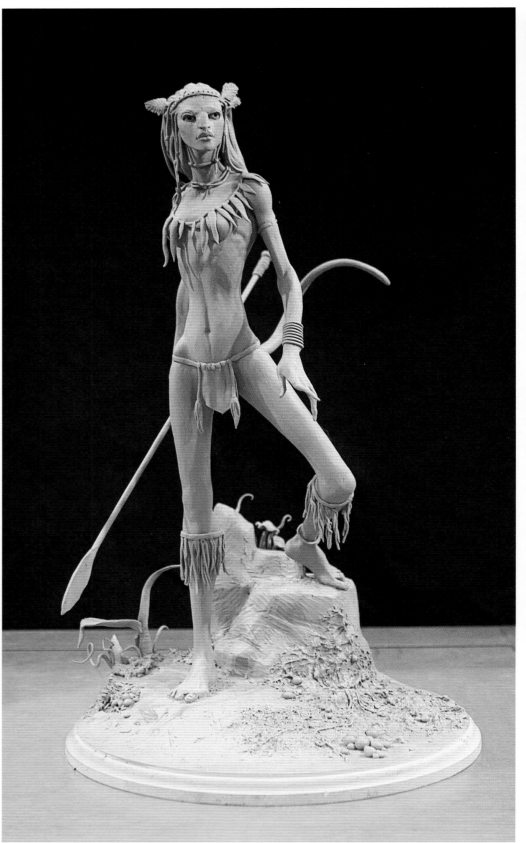

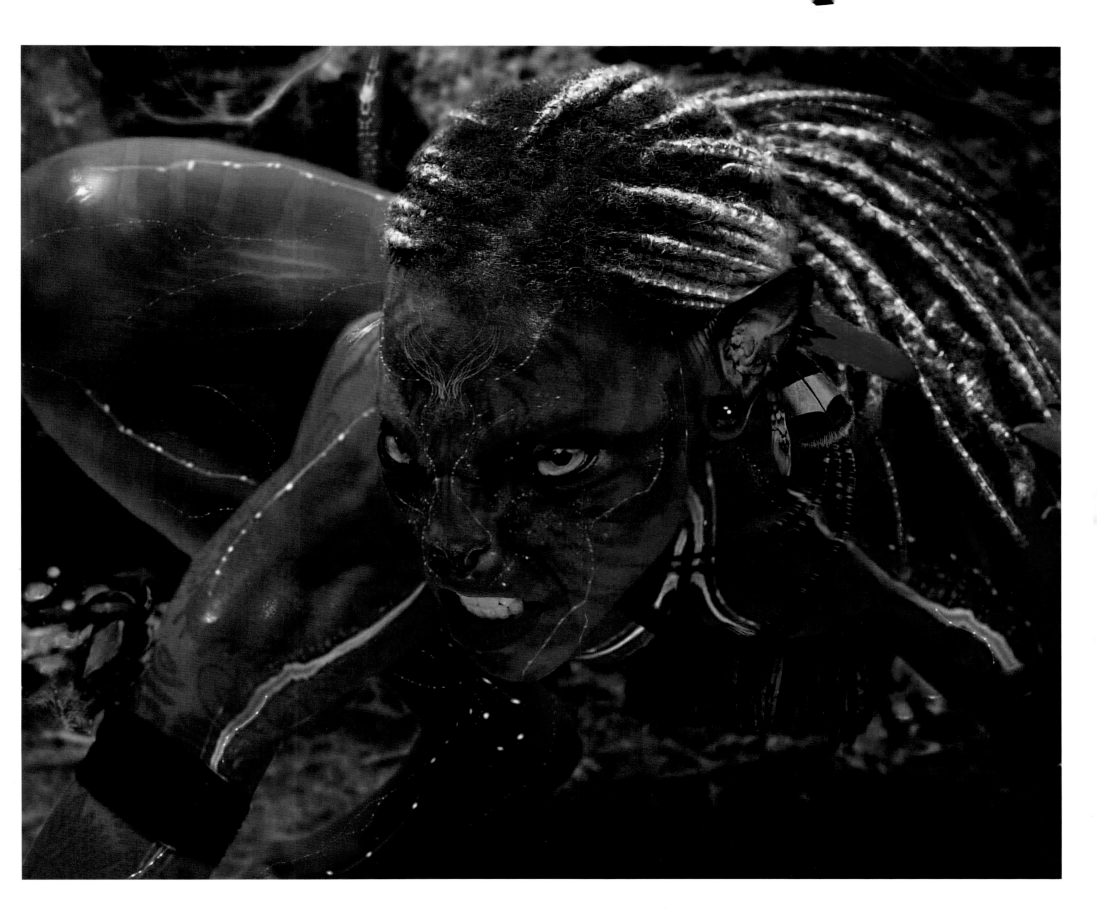

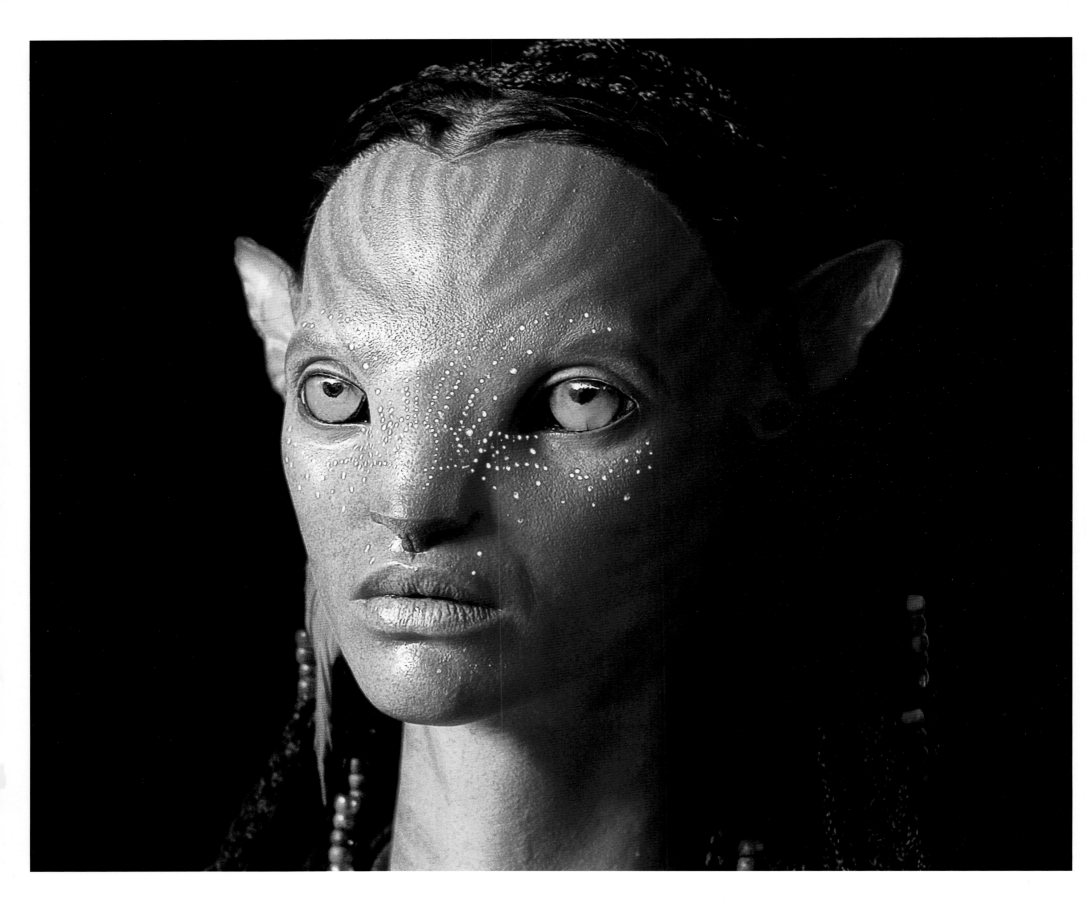

NA'VI LOOK Years before film production began, Cameron wrote into the "script-ment" for *Avatar*: *Invisible to him, draped on the limb like a leopard, is a striking Na'vi girl. She watches, only her eyes are moving. She is lithe as a cat, with a long neck, muscular shoulders, and nubile breasts. And she is devastatingly beautiful—for a girl with a tail. Her name is Neytiri.* The most recent of Cameron's signature strong female lead characters, Neytiri is daughter of the clan leaders and an Amazonian alien huntress, nearly ten feet tall with iridescent, cyan blue skin and zebra-like purplish stripes. She has feral ears and a snout, and her physique is long, lean, and angular. Moving soundlessly and swiftly through her forest, she is a mythic embodiment of our noblest potential selves. Neytiri's shape, color, and look became the touchstone for all the creative development on the film to follow. Bringing her from Cameron's inner vision into reality was a multistage process, beginning with the sketchpad—as 3-D designer Ben Procter says, "a pencil is still the ultimate design tool." Lead sculptor Jordu Schell is credited with translating Neytiri's look into the approved maquette on page 48, which largely defined her body shape—and that of all the Na'vi thereafter. In describing Cameron's efforts to communicate her look to him, Schell noted, "This sketch of Jim's (below) is still one of my favorite images for the film. It just captured something perfect about her. It's very simple—neither the definition of the edges of her head nor the sides of the face are there, just her features, sort of floating on this grayish-brown background on toned paper. It's fantastic. Once I saw this, I finally got a strong feel for what he was after." John Rosengrant and the Stan Winston Studio then further developed and finalized the facial features of Neytiri, as well as for all the Na'vi and avatars.

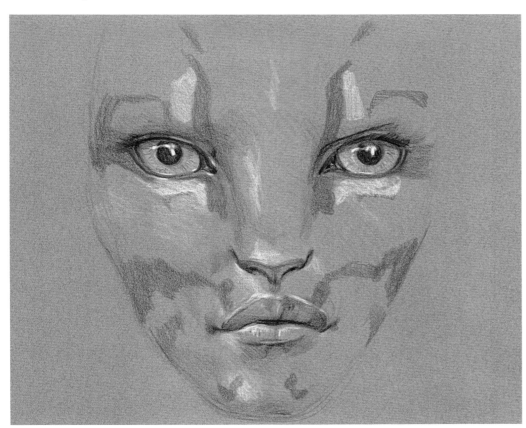

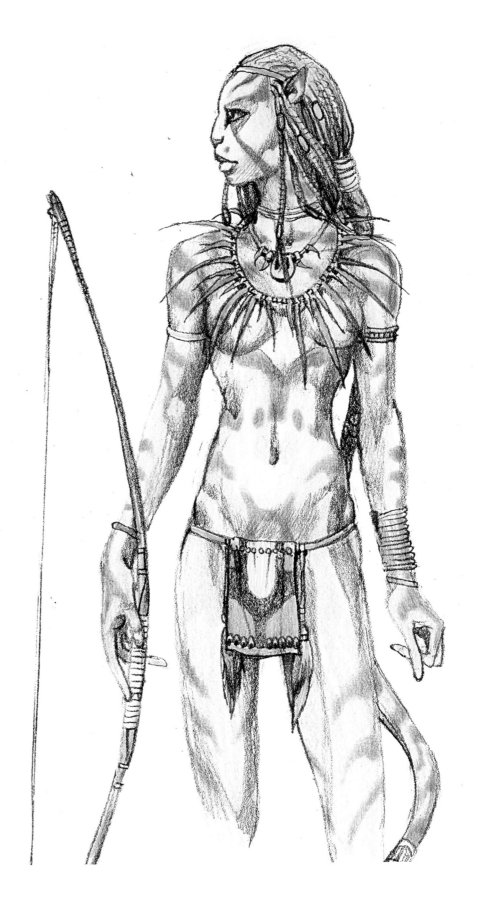

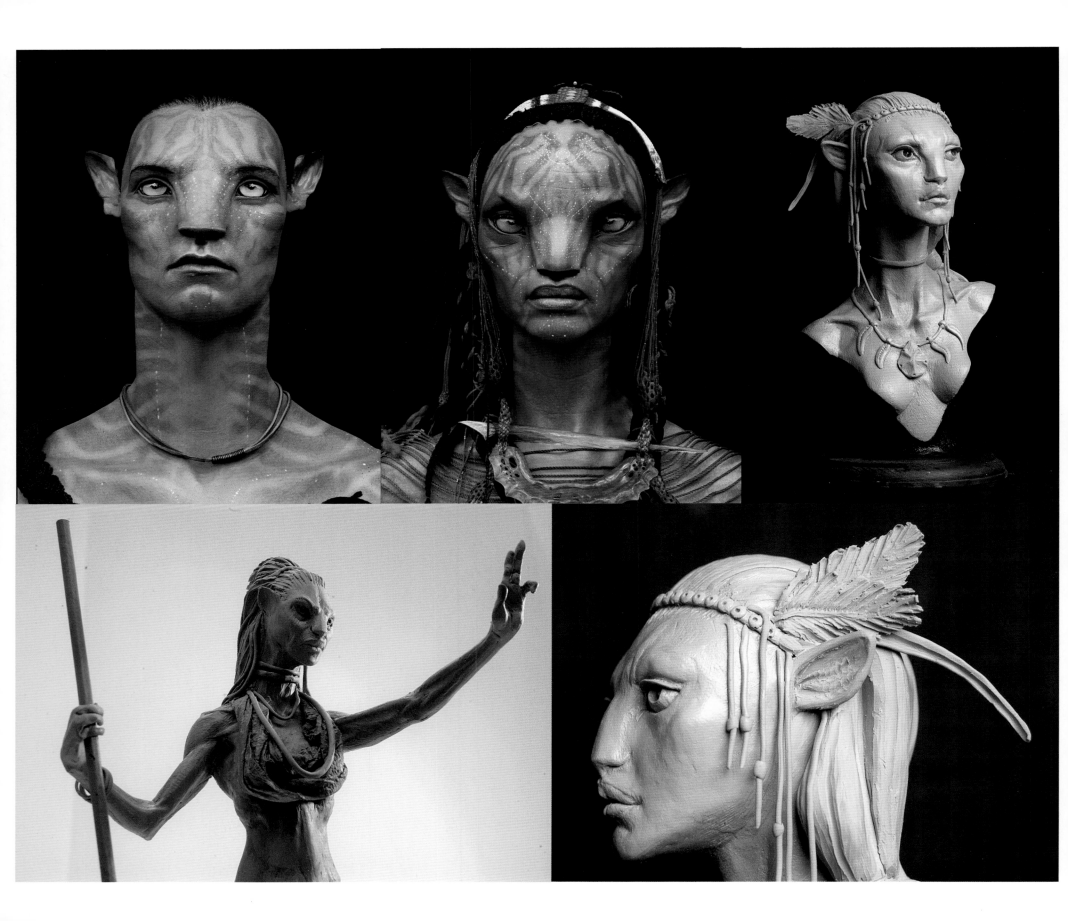

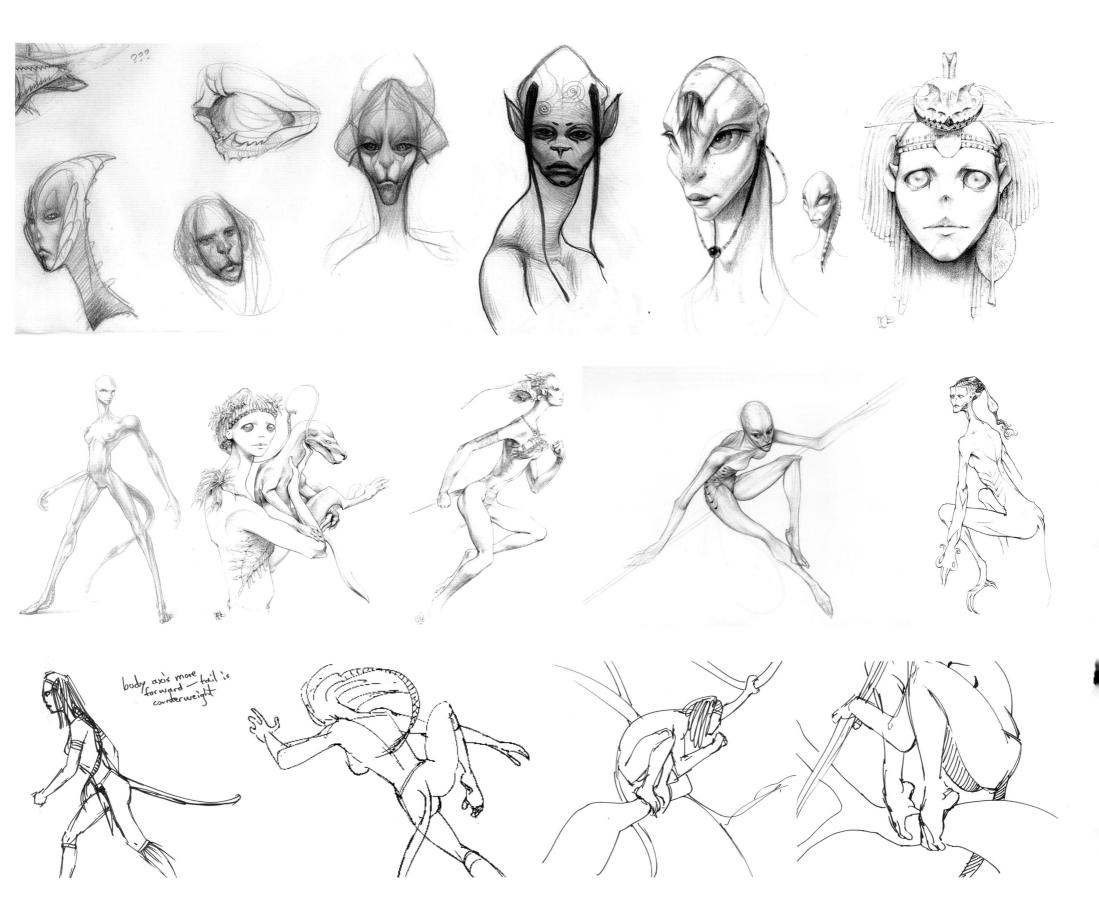

???

body axis more forward — tail is counterweight

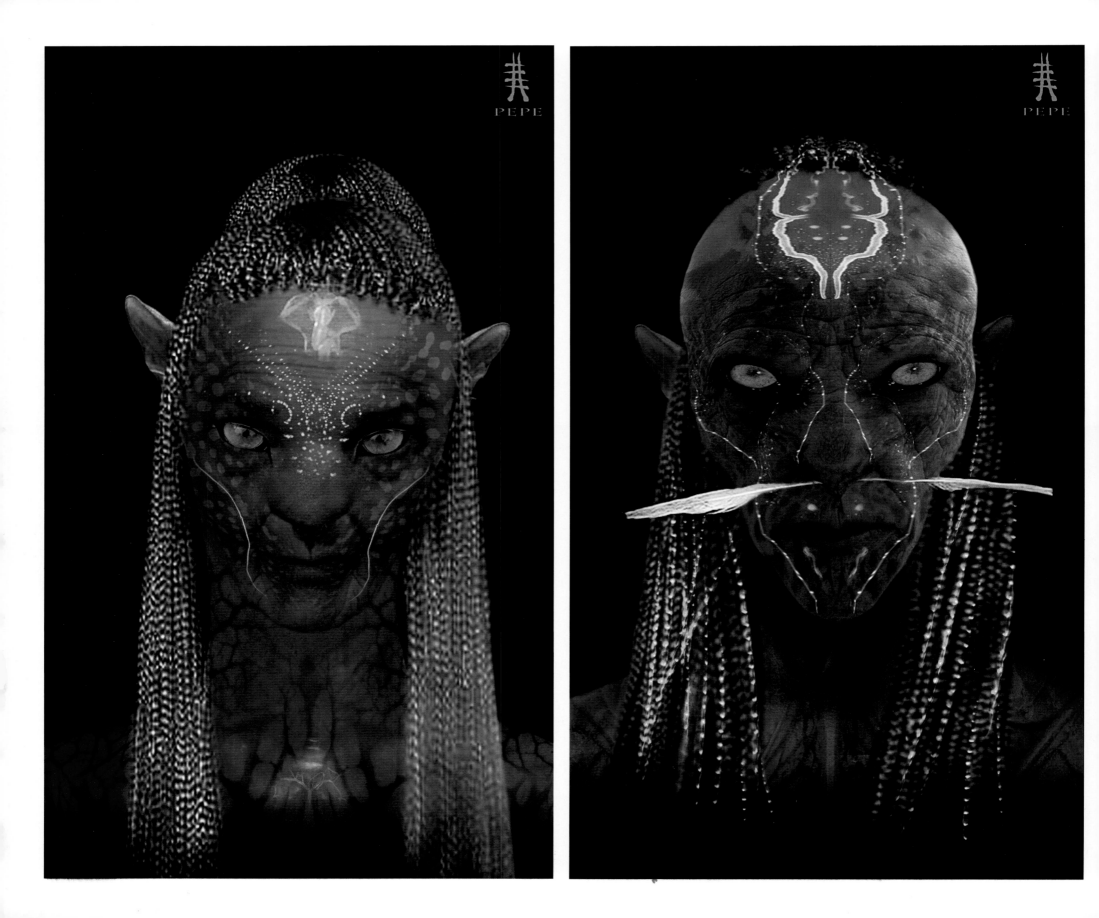

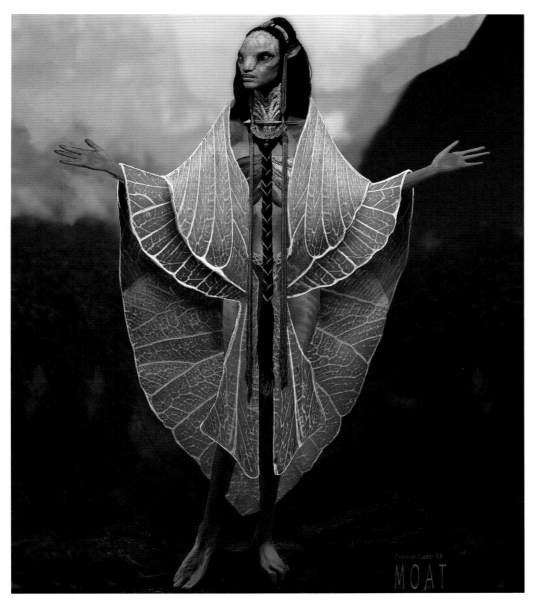

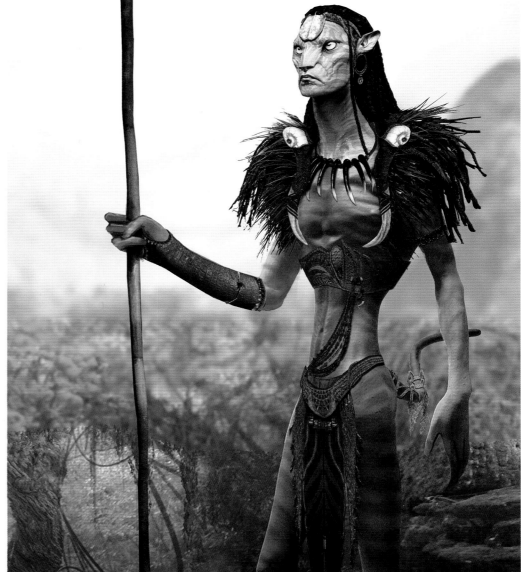

NA'VI CLOTHING In developing the Na'vi look, Weta Workshop understood the importance of building a culture that had a believable heritage, and they were instrumental in identifying the Na'vi as weavers. They explored the tough questions of how these people lived day to day, and resolved, for example, that the Na'vi dress was primarily for comfort and practicality. They wear ceremonial pieces like those shown on clan leaders Mo'at and Eytukan here, but because both the men and women fight, there needed to be a balance between adornment and armament. Costume art director John Harding oversaw much of the early beading, woven fabric, and garment development work as well as the creation of jewelry and weapons that the Na'vi use.

Cameron, Rick Carter, and Richard Taylor (the head of Weta Workshop) all agreed that if they were going to successfully communicate the textural subtleties, the weaving styles, and the translucency in the jewelry (for example), then samples initially needed to exist as physical props that the director, the art department, and finally the digital-effects team could handle, feel, and

touch. Academy Award–winning costume designer Deborah Scott encountered some challenges: "I'm learning about working with a costume that is never actually going to be worn by a human being . . . it still has three dimensions, however, so I've come to appreciate that every item needs to be realized all the way around. For me it's a new way of working—a real leap of faith." Bits and pieces were either fabricated or collected for her and as samples for the digital artists at Weta Digital who required tactile information such as: What is the weight? Does it stick or blow about in the wind? How does it interact with the thread next to it? Does it float or sway? Is its surface rough or smooth? Ultimately, Weta received a combination of image files, actual costume pieces, and texture references, which was followed up by real-world dialogue between Scott and Weta about how to successfully apply these elements onto the fully synthetic, mobile characters within the CG software.

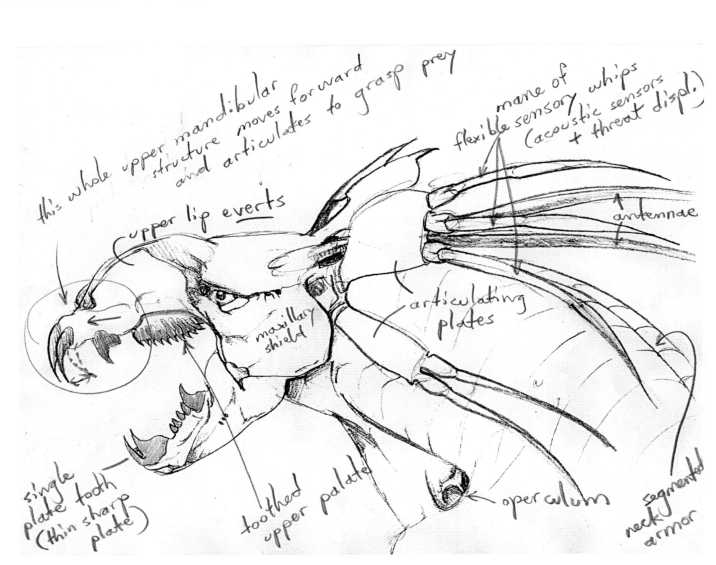

this whole upper mandibular structure moves forward and articulates to grasp prey

upper lip everts

mane of flexible sensory whips (acoustic sensors + threat displ.)

antennae

maxillary shield

articulating plates

single plate tooth (thin sharp plate)

toothed upper palate

operculum

segmented neck armor

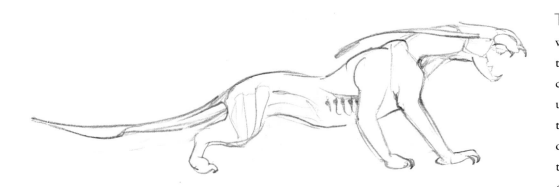

THE THANATOR Because of the scale and scope of this filmmaking enterprise, it would be challenging for any single artist to be credited with developing or finishing any one of the creatures, vehicles, or landscapes. *Avatar*'s world-building creative development spanned the course of several years, with designers working around the clock to offer up this fully crafted universe. Nonetheless, while many helped realize the look of the creatures, all will tell you that the Thanator, more than any other, was unarguably "Jim's baby." He directed and oversaw its development from beginning to end. Designed to shock and frighten Avatar Jake during his first trip into the forest on foot, the Thanator, as Cameron wrote in the script, is *the most fearsome of the Pandoran land predators—a black, six-limbed panther, the size of a tractor trailer, with an armored head, a venomous, striking tail, and a massive, distensible, armored jaw with nine-inch fangs.* All of the sketches found on these pages are by James Cameron.

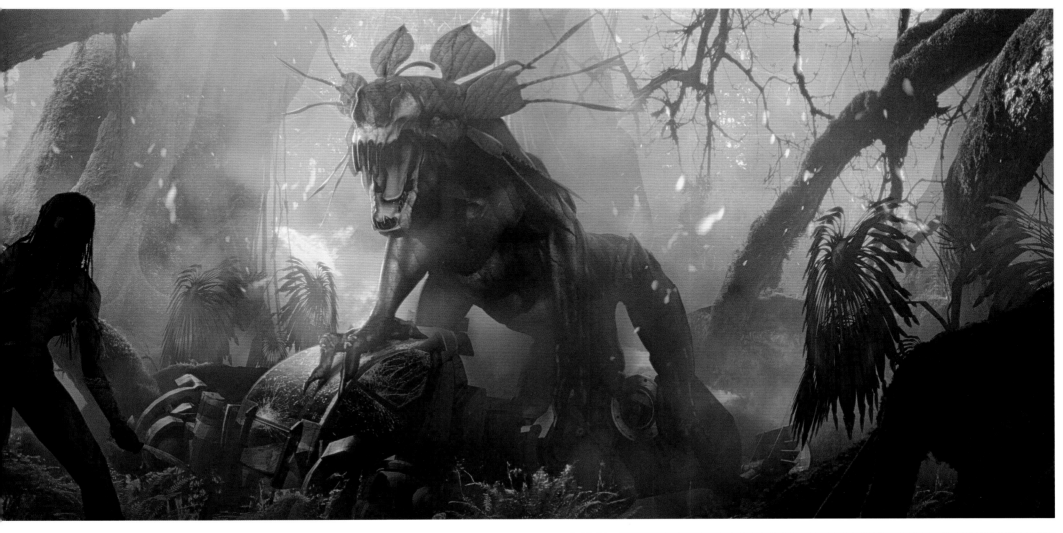

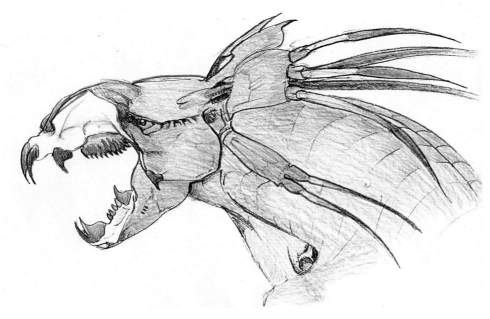

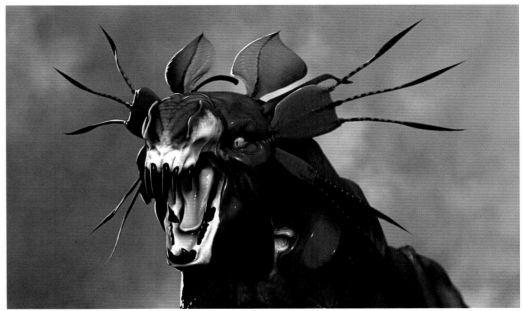

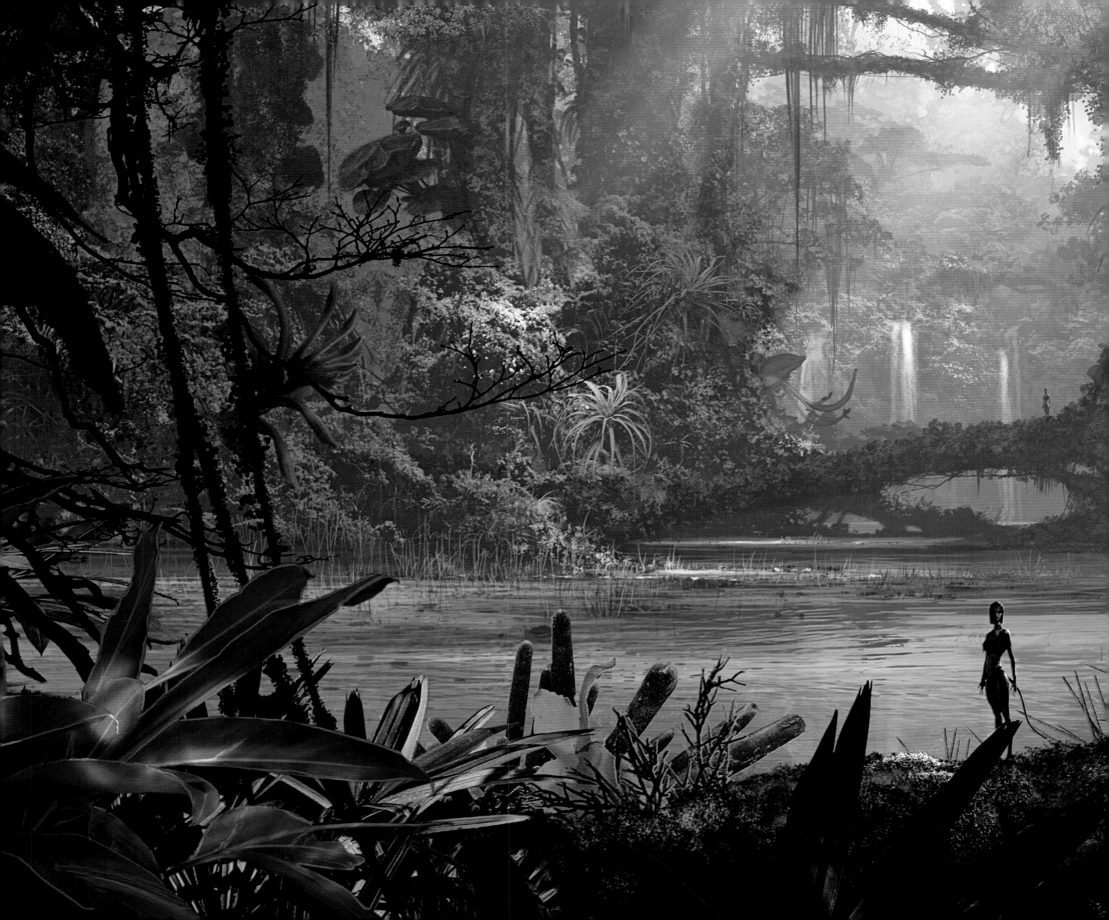

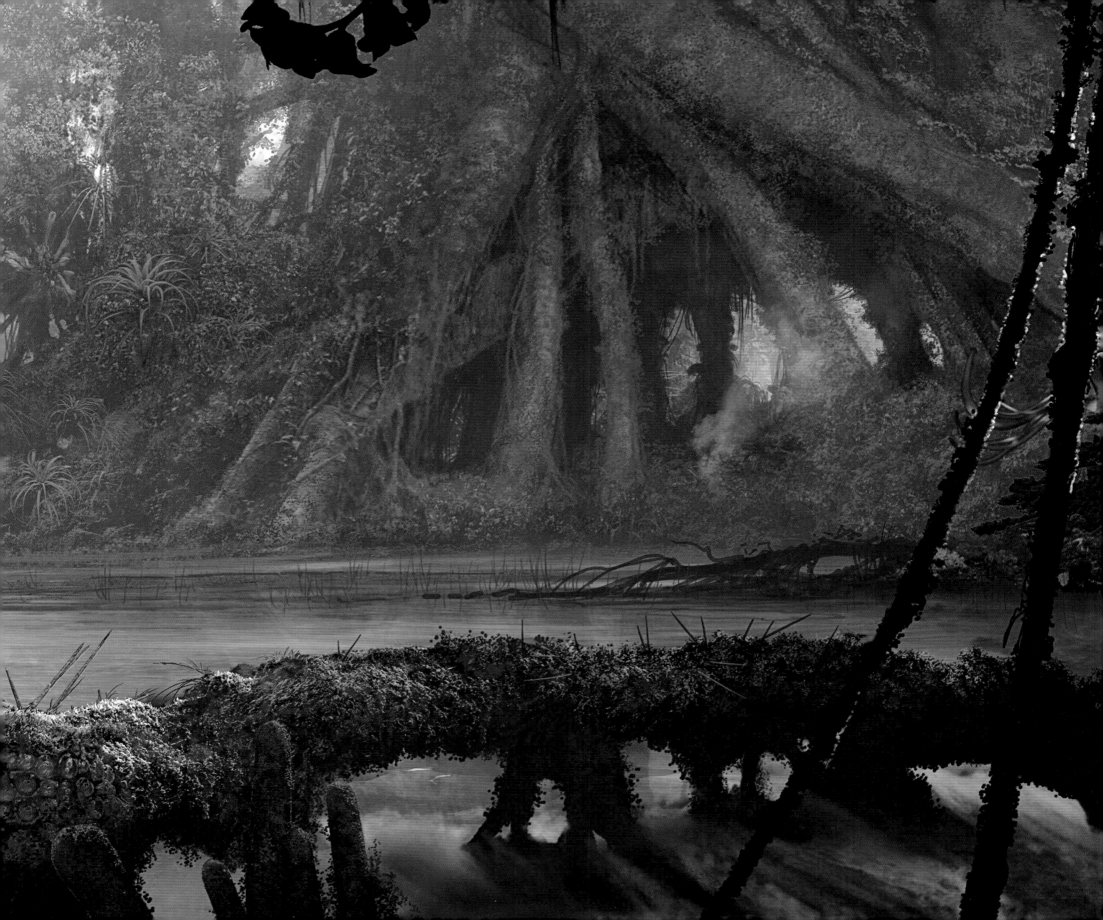

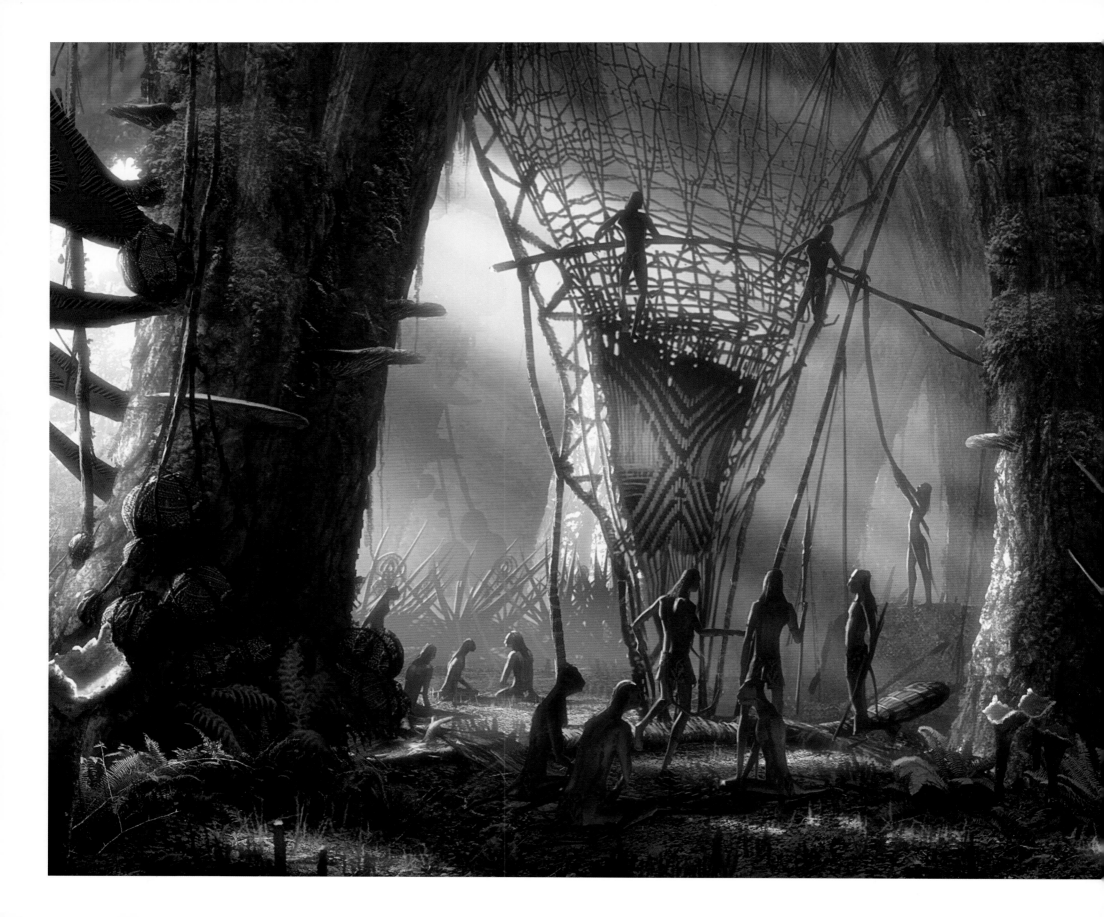

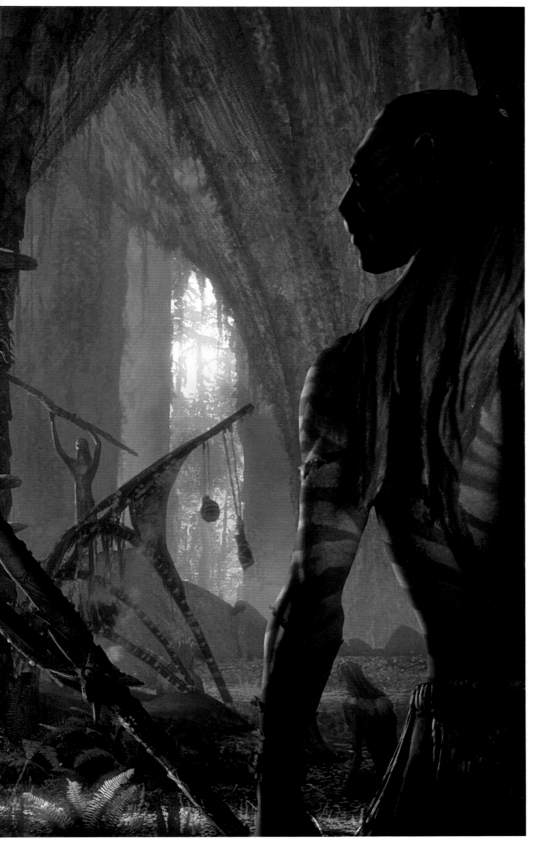

HOMETREE "*It's hard to put into words the connection the people have to the forest,*" says Jake in a voice-over. "*They see a network of energy that flows through all living things. They know that all energy is only borrowed—and one day you have to give it back.*" Forbidding and larger than life from afar, the multitiered Hometree is the center of Jake's new world; designing it and defining the life of the Na'vi people went hand in hand. It is one the film's critical set locales for the many emotional transformations of the main character. Early illustrators took inspiration from the script: *Hometree, like a gothic cathedral overhead. Sunlight streams down through gaps in the towering vault; 250 meters tall, with a trunk four times the diameter of the largest sequoia and a base of massive mangrove pillars. . . . [With] an open central area . . . helical core of natural spiral staircase . . . a vast, cylindrical gallery.* Rob Stromberg reflects: "I always thought of this as a multilevel world." Hometree towers above the forest's natural canopy, its strangler roots creating the first-floor matrix at the tree's base, where the Na'vi enter and exit. From within it resembles the inside of a shell, with a central core of three main levels and spokes flaring out like a DNA helix. As with all interiors and exteriors for the film, the design approach was holistic, considering both how things worked (where the Na'vi sleep, eat, store weapons, and gather) and also how best to provide Cameron with detailed environments that he could shoot cinematically. The first level interior image to the left was an early exploration for this; above is one of many Na'vi weaving patterns designed by talented concept artist Daphne Yap.

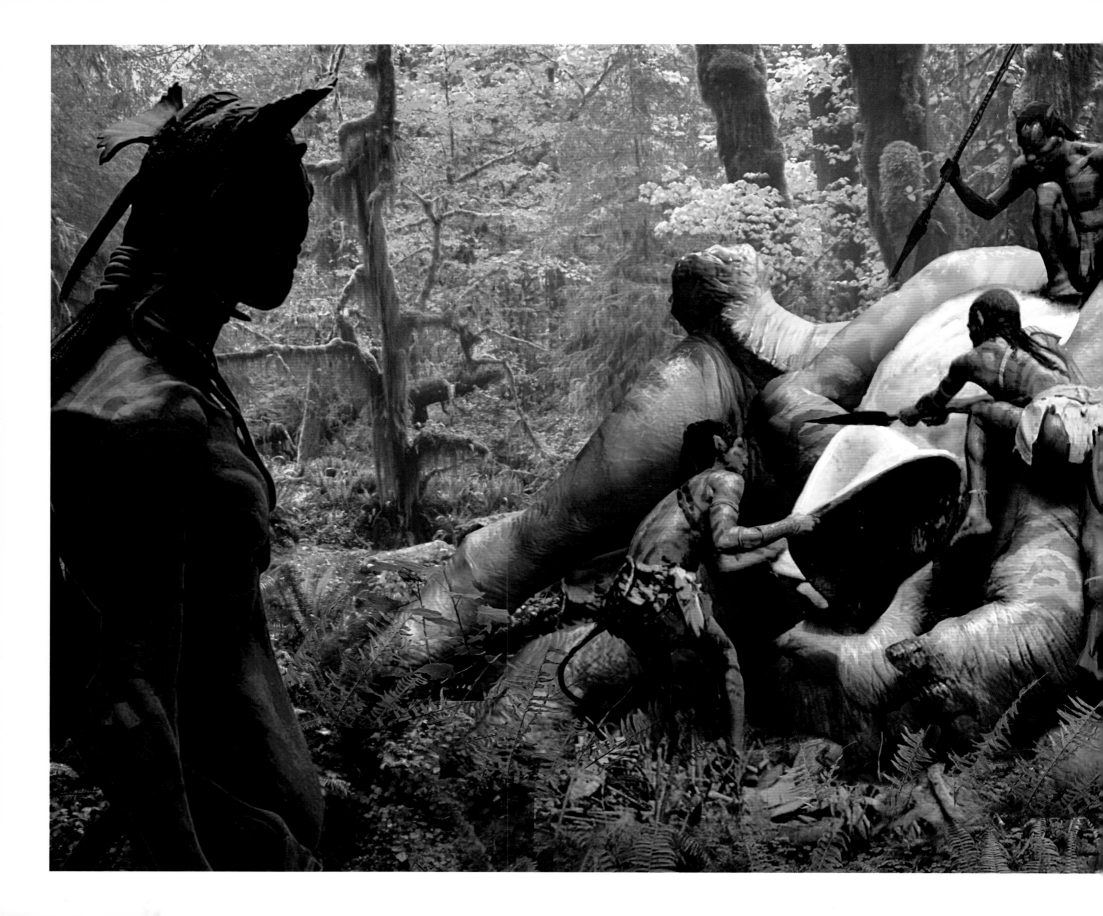

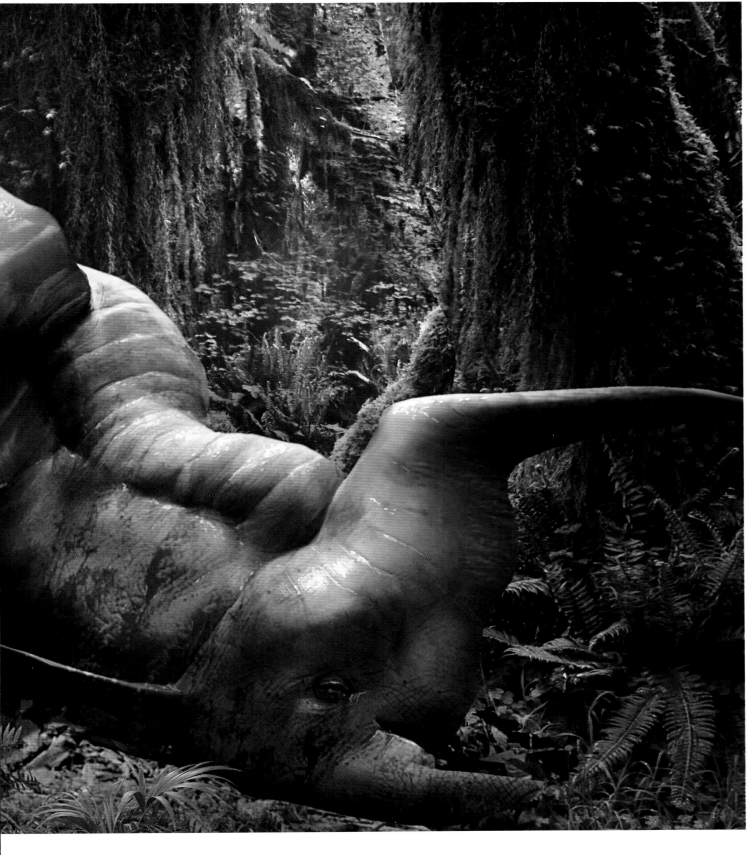

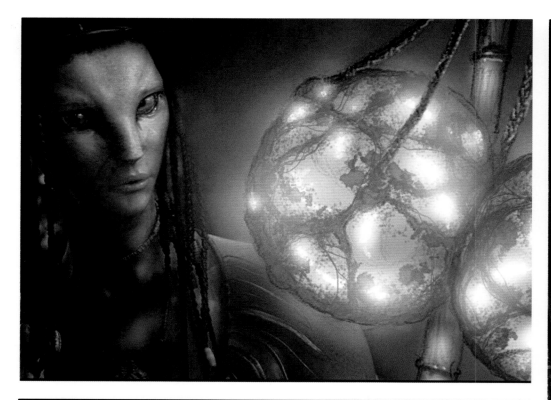

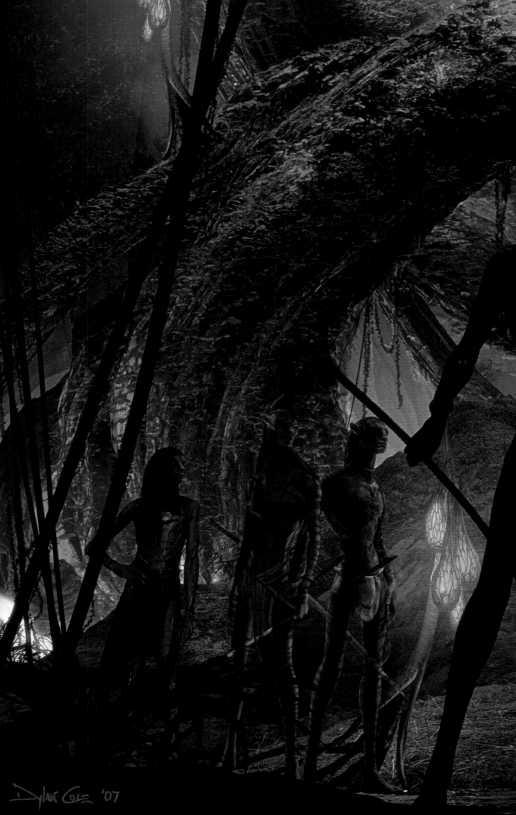

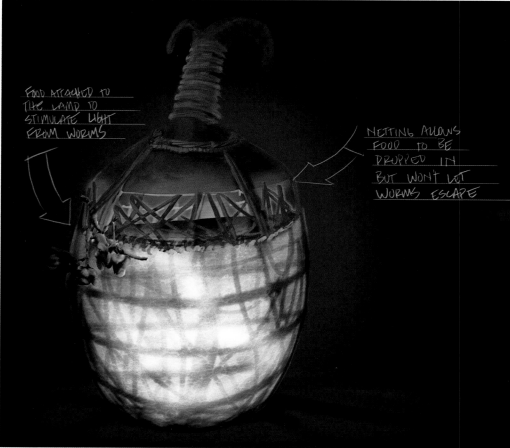

FOOD ATTACHED TO
THE LAMP TO
STIMULATE LIGHT
FROM WORMS

NETTING ALLOWS
FOOD TO BE
DROPPED IN
BUT WON'T LET
WORMS ESCAPE

Dylan Cole '07

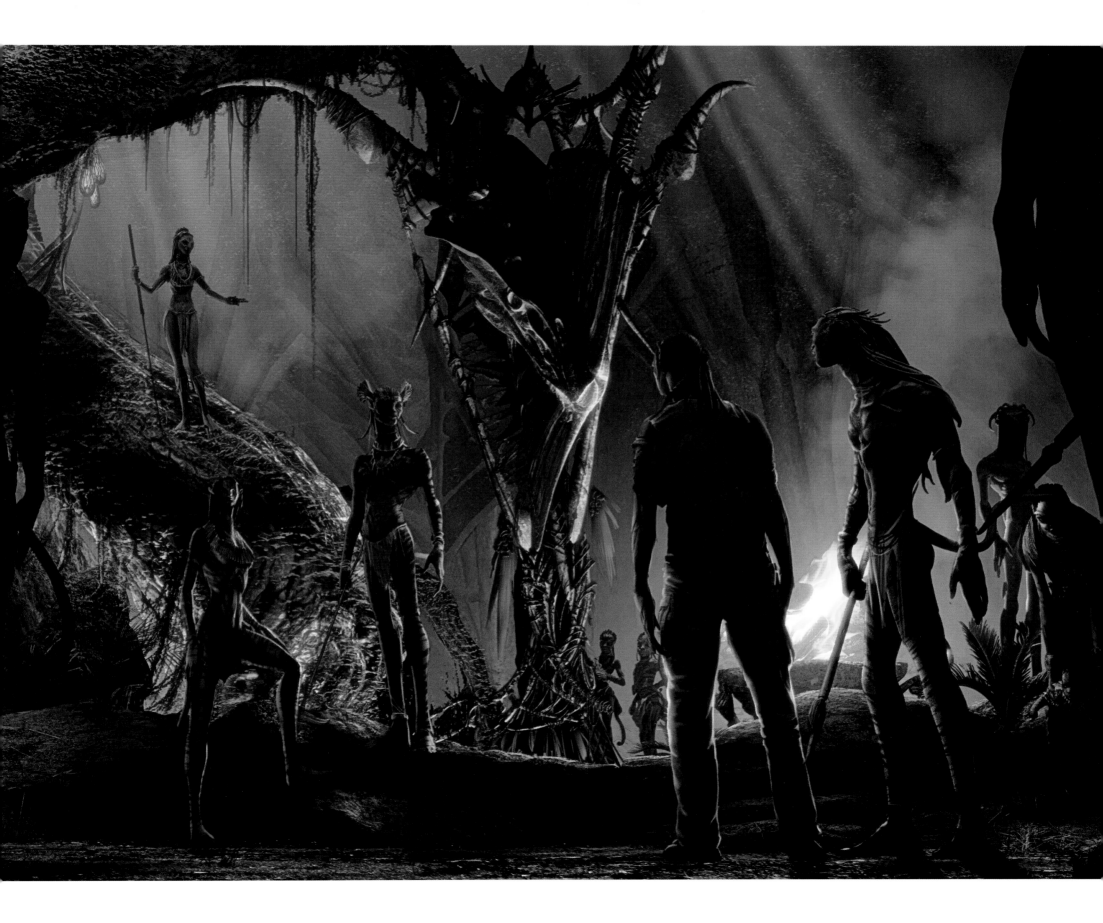

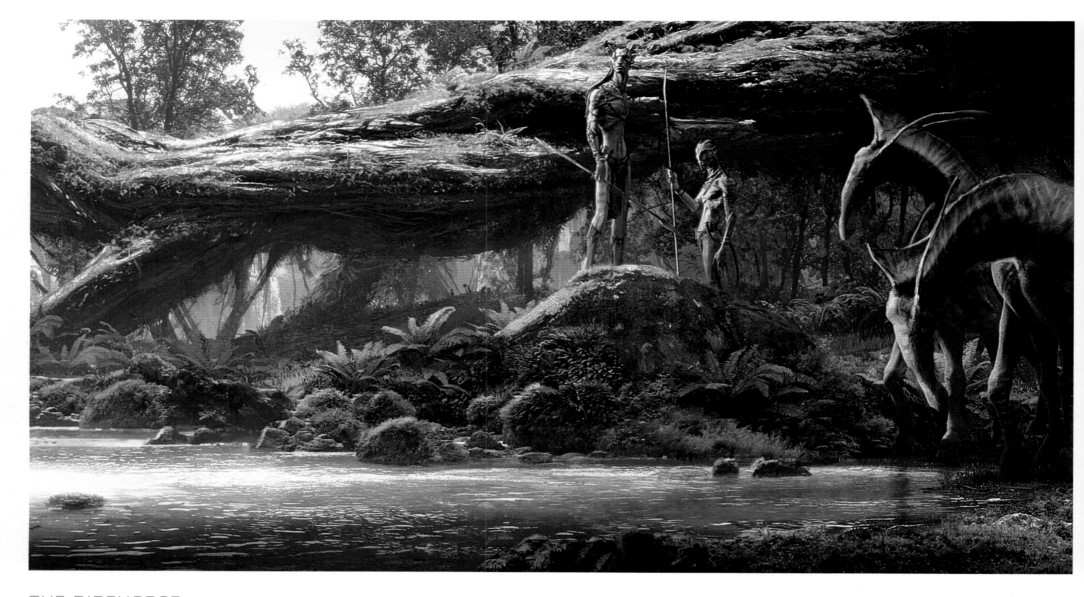

THE DIREHORSE "It had been the town bike of creature design," says creature designer Neville Page. "Everyone had taken a crack at it." It wasn't until famed artist Wayne Barlowe sketched out a silhouette that included the now-signature horny mane that things began moving along in the right direction. "Human beings first see shapes 'in total.' That is how your brain receives information," says lead designer TyRuben Ellingson. "That's why a loose sketch can be so critical and why you'll hear designers ask the question 'Does the silhouette read as legitimate?'"

Once the overall shape was set, the illustrators could begin to tackle the director's additional notes: *six legs, cross with a dinosaur, saddle-like, plated back, yellow eyes, bony mane, elongated moth-like neural links,* and *no hair.* For all the creatures, Cameron was interested in designing a way for the beasts to breathe through an orifice other than the nose. With assistance from Page, they resolved to place the tracheal penetration of this "alien Clydesdale" at the base of the neck, where there was room between the muscle groups to port air into the lungs and

still have the creature's three-dimensional body lines logically flow. If they were not successful with the biomechanics here, once the digital artists inherited the design and began to embark upon movement studies, the viewer would immediately notice—without necessarily knowing why—that the creature's movement was most likely "unsettling" and "wrong." Overall, the design priority was always twofold: First, achieve a creative and distinct look, and second, ensure that the creature is also plausible. Once these elements were resolved, Stan Winston Studio's designer, Christopher Swift, created real-world maquettes, adding in a face inspired by the appearance of an anteater and detailing the breathing orifices in three dimensions. Swift then began laying down bold, striped patterns and inserting the creature into environments so they could begin exploring color and tone. Cameron wanted the Direhorse to stand out in the forest, so they began with an all-white creature and layered that over with more complex tonalities and patterns, as exhibited in the image to the right.

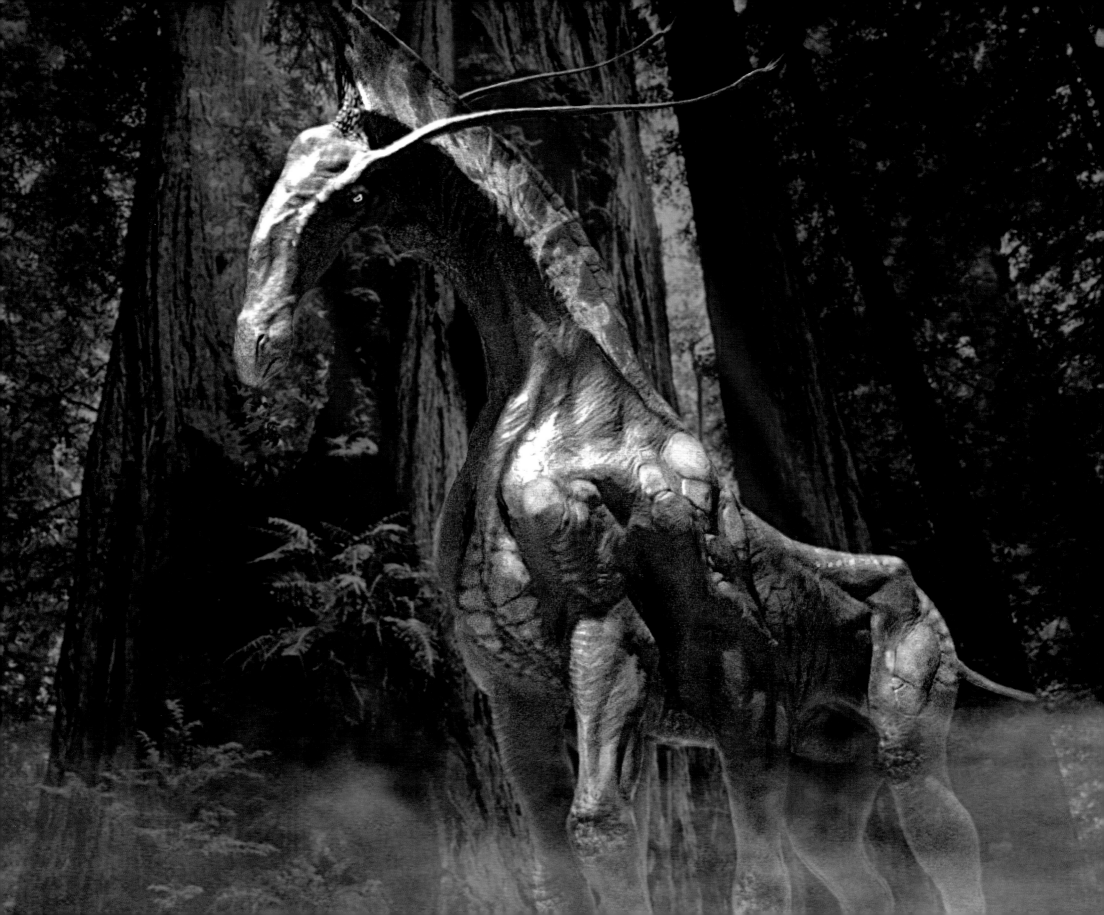

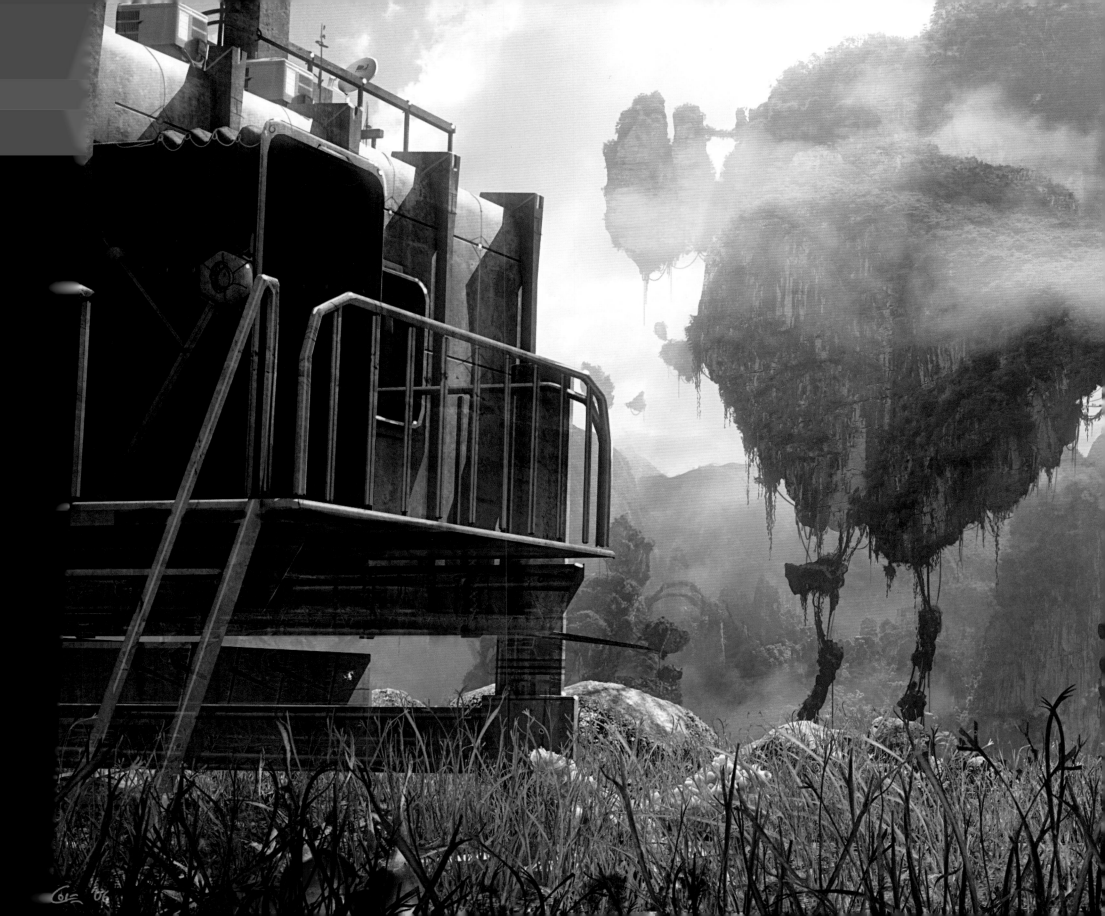

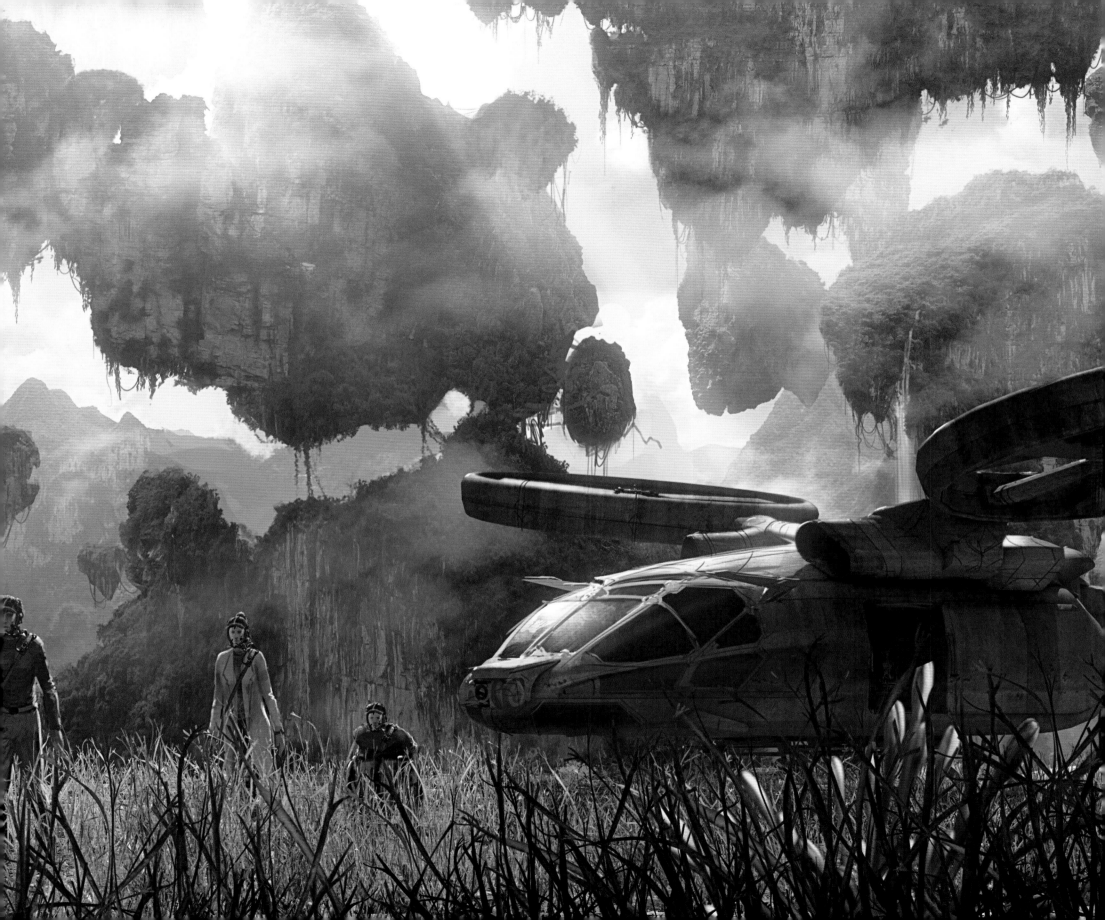

SITE 26 "*Everything is backward now, like out there is the true world, and in here is the dream,*" recounts Jake into his video log at Site 26, otherwise known as the "shack." It's the halfway point between the human world and the Na'vi world. It is a high-tech mobile lab, but it is also a place where bonds are forged, secrets are revealed, truths are spoken, battles are fought, and some characters come close to death. Like our main character and the film itself, Site 26 is an ordinary place set within extraordinary circumstances. When conceiving the building's look, Cameron's directives to designer James Clyne were simple: "I want it to basically look just like an RV of today. Just make it look like an RV." So the main challenge, once again, was to design a building that was both otherworldly and plausible—something slightly futuristic, but also possessing a bit of "home." As for the environs, the tone for this was set within the script itself, which reads: *Samson lands, beating the grass with its rotor wash. Humans step out wearing masks. They move toward the shack, taking in the spectacular panorama.*

"Jim wanted the arrival to this area to be to be the first view of the floating mountains," recounts concept designer Dylan Cole. "He wanted it to be grand and big and show how this place was perched right up in there at high altitude with a clear perspective of the 'hallelujahs,'" which both ominously and gloriously hint at the mysteries held within the Pandoran world. The keyframe on the previous spread is a composite of a Steve Messing panoramic floating mountain translight (live-action set background) painting, cropped and inserted into the backdrop of this scene.

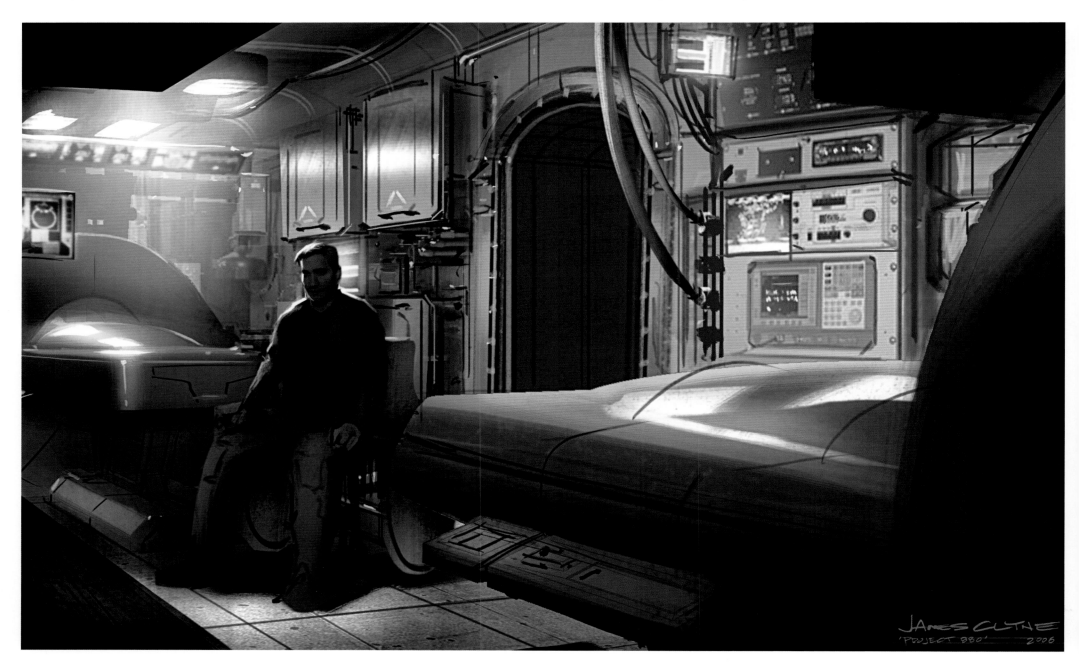

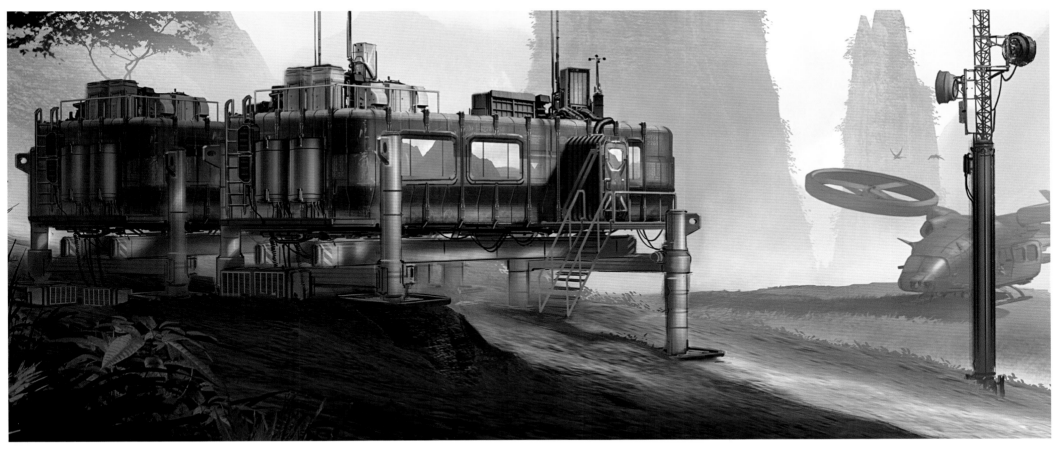

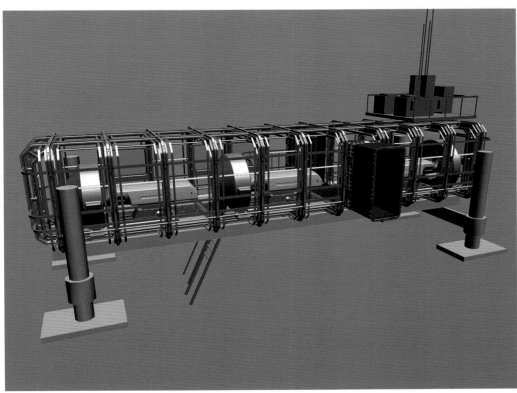

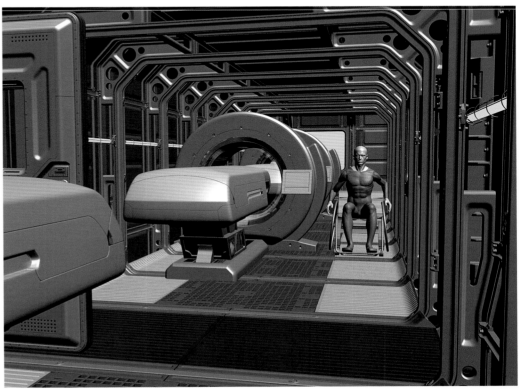

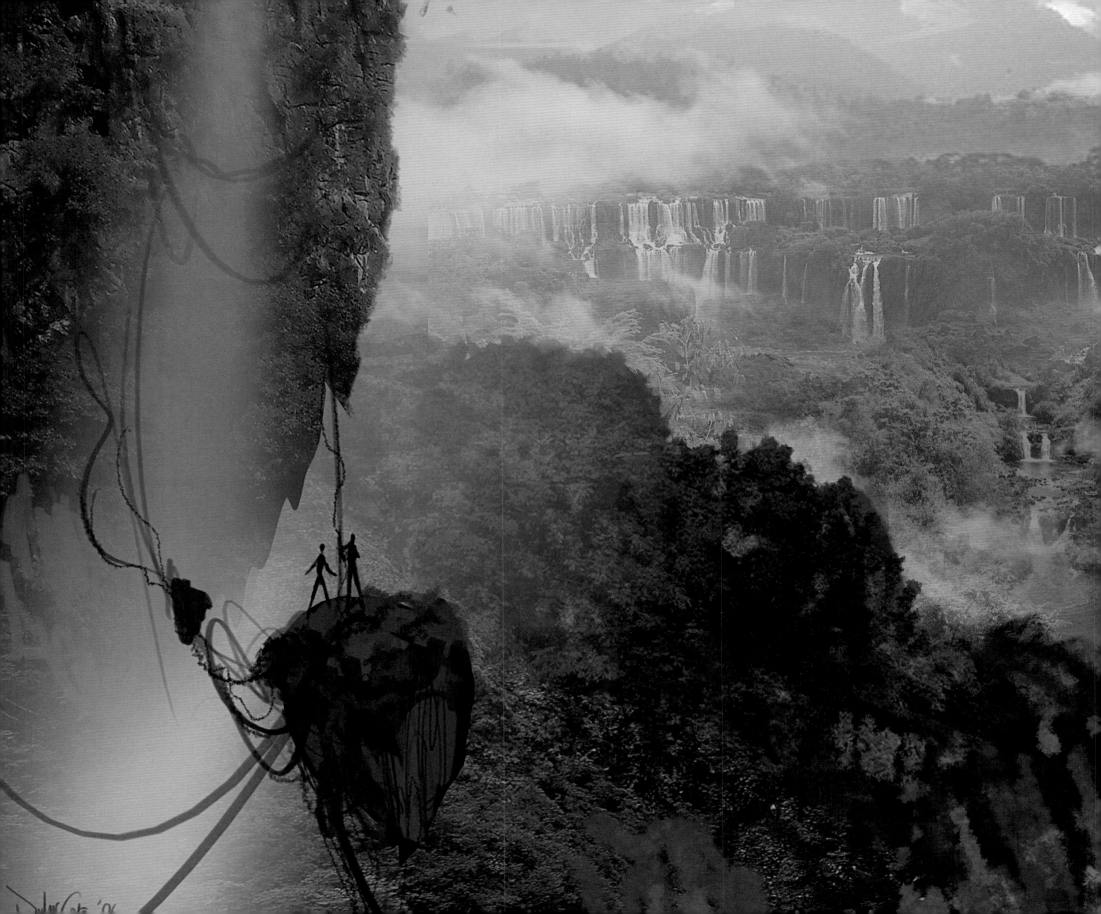

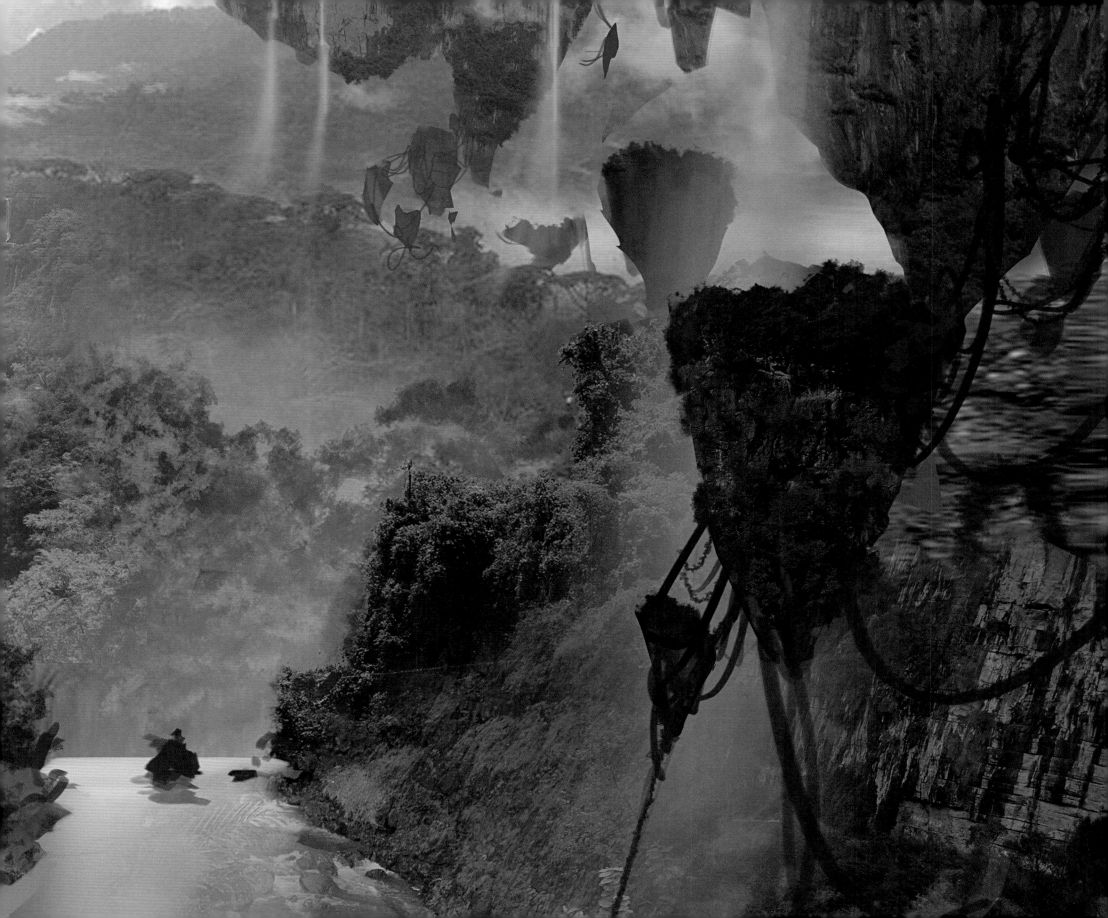

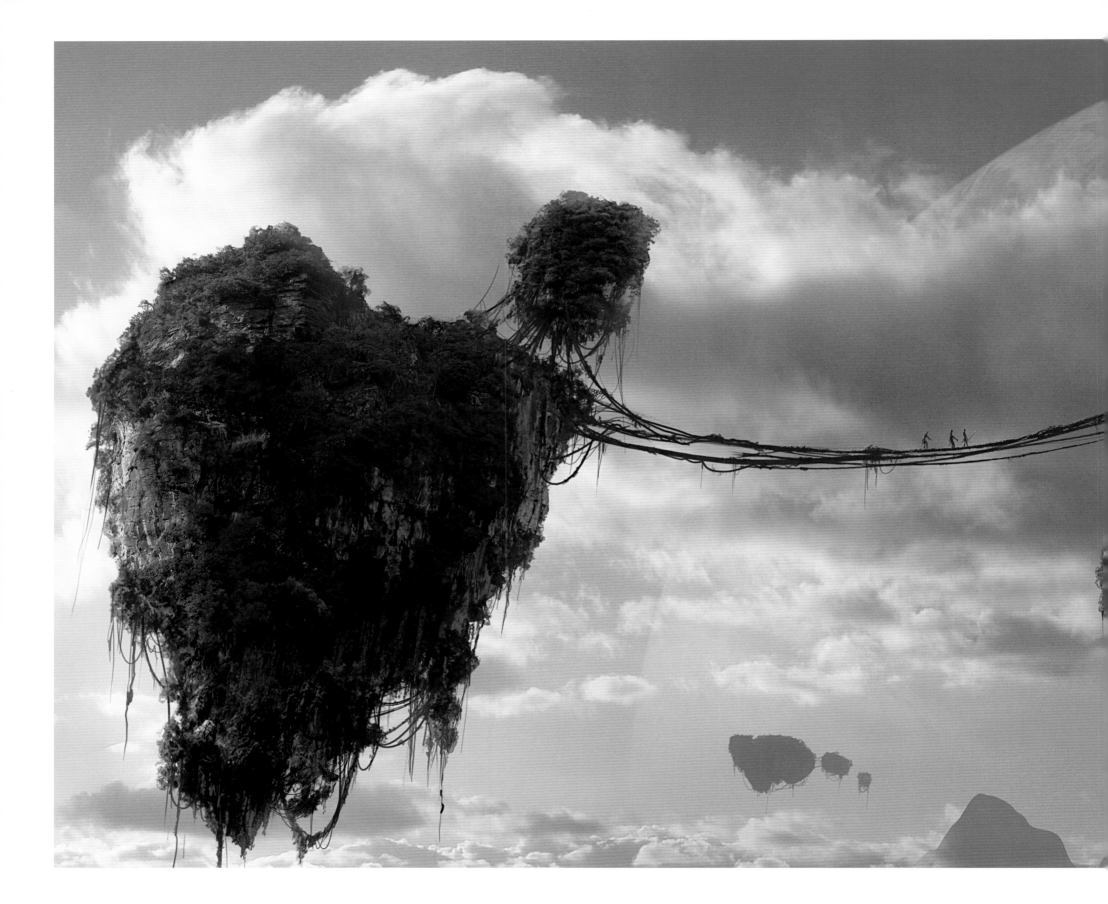

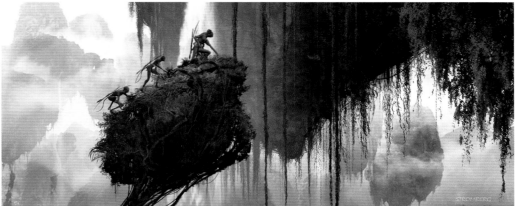

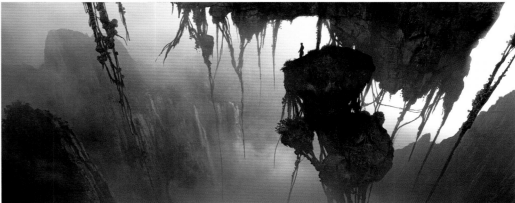

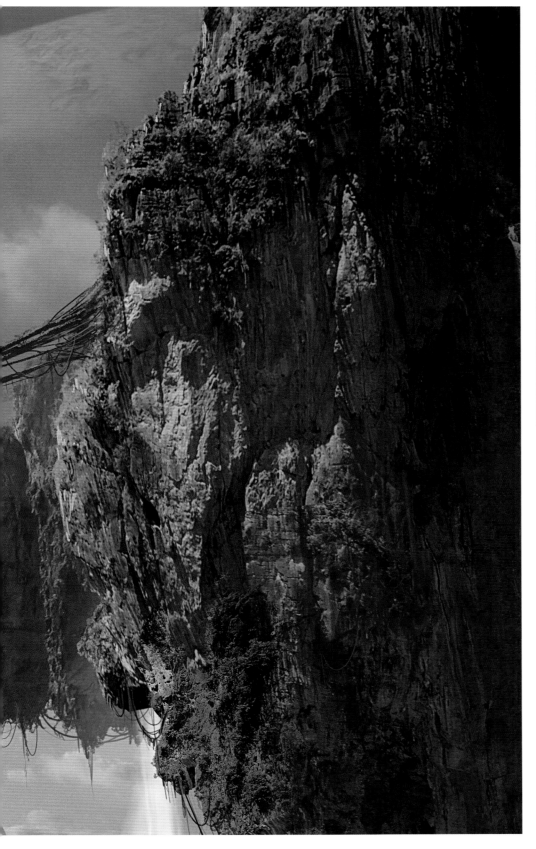

MONS VERITAS

In designing an environment that is both treacherous and accessible, it was all a question of scale. In the wide shot to the left you see Mons Veritas—the Mountain of Truth—a rock face larger than Yosemite's Half Dome. The scale is epic. For the close-ups, which encompassed the human—or Na'vi—perspective, the goal was to create a sense of vertigo and communicate the massive height and potential danger to the characters, as well as set up this dynamic, aerial environment for the battle scenes to follow. Overall, the environment was not intended to be particularly friendly; on Pandora the floating mountains are in constant flux, akin to large boats drifting and grinding into one another, creating boulder-sized raindrops of crumbling rock. Over time vines have grown, trickling down to form a kind of stairway, a gnarly tangle of roots and rocks—the Beanstalk—that the characters climb. Following these descriptions, concept designer Dylan Cole was largely responsible for developing the look of this environment. At one point the director said, "You know, there's still an angle that I really would like to see," and he pulled out a piece of paper. "A more dramatic angle looking down," he continued, loosely sketching out his concept. Cole took that idea and created a painting that executed the director's freshly minted drawing in complete detail—this ultimately became a shot in the movie. "[Jim] was looking for much more perspective, where you see all the way down to where they came from—the Beanstalk wrapping around with hints of the rivers and mountains down below." The repeating figures installed in Cameron's loose sketch assisted in establishing that feel.

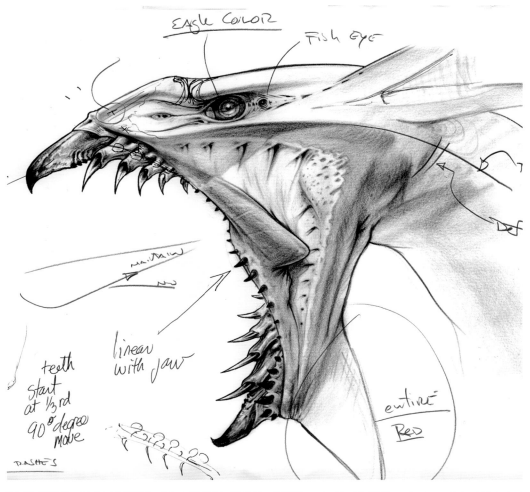

EAGLE COLOR
FISH EYE

teeth
start
at 1/3rd
at 90°degree
move

linear
with jaw

entire
Red

DASHES

MAINTAIN

Def

THE BANSHEE

Thwap thwap! is the sound Banshees make when their leathery twenty-foot wings take flight. More bat than bird, and shaped like a sting ray, the wildly colorful Banshees have four wings with translucent membranes, glassy fangs, razor-sharp talons, extra eye-like sensors, a distended jawbone, whip-like antennae, and bony heads. Agile, elegant, and fierce, mountain Banshees take shelter in clusters of hundreds within shaded grottoes in the heart of Mons Veritas. They would sooner shriek, glare, hiss, and snap with their rows of fangs than surrender to a symbiotic relationship with a Na'vi. Wild Banshees, as the script describes, *huddle on rock outcroppings as far as the eye can see. They cling to the walls with foreclaws on their wings, or perch on ledges.* One of the heroic creatures of *Avatar*, Banshees enjoy a lot of screen time. These aerial predators feature in intimate close-ups, battle scenes, joyriding nose dives, delta dives in combat, snap rolls, hairpin banks, soaring aerobatic turns, and extended "creature against machine" attacks. In the design process, "literally head to toe, every single element of the creature's look and movement was thought out. Whether or not we achieved it so that it is biomechanically sound, we, at the very least, pursued it that way." Wayne Barlowe's automotive design concept—cars in particular—informed the approach to creating the creature's "form language." "Take a look at the point of its chin and that single line that flows over the top of its head and travels down the neck, across the back. Then there's the line of the zygomatic arch to the teeth bone, which travels down to its jugular vein and then into its 'intake'—Jim has coined this its 'operculum.'" Cameron notes: "I love the Banshee; it's gorgeous. It seems very alive and very plausible. It's a four-winged creature with no legs. It's not a bird; it's closer to a bat, in the sense that the limbs are integrated into the wing structure." On this spread are color samples of Jake and Neyteri's final Banshees in aerial and side views, as well as one of Neville Page's head sketches, above left, complete with his and Jim's design notations.

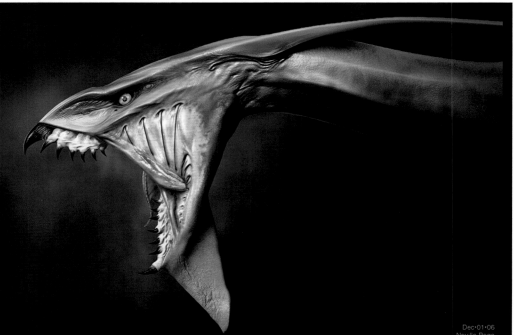

Dec·01·06
Neville Page

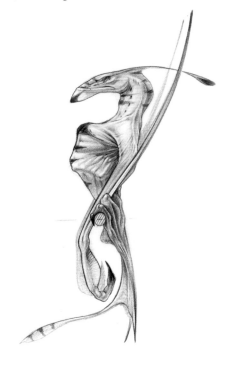

Navi Inspired
Banshee Tribal
Tattoo

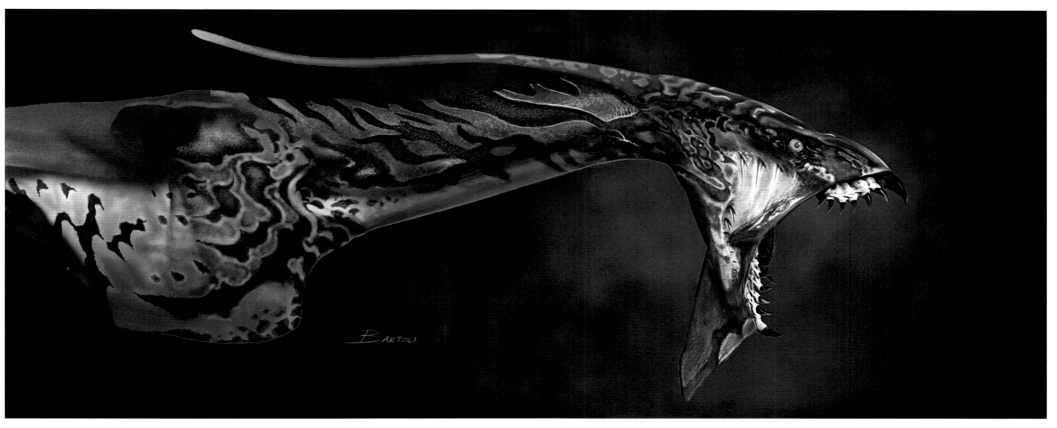

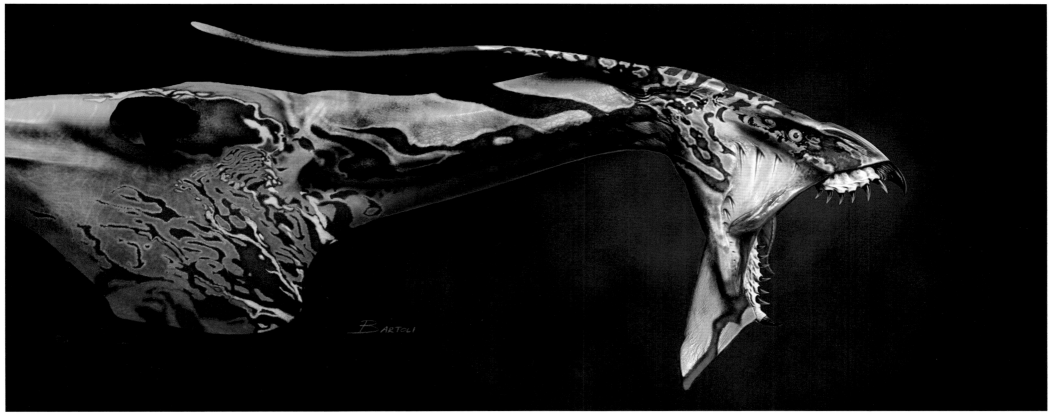

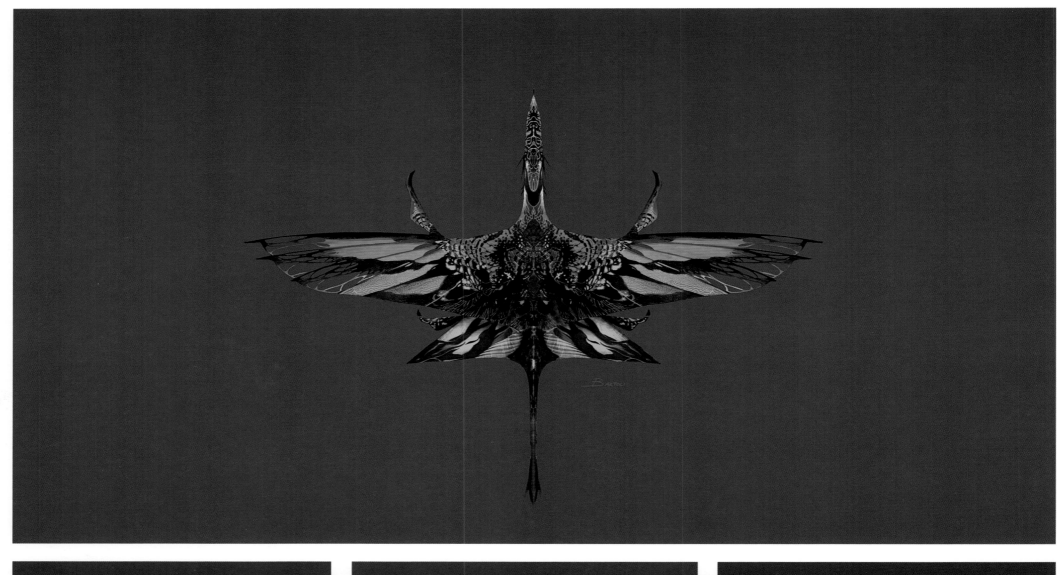

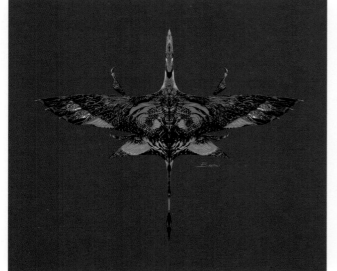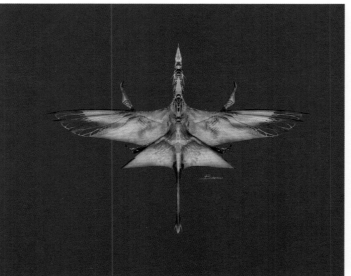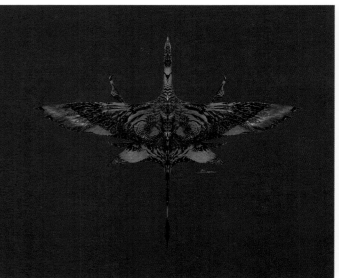

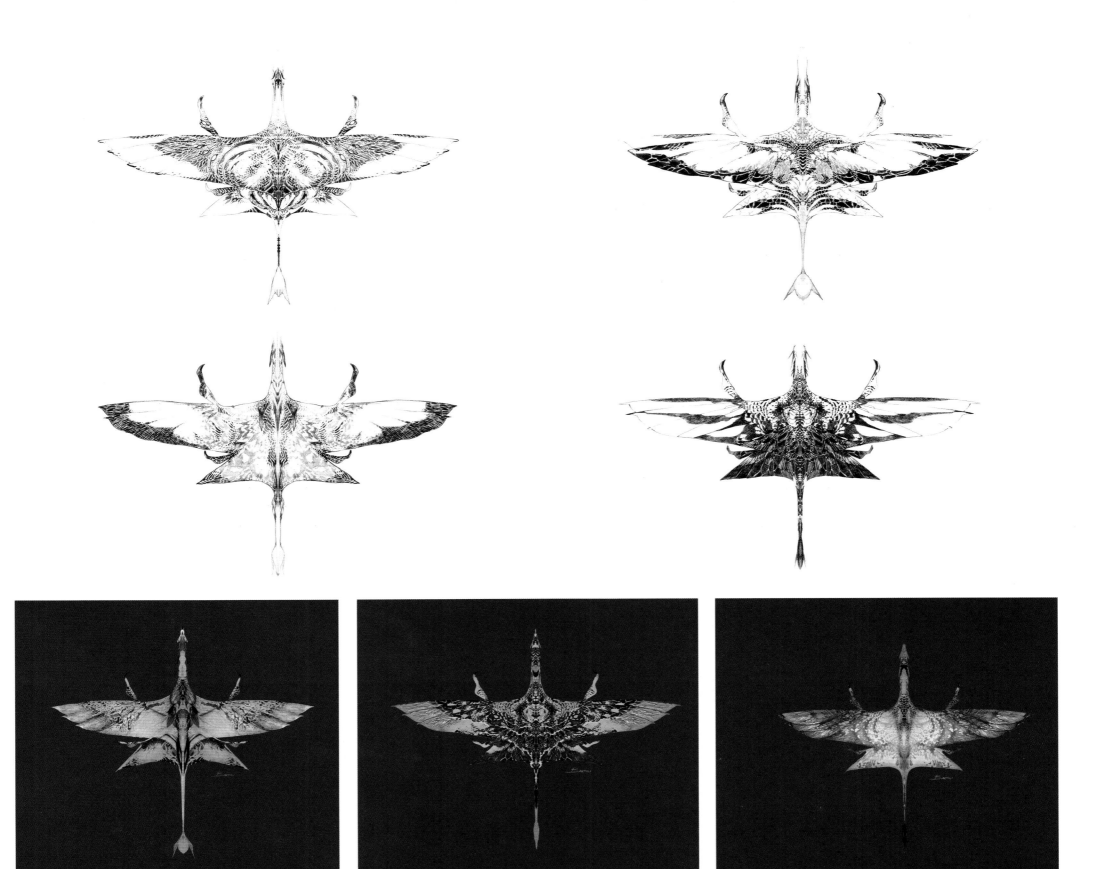

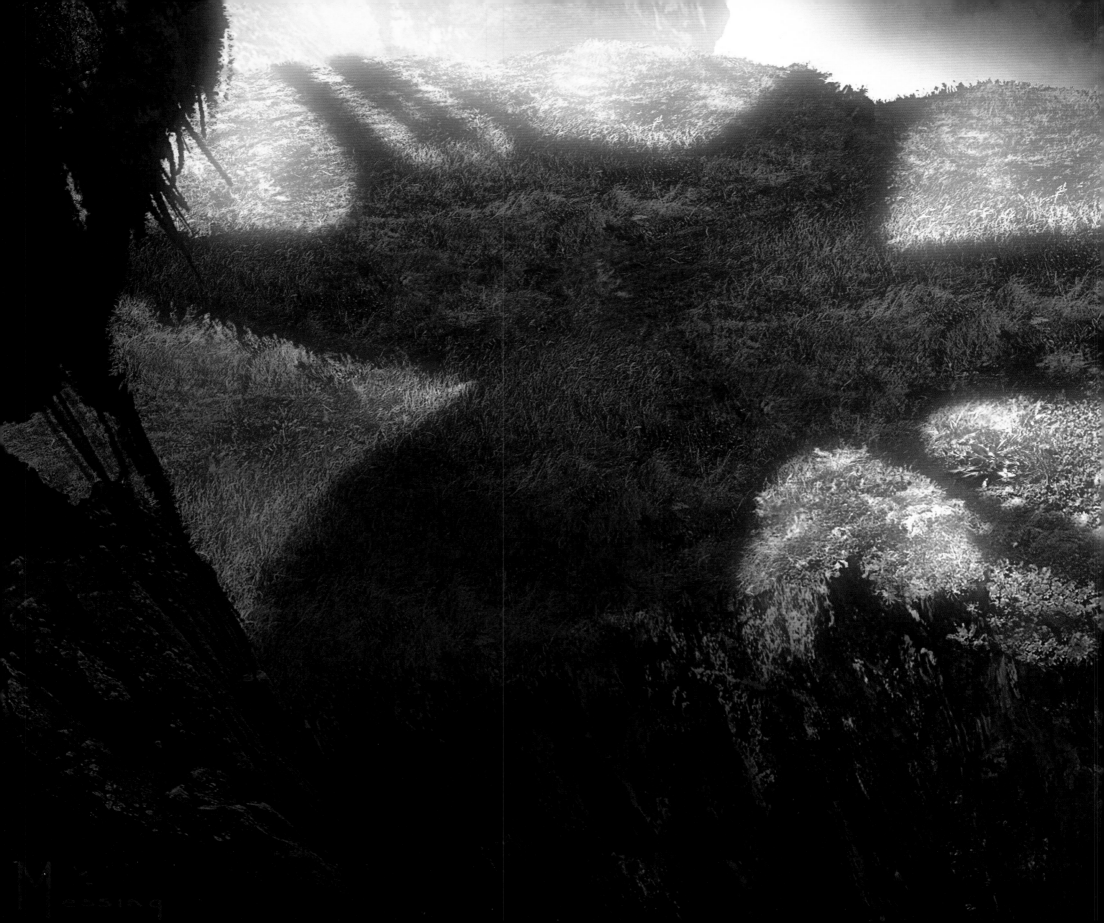

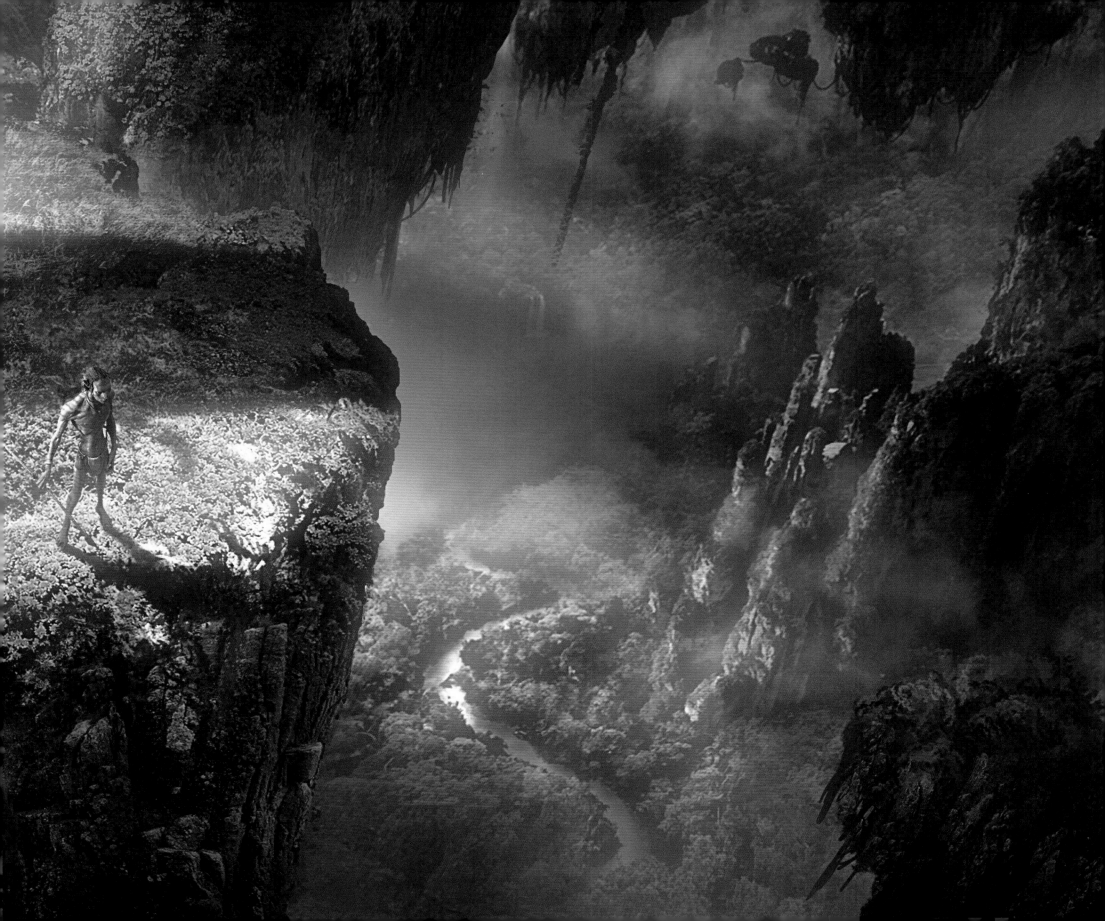

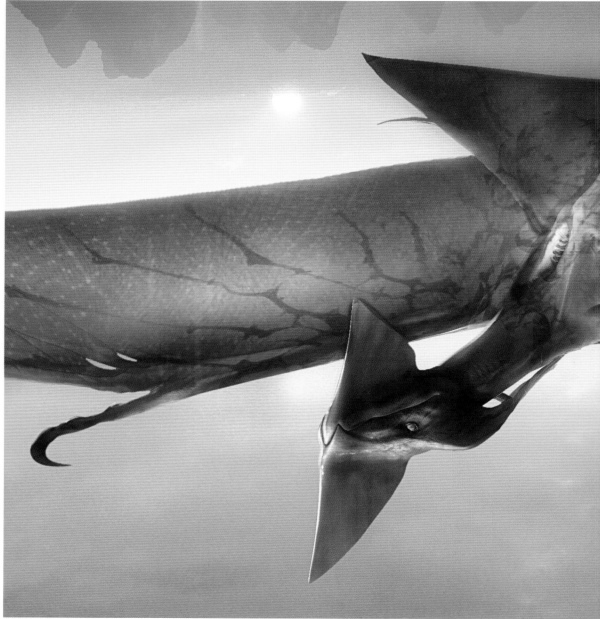

THE LEONOPTERYX By air, the Banshee-eating Leonopteryx is the king predator of Pandora. Wayne Barlowe's initial sketch set the tone, fashioning a flamboyant-looking creature in the spirit of America's bald eagle. Character and creature designer Jordu Schell then designed a clay sculpture, followed by Neville Page tackling the resolution of the many design questions, including where to place the additional sensory pits acting as alternative eyes and how the mouth—with its very large teeth and low jawline—would close. The challenge lay in the mechanics of deployment and when Cameron suggested, "just have them pop out," the parrot's jawbone provided the answers. In the spirit of Janine Benyus's *Biomimicry: Innovation Inspired by Nature*, Page says, "That's the way nature does it, and that's the way it works on our Banshee and the Leonopteryx." The bug-like, colored wing tips were the final crowning detail, thought to lend a greater level of articulation to the wings as well as improve the plausibility of the bird's flight. Concept artist Daphne Yap contributed the signature color and patterning details to this most magnificent creature of the sky. Upon seeing test movement studies from Weta Digital, Page commented, "You can see the muscularity of its 'arms' within the wings, the strength of its shoulders, how it adjusts its weight, looks around, and twitches. Unbelievable stuff. That's where I receive way too much credit for what I do, because the animators are the ones who infuse it with life, and that's what the audience responds to, those nuances of a blink or a twitch."

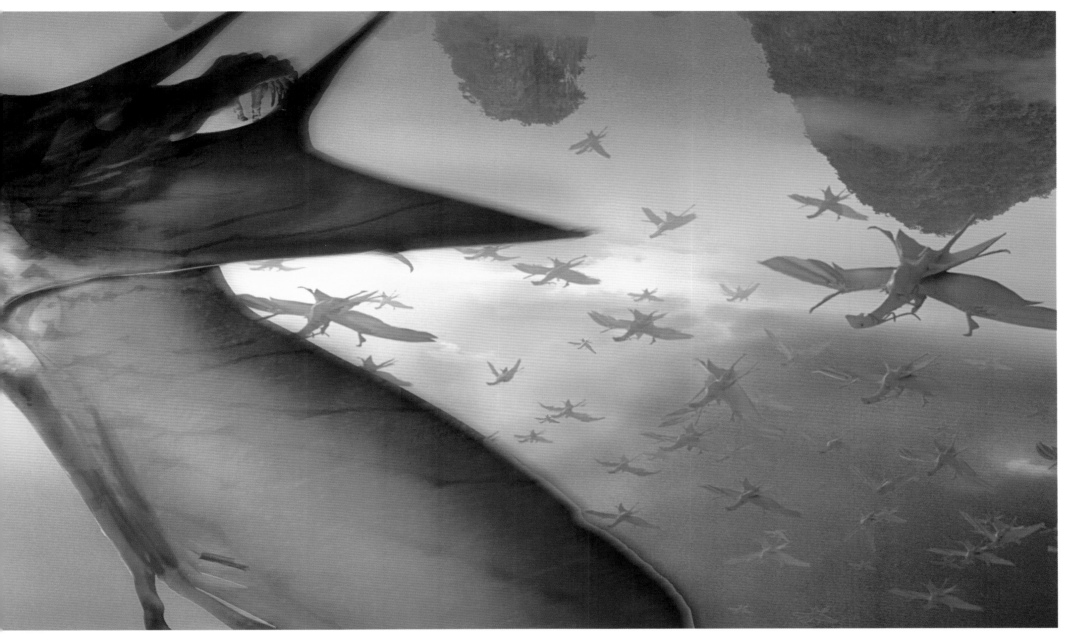

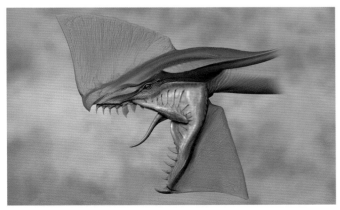
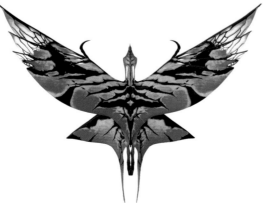

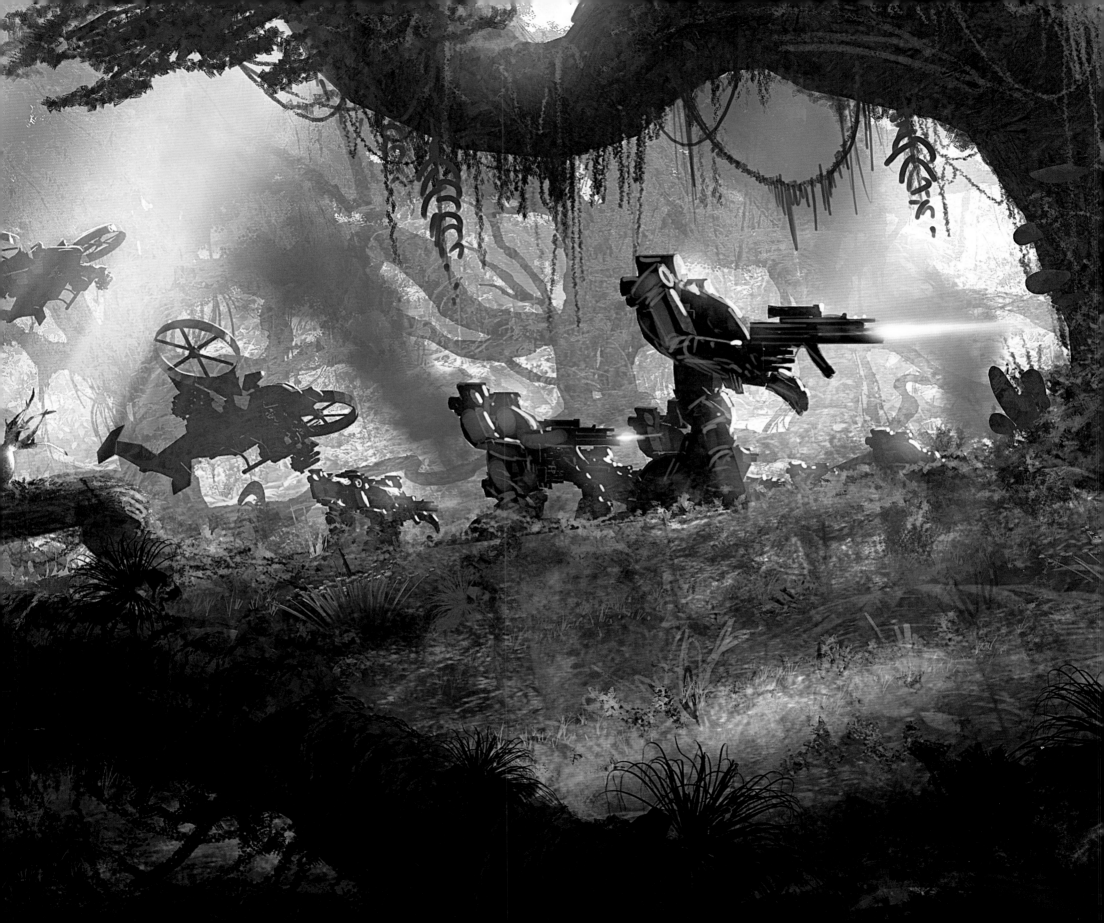

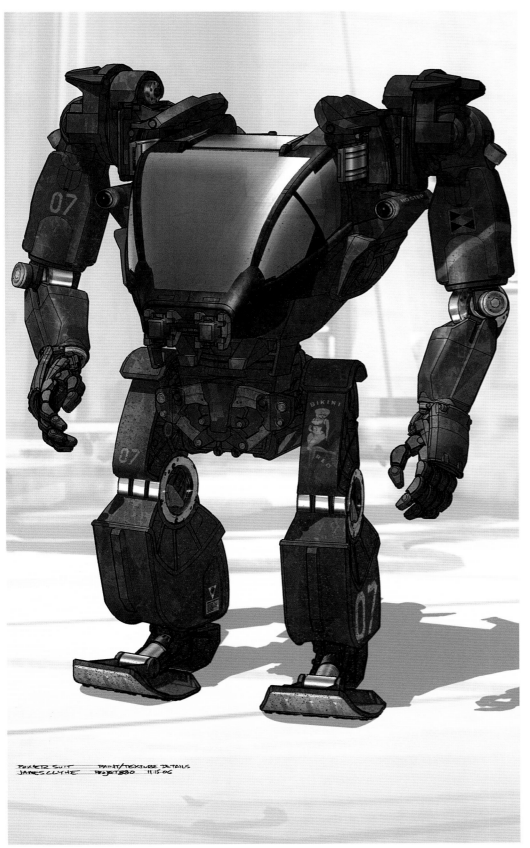

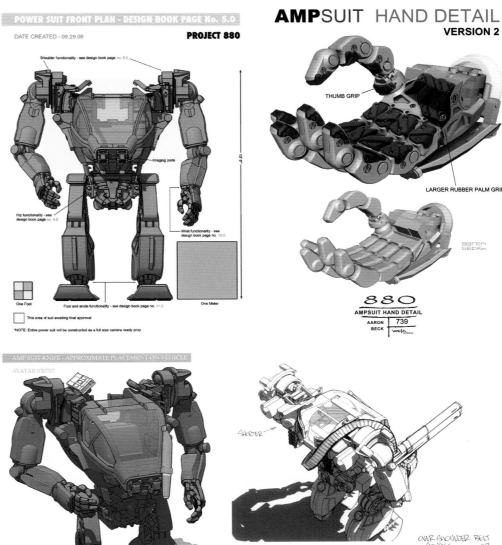

Shoulder functionality - see design book page no. 8.0

Imaging pods

Hip functionality - see design book page no. 9.0

Wrist functionality - see design book page no. 10.0

One Foot

Foot and ankle functionality - see design book page no. 11.0

One Meter

This area of suit awaiting final approval

*NOTE: Entire power suit will be constructed as a full size camera ready prop

AMPSUIT HAND DETAIL
VERSION 2

THUMB GRIP

LARGER RUBBER PALM GRIP

aaron beck

880
AMPSUIT HAND DETAIL
AARON 739
BECK

AMP SUIT KNIFE - APPROXIMATE PLACEMENT ON VEHICLE

AVATAR 030707

SHORTER →

OVER SHOULDER BELT

THE AMP SUIT TyRuben Ellingson was responsible for overseeing the conceptual development of the Armored Mobility Platform, the massive thirteen-foot "walkers" originally referred to on the set as the "power suit." As with all the designers' work, the overarching theme was "form follows function." In the storyline, the AMP Suit was originally conceived of as an amplification of a foot soldier—and as such it evened up the Thanator-human match in the final battle. On Pandora it was useful for many day-to-day tasks as well. As with all the human apparatus, Cameron required that it be very functional and accessible for the characters in the film. The AMP Suit had relatively good viewing capacity, with rearview mirrors, exterior toe pads drilled into key spots for the actors to casually enter and exit, and more. The sketch on page 27 shows James Clyne's original "pit stop" design for retrofitting, armament reloading, and repair access. Actual pneumatic elevators were constructed for the live-action sets.

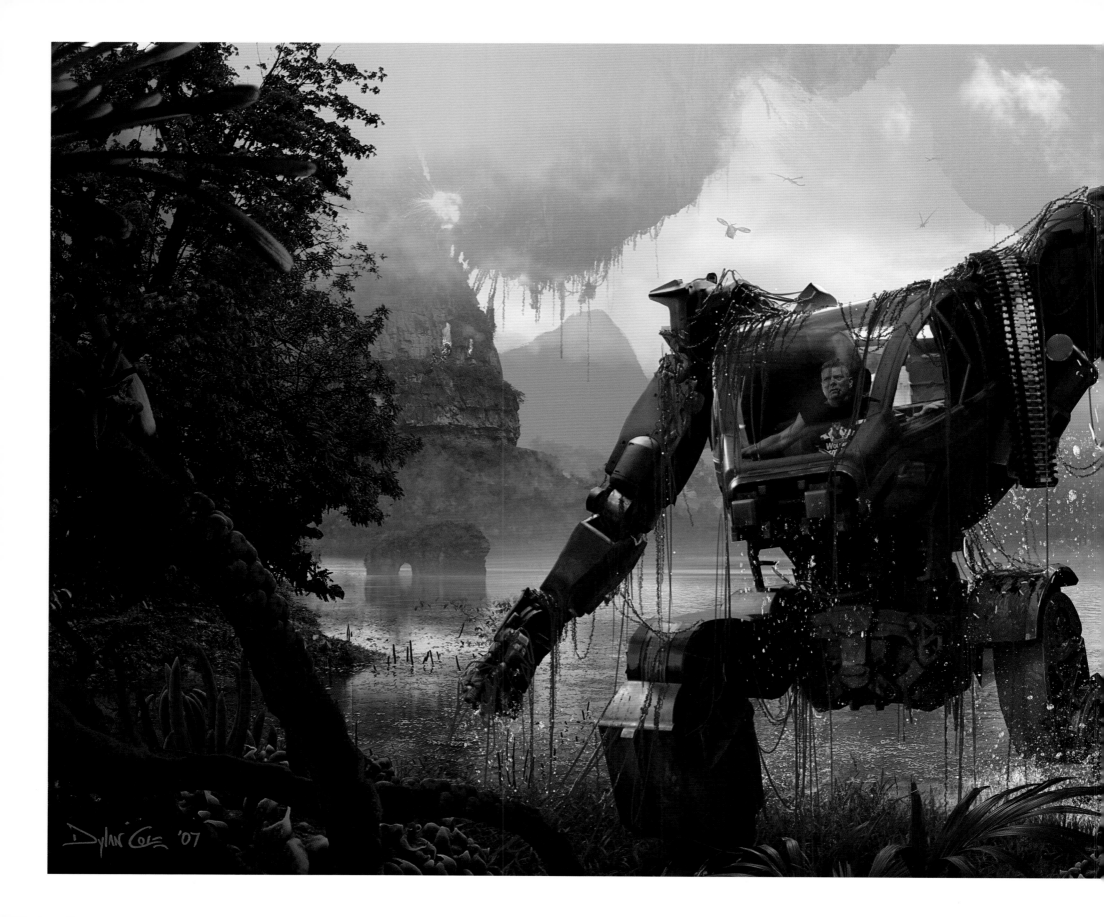

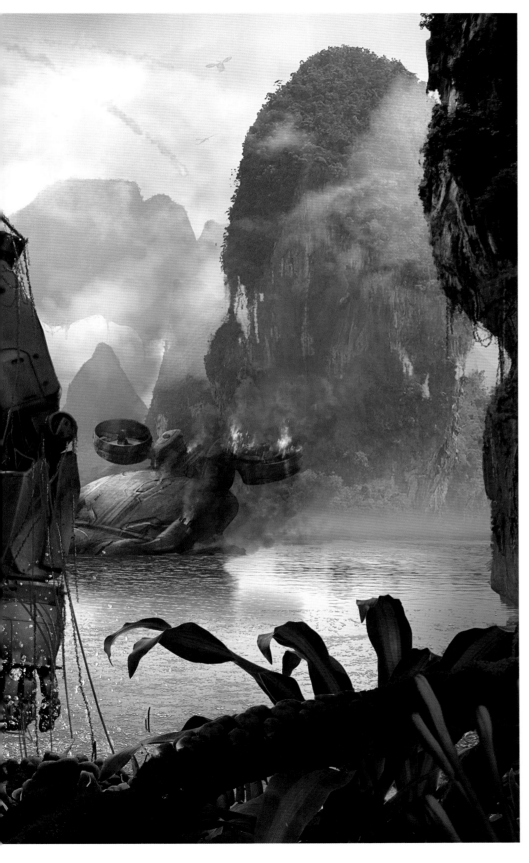

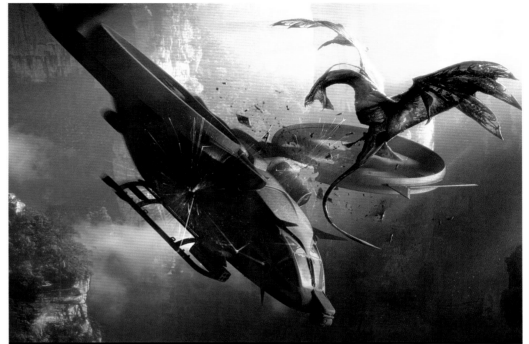

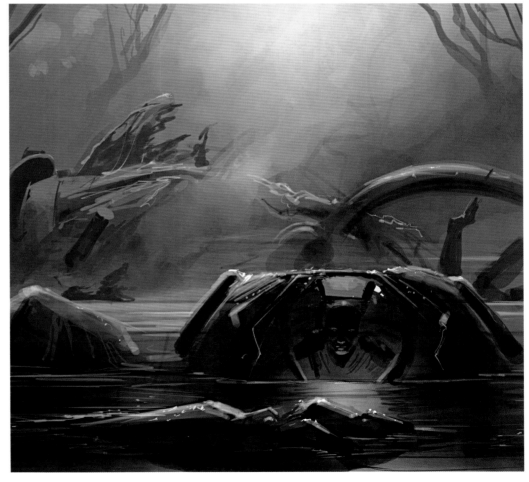

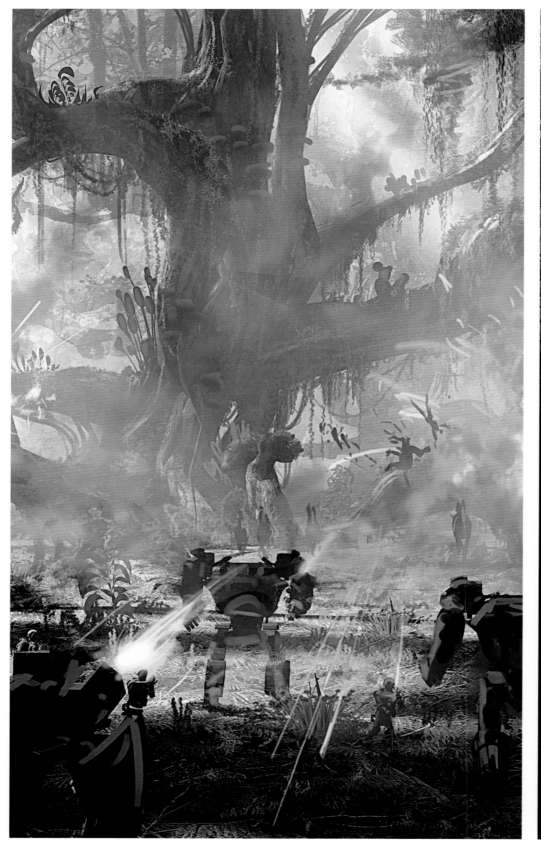
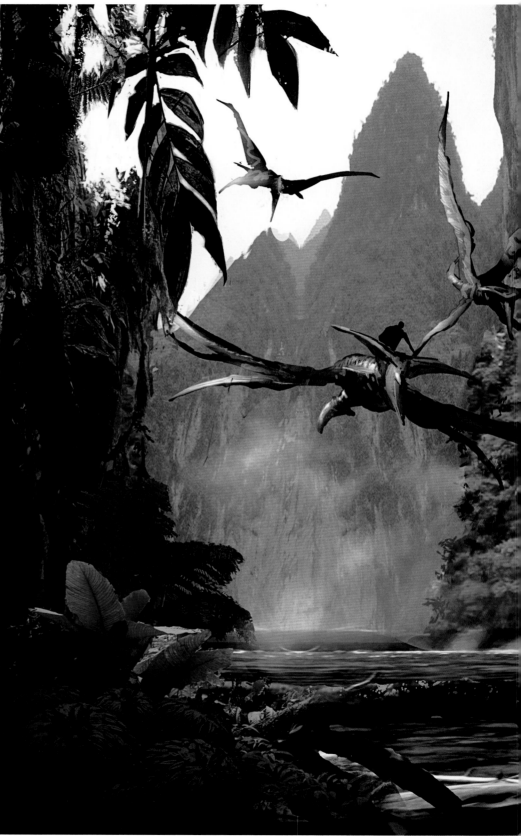

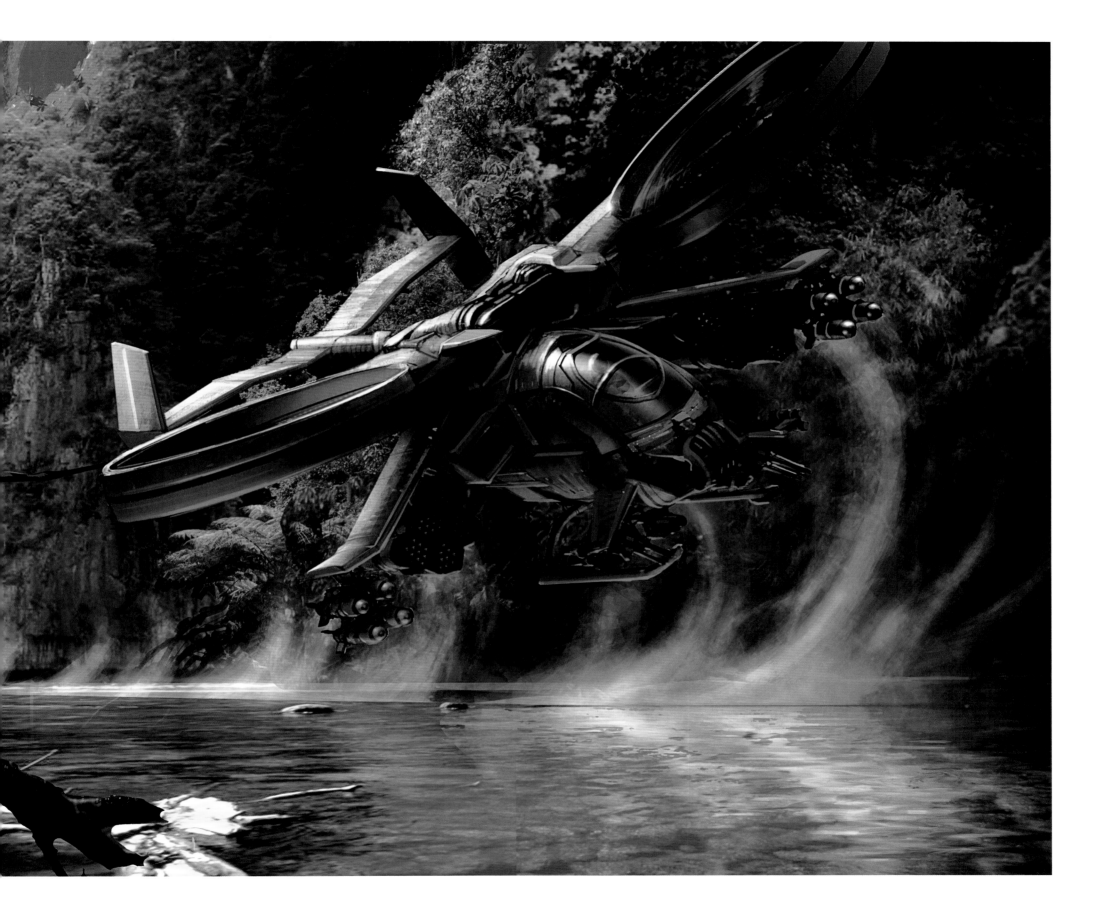

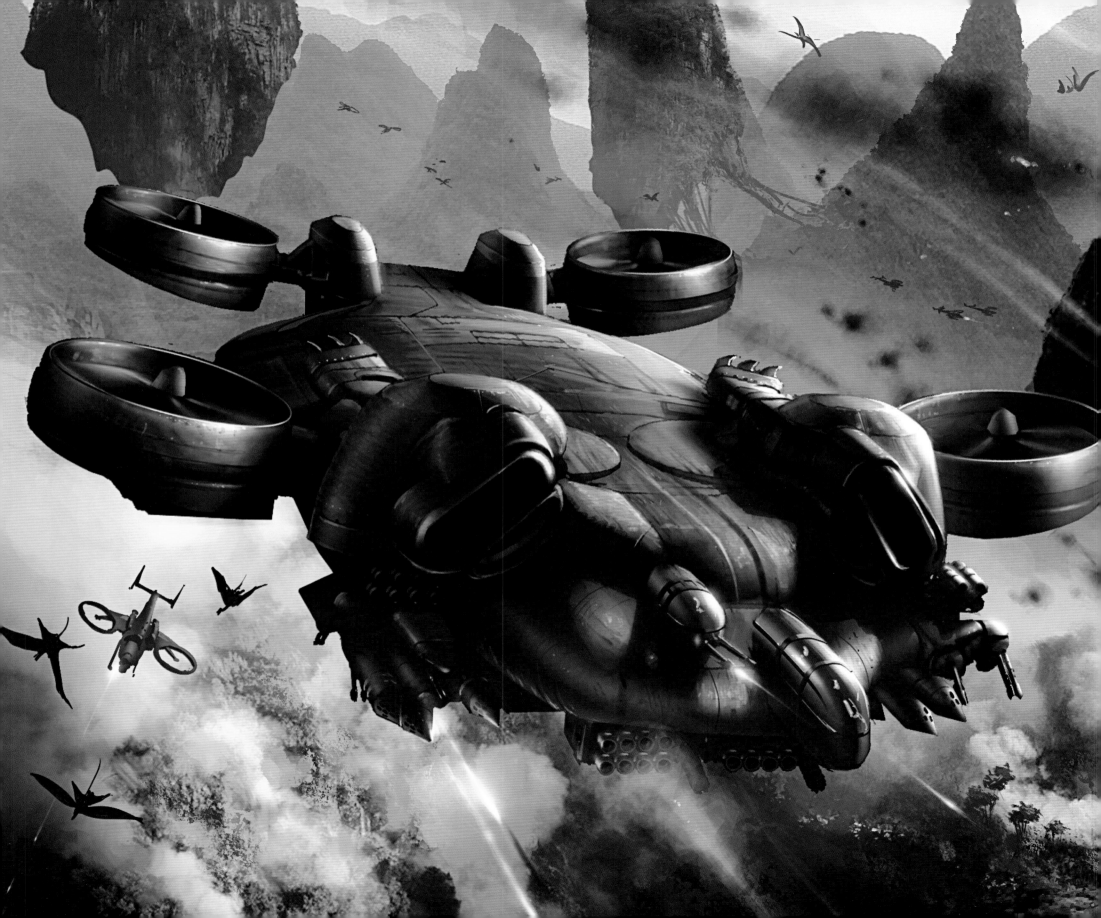

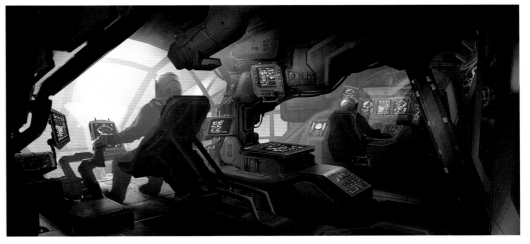

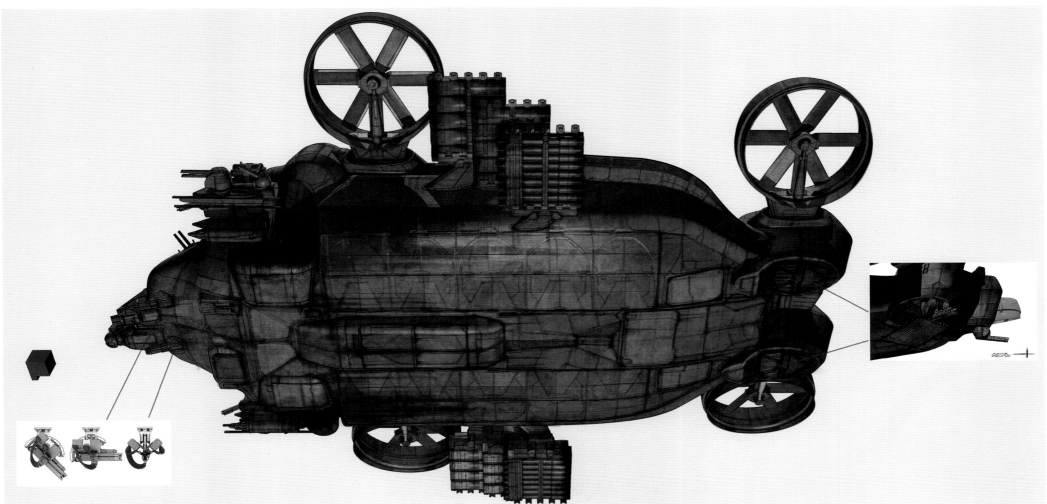

THE DRAGON "It's a fantasy vehicle, reminiscent of WWII big bombers, but with multiple rotors, multiple cockpits, and eccentric weaponry. Think of the Dragon as being a big, muscular beetle," was the way Cameron described the initial design specs to TyRuben Ellingson. Ellingson infused his ship designs with fantastic qualities, while also keeping the requirements of the story under consideration. He comments, "I had a perfect blending, in my small universe, of being very precise on the technological end but then also I could push it so that they are memorable, iconic, movie machines. I was able to express two sides of the design curve, if you will, and always have a fresh task."

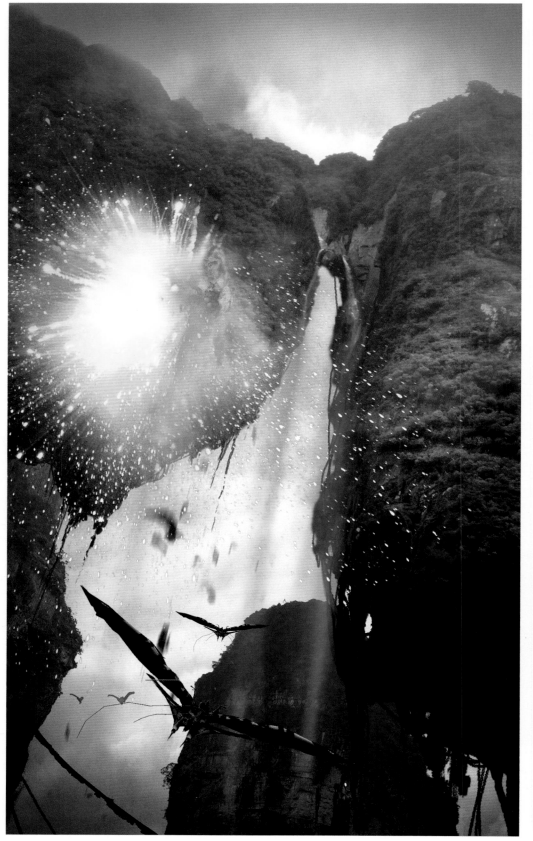
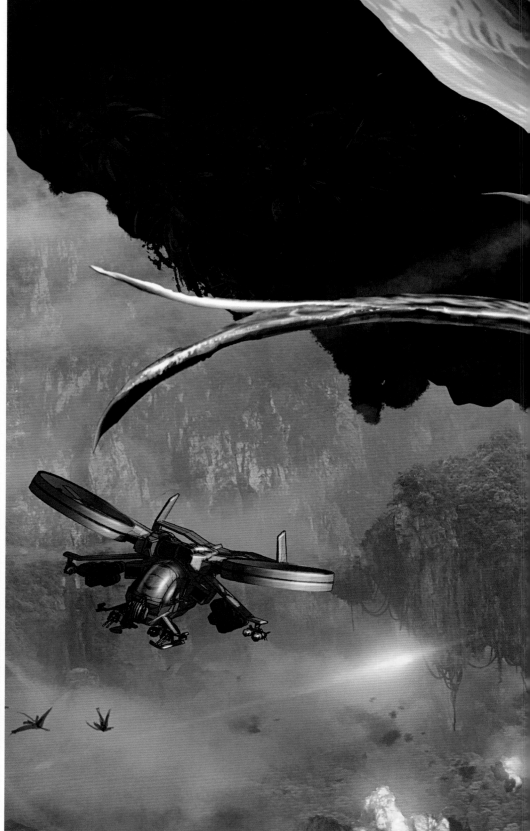

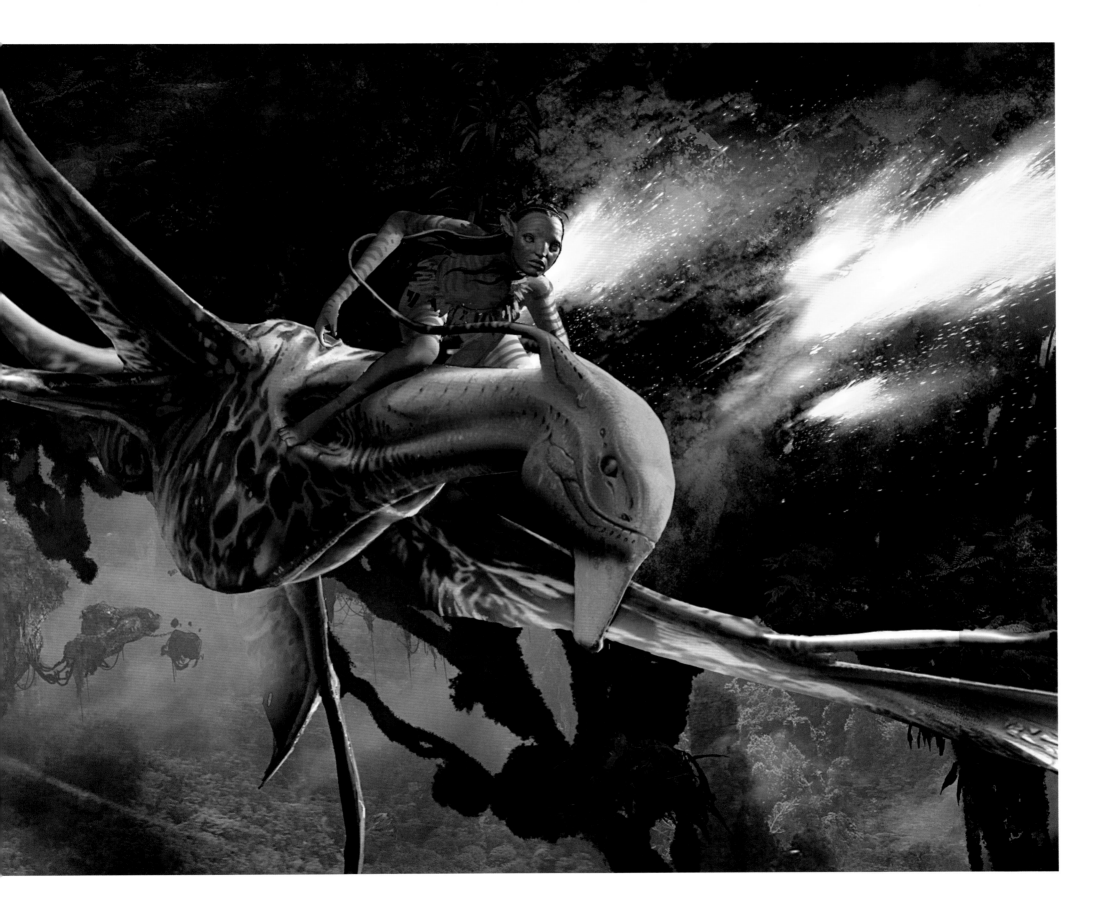

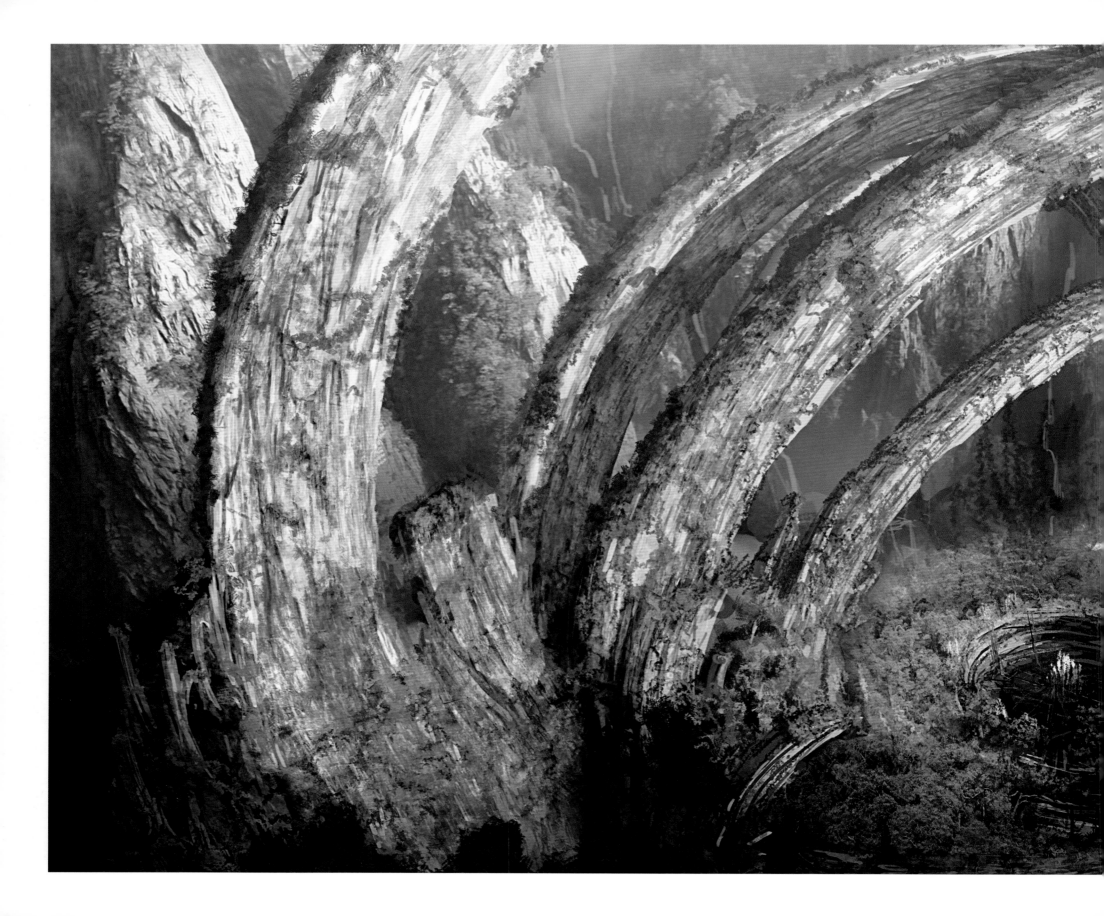

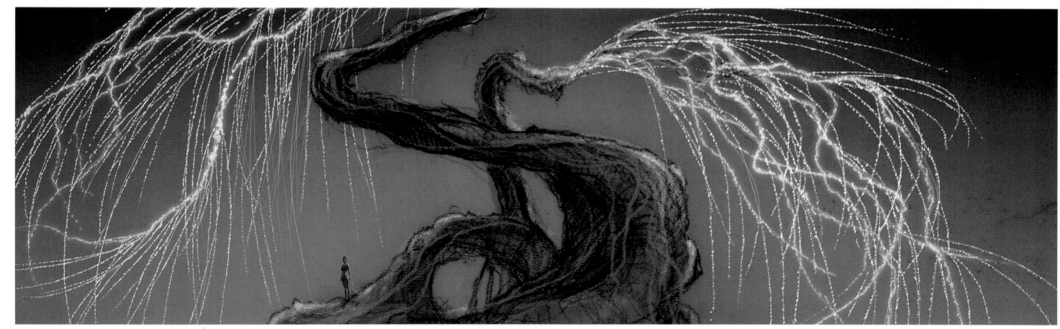

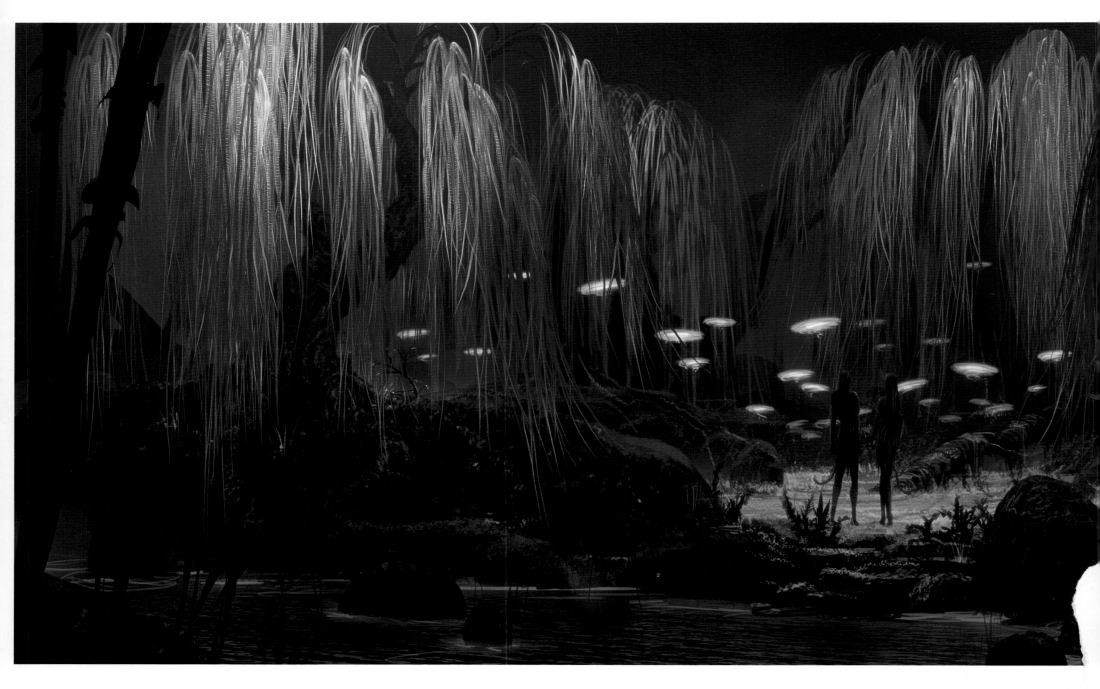

A

B

C

D

E

F

G

H

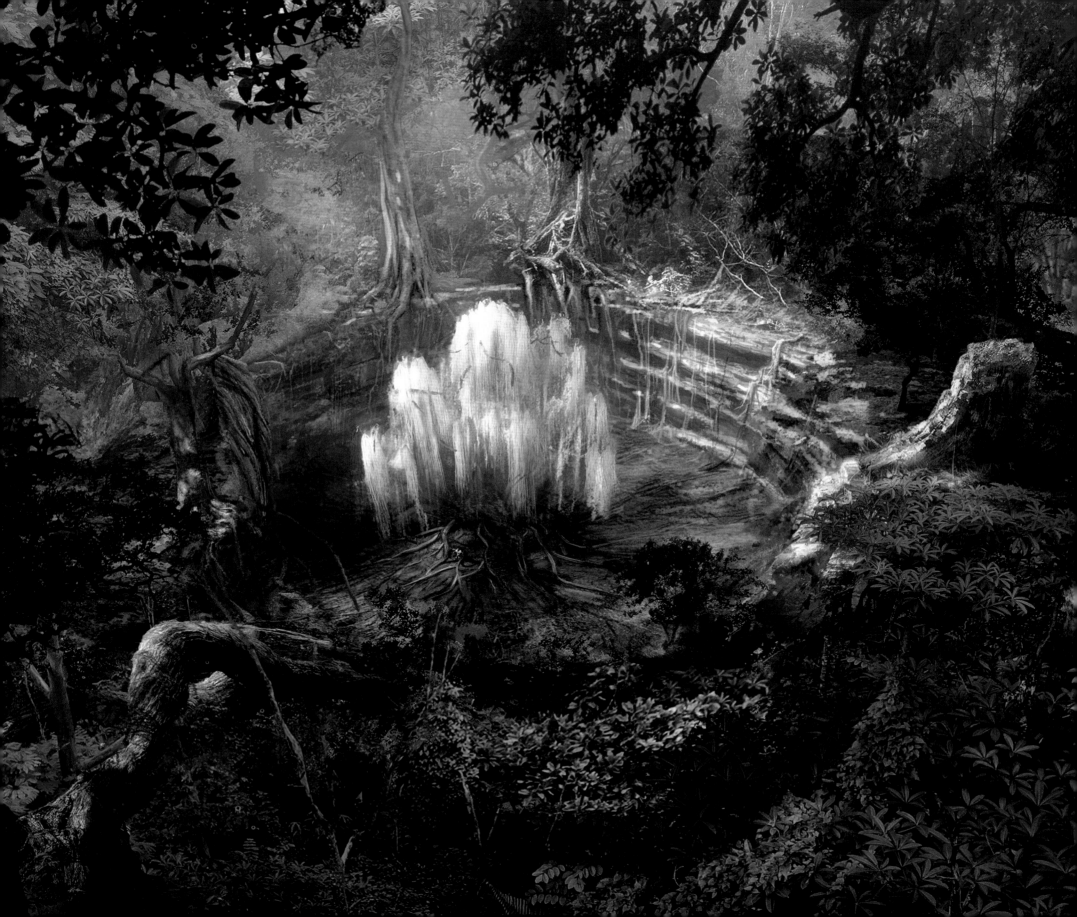

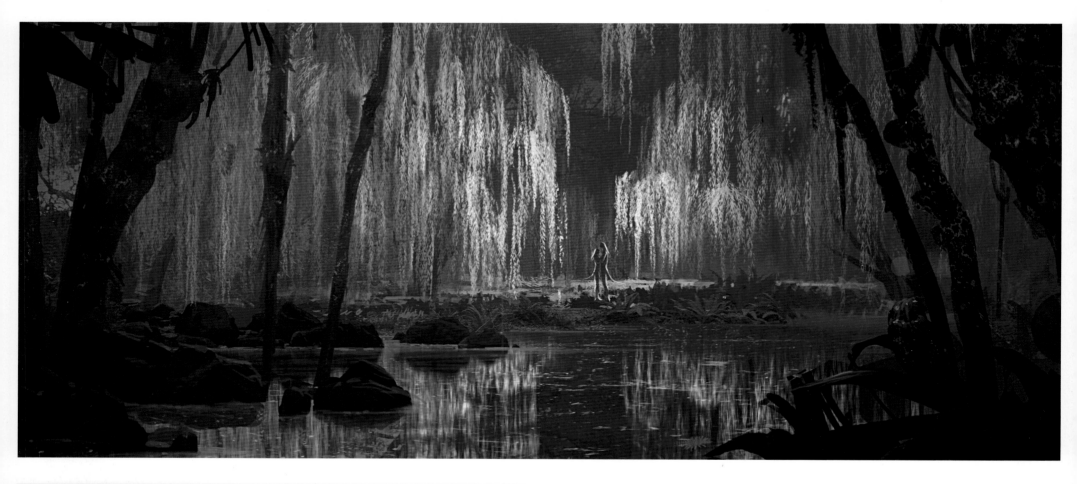

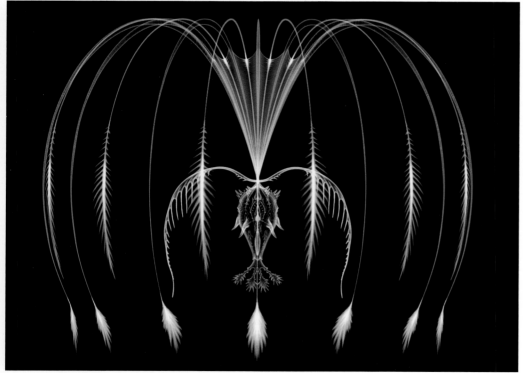

WOODSPRITES With the lightness of a dandelion seed and the subtle movement of a pulsating jellyfish, the Woodsprites are designed to float along in bands of hundreds in and through the Pandoran air. Woodsprites, or "seeds from the sacred trees," may each be the size of a butterfly, but their influence on the storyline was large. "*I was going to kill him, but there was a sign from Eywa,*" says Neytiri to her father about her first encounter with Avatar Jake when a Woodsprite landed on the end of her bow. "Part of creature/character design is like being an actor," says Neville Page. "The design considerations always included questions of what is the character's motivation, what does it do in the scene, and how will it interact." First attempting the design in 2005, the artists described their efforts as "difficult." Cameron had been specific: "It's got tendrils and the ability to glide. It's umbrella-like but has a bulb in the center, and it needs to be beautiful." Nearly two years later, Page had an overnight revelation and came up with a look he described as an "organic chandelier." "It's like doing fountain design!" he says, further describing his efforts. "I've finally learned my lesson. I'm not even going to attempt to challenge what Mother Nature has done so well . . . I'm just going to take what is so beautiful and be inspired by it."

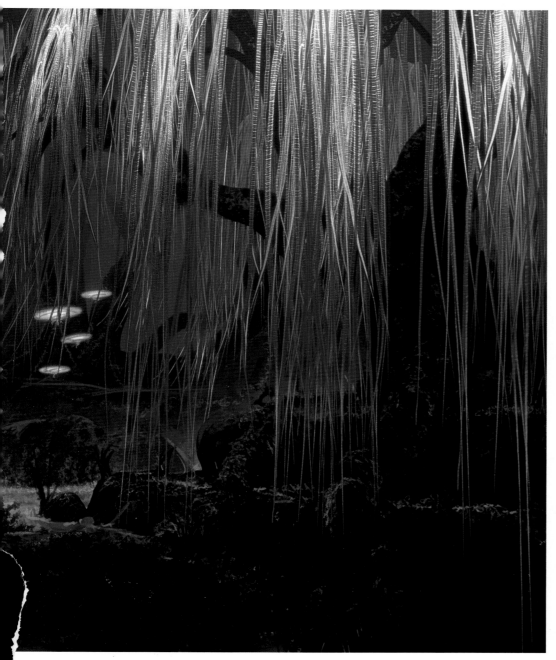

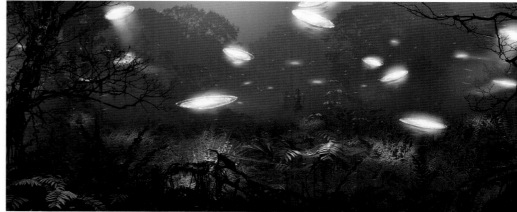

THE FAN LIZARD "This is our swan moment, when our ugly duckling turns into a beauty," says creature designer Neville Page about the daytime state of the forest-dwelling Fan Lizard, another Cameron inspiration. Rob Stromberg and others pulled their initial illustration ideas directly from the script, which depicts otherwise non-descript lizards *unfurling their long spines, like Chinese fans, into meter-long, disc-shaped membranes,* allowing them to fly—or float like jellyfish—in the Pandoran air. The lizards' nighttime state is meant to inspire a lightness of heart and mind in the characters as the creatures explode with bioluminescent color in a heated swarm, akin to a band of synchronized fireflies. In yet another example of the film's exploration from the familiar into the fantastic, animation studies produced by Alex Alvarez allowed the illustrators to experiment with the addition of a unique element—in this case various radial patterns produced by the Fan Lizards' fully spinning discs, which looked like the tips of a propeller blade, generating thicker and thinner lines. All of this development work was then exported to Weta, who reinterpreted the approved designs once again into their final photorealistic form for the big screen.

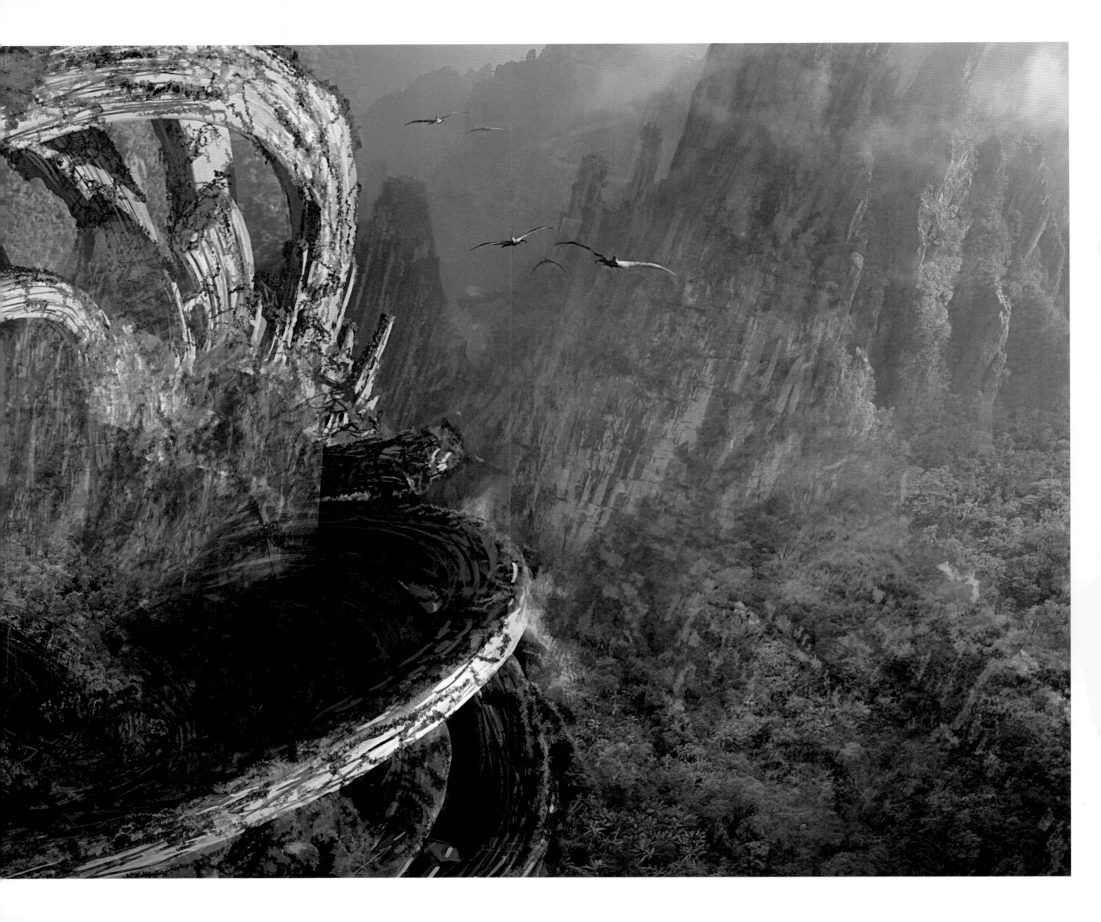

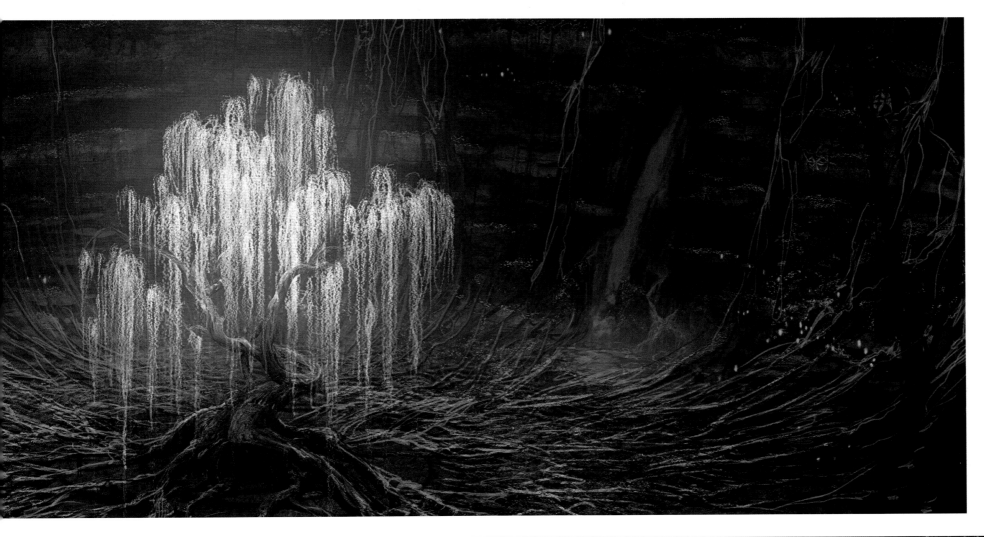

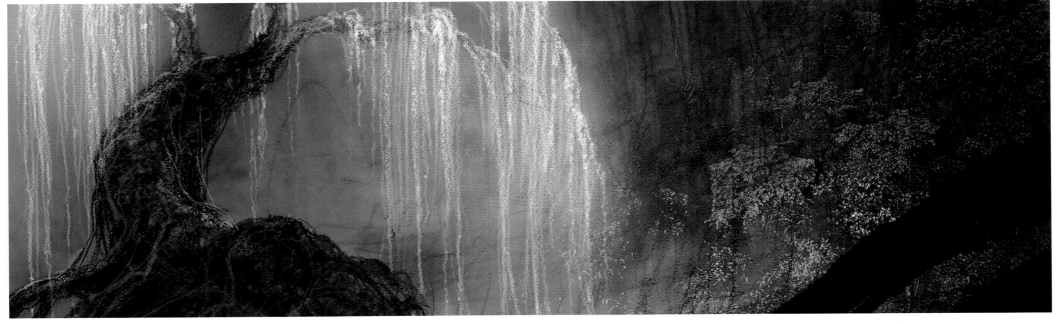

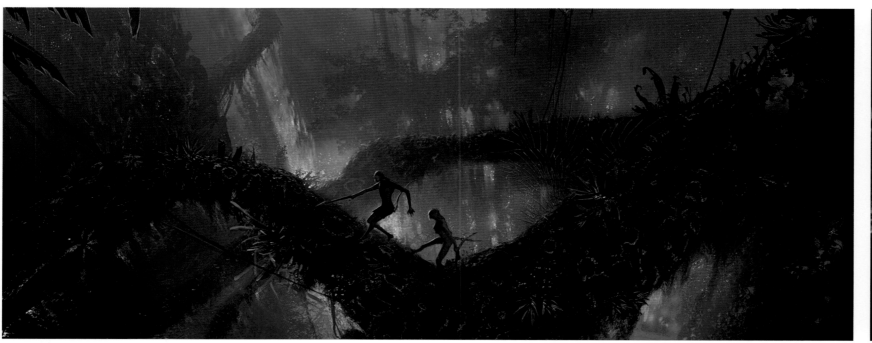

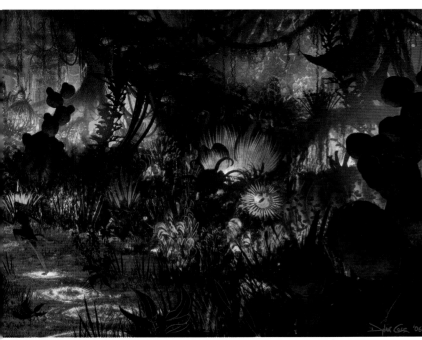

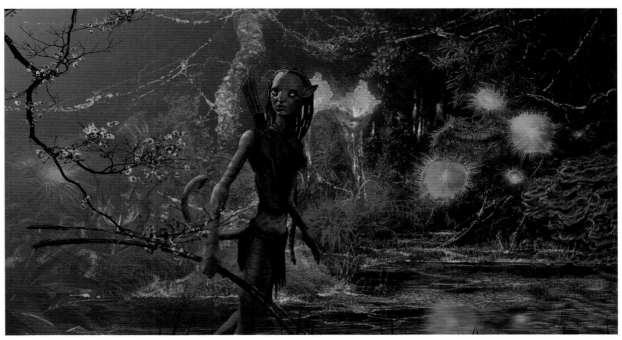

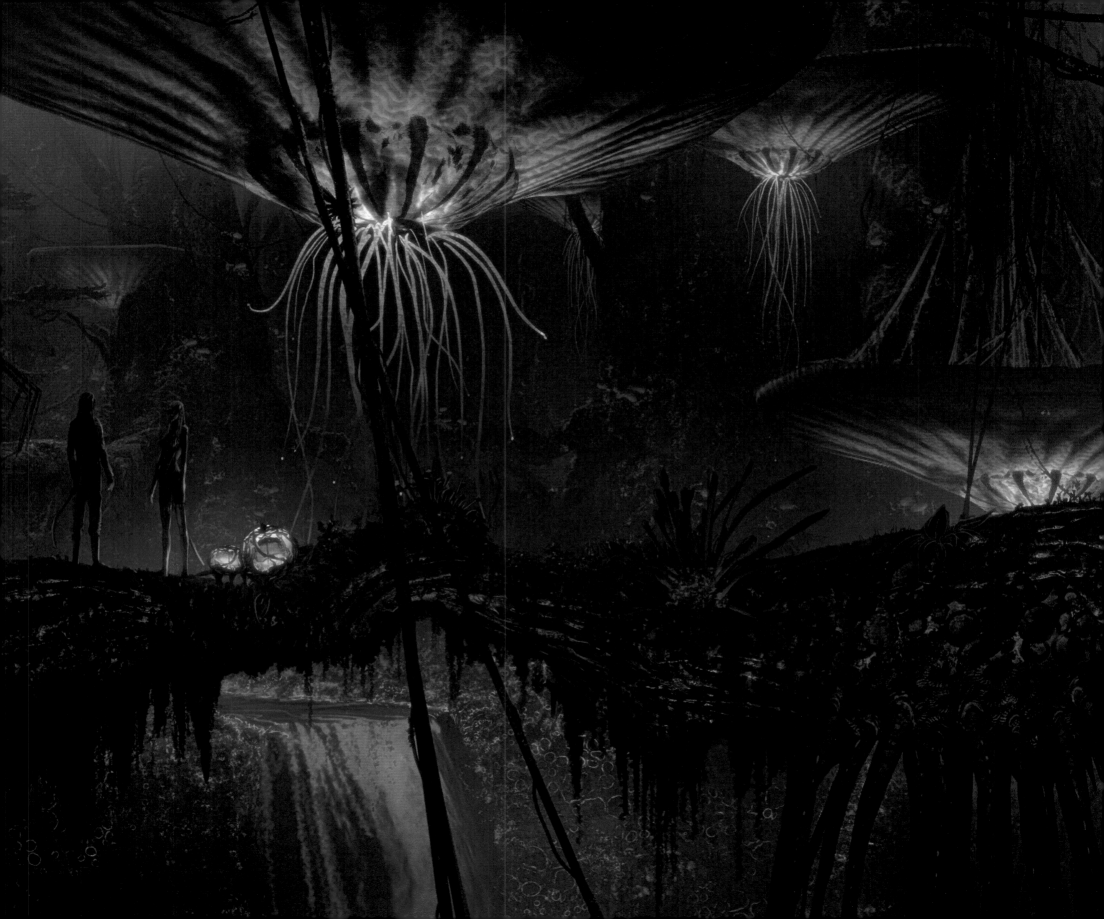

Epilogue
James Cameron

When I sat down to write the first draft of *Avatar* in 1995, it burst forth like a river through a breaking dam, seeming to write itself in just three weeks. The reservoir behind that dam had been filling since I was a child, with images from a thousand science-fiction novels and hundreds of movies. Every piece of fantasy art ever created, every *Analog* and *Eerie* magazine cover, all fed into that reservoir. In addition, my real life experiences under the ocean, from the profusion of life in the coral ecosystem to the alien forms lurking at the edges of our submersible's lights miles down in the blackness, found their way into the swirl of ideas that fed *Avatar*. But when that first draft was done, complete with all manner of new creatures and environments, the real work had only begun. Because all of these myriad things existed only as shadows in my mind, placeholders, if you will, for the fully formed creatures that would emerge out of the rigorous process of design.

The design process for a movie like *Avatar* requires many artists and many imaginations, harnessed to a single cause. We sought out and selected the very best fantasy artists in the world, and turned them loose. They promptly ran off to the horizon in all directions, stretching the envelope far beyond what I had imagined. I found myself in the role of herding cats, gently coaxing them back toward the forms as I had imagined them. But of course this was not a precise process, because these creatures did not exist sharply defined, but only as faint ghosts. Potentials. Things that might be.

But these ghostly outlines were enough to guide the design process, and so, in a fashion that must have seemed arbitrary to this stable of amazing artists, I winnowed the ideas down until the shapes and colors of these beasts began to emerge. Where I had something very specific in mind, I drew it myself, such as with the Thanator and the Viperwolf. But for the most part it was an evolutionary process, as ideas emerged and survived the group's deliberations in an almost Darwinian way. The guiding principle that we applied to all decisions was summed up in the question that I always asked the artists: What is the metaphor? What are we trying to say with this creature? If it's supposed to be a horse, what, quintessentially, is a horse? So the horse that emerged was fifteen feet tall, armored like a dinosaur, with purple stripes, six legs, and a meter-long nectar-feeding tongue—but it is still undeniably a horse, just like the Thanator is undeniably a panther and the Viperwolf is undeniably dog-like.

The Banshee is the most important creature in the film, because as the story unfolds, we see that the Na'vi are a flying culture and that they are closely bonded with their winged mounts, as a medieval knight was with his horse. Some of the earliest designs were quite alien, more like stingrays or living jet fighters. Then, as we tried to wrestle the shapes back to something more familiar, they quickly became *too* familiar—pterodactyls and dragons. The goal became to mix the familiar and the alien in a unique way; to serve the metaphor and create a sense of familiarity for the audience, but to always be alien in the specifics. The metaphor I proposed for the Banshee was neither pterodactyl nor dragon, but eagle. A great bird of prey, a raptor whose diving attacks are swift and deadly. In execution, the Banshee took on aspects of familiar flying creatures. It has the membranous wings of a pterosaur; the hook-like claws of a fruit bat; the bright eyes and splayed wing tips of an eagle. But it also has the jaw mechanism of a barracuda, the coloring of a poison-dart frog, and the hinged teeth of a viper. And its nostrils, inducting straight into the chest cavity like the intakes of a jet engine, are unlike anything on Earth. The audience is reminded always that one is on a truly alien planet.

Neville Page, Yuri Bartoli, Daphne Yap, and the other creature artists brought such a smorgasbord of ideas to the table that I was challenged to select among them. Then John Rosengrant and his tribe of artists from Stan Winston Studios swooped in to define the Na'vi and avatars, and the proliferation of ideas began again. Out of this fertile process came the alien beauty of Neytiri and her clan, as well as the clarity of Sam Worthington and Sigourney Weaver shining through their avatar characters.

The design of Pandora and her various environments required the same fecundity of visual ideas. Rob Stromberg led a team of artists tasked with literally creating another world. Rob's lucid paintings inspired the team to reach his level of fantastic reality. Again, the goal was to find the alien within the familiar. At first glance, one must see something recognizable enough to be real; upon further examination, one sees the strangeness. Mountains rendered with photographic clarity that are nevertheless floating, Magritte-like, far above the ground. Plants that seem familiar from the microcosm of Earth's coral reefs and forests, but whose sheer scale makes them alien and exotic in the forest of Pandora.

And still, this was only half the problem solved. Because *Avatar* is about a clash of cultures, and the technological culture of Earth needed the same care in the design process and the same rigorous application of metaphor. Rick Carter, presiding over the entire design team, had the difficult task of figuring out not only what looked right, but also how to build it in the real world. Because unlike the Banshees and the Leonopteryxes and the other fantasy beasts and settings that were rendered only in CG, the world of the humans had to actually be built. Ben Procter, Dylan Cole, James Clyne, TyRuben Ellingson, and the others papered the walls with a cornucopia of ideas from which the machines of *Avatar* emerged, all looking both fantastic and yet plausible and functional enough to really work.

It was a director's dream, and an unprecedented experience for me, to work with such a talented bunch. I hope they share my pride in what they have created: a world that we visit at our peril, because we may never want to leave.

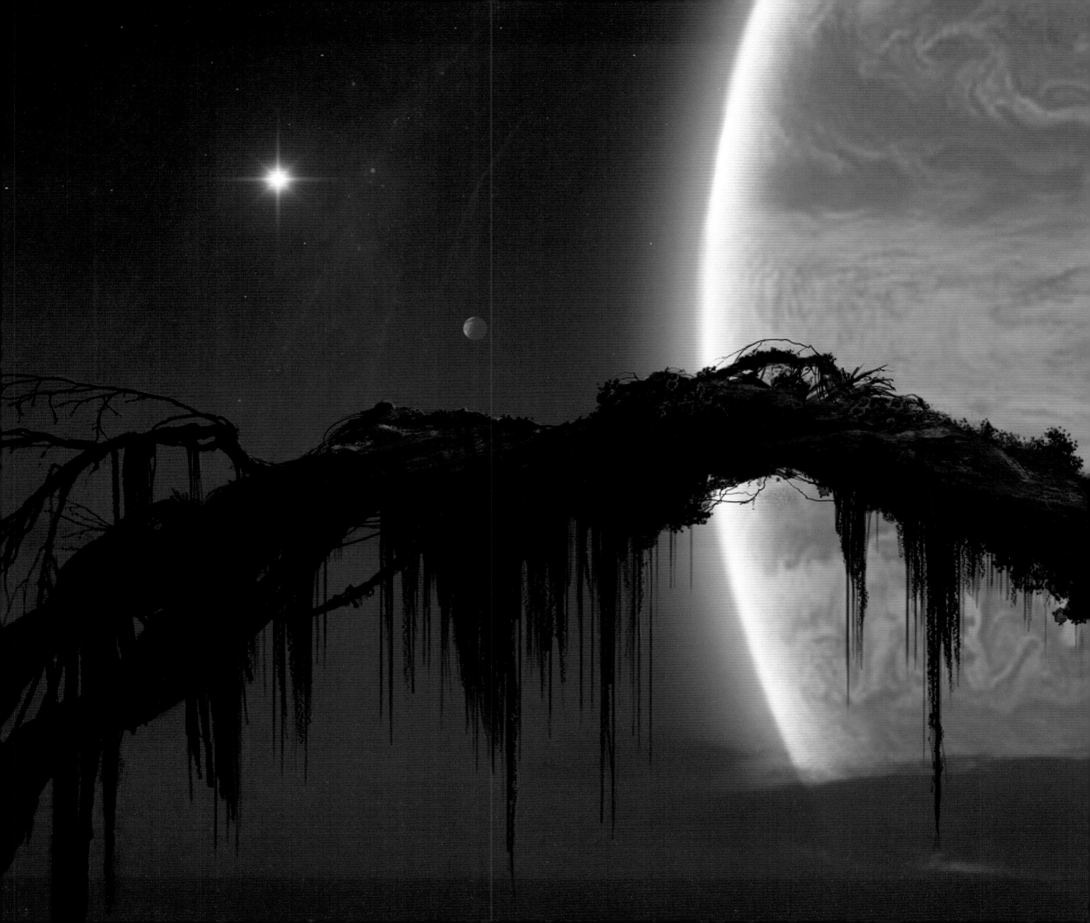

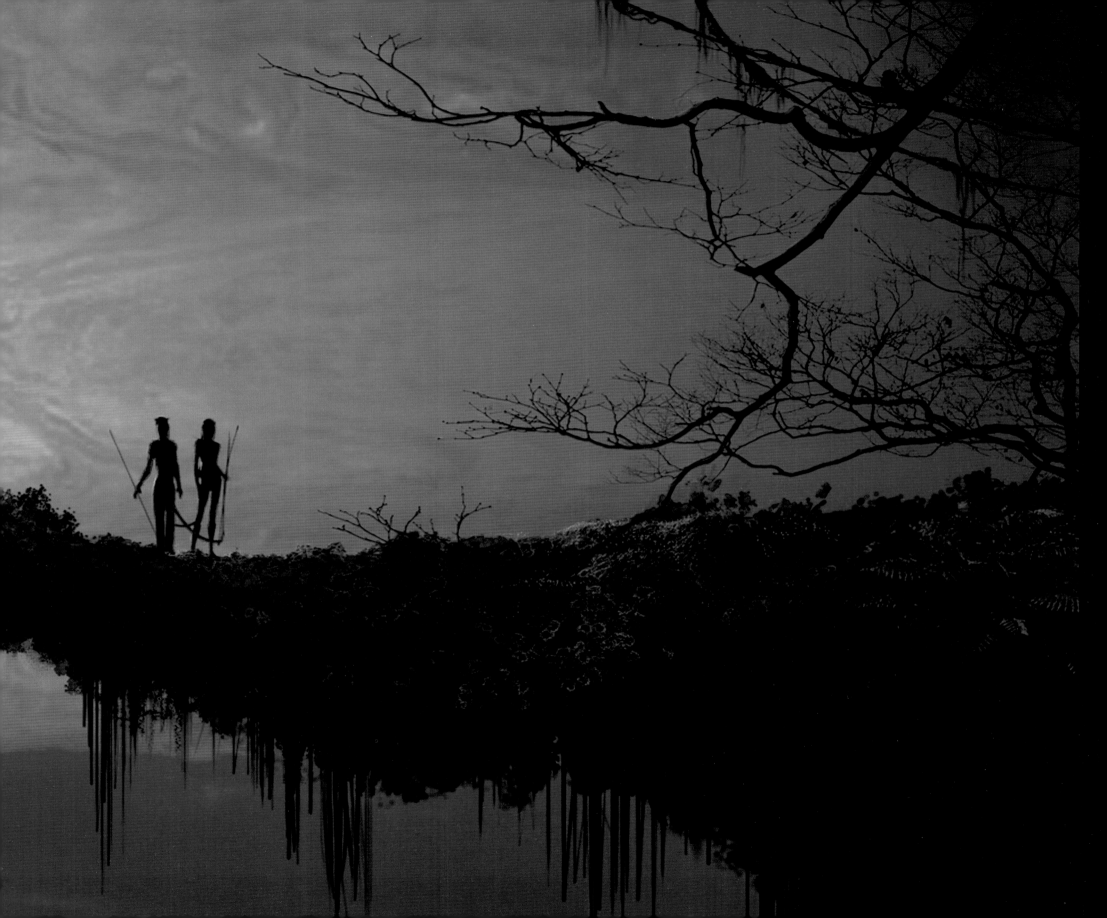

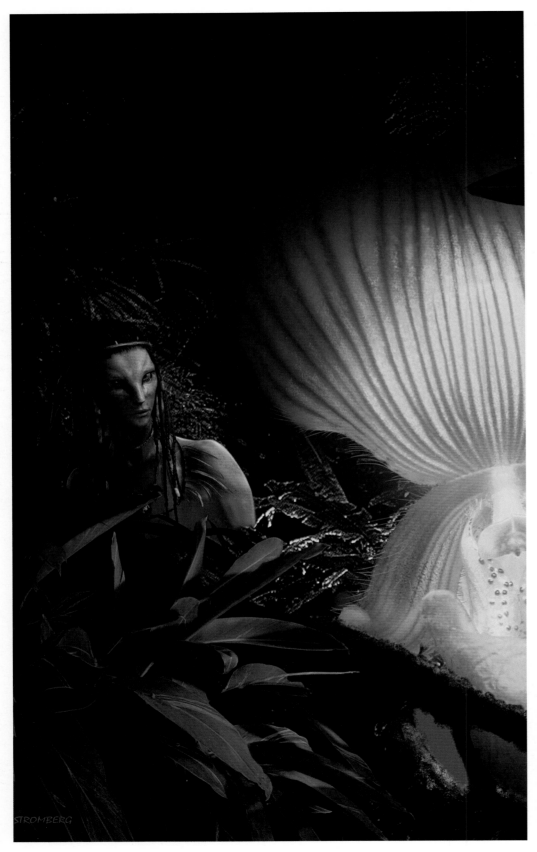

A special thank you to the following artists whose work is included in this publication:
Robert Stromberg, Dylan Cole, Steve Messing, Seth Engstrom, Yuri Bartoli, Ben Procter,
James Clyne, Ryan Church, Neville Page, TyRuben Ellingson, Jordu Schell, Victor Martinez,
Paul Ozzimo, Craig Shoji, Daphne Yap, Tullie Summers, Tex Kadanaga, Christopher Swift,
Joseph Pepe, Scott Patton, and John Rosengrant.

Additional thanks to the Weta Workshop New Zealand staff: Steve Lambert, Aaron Beck,
Leri Greer, Christian Pearce, Nick Keller, Gus Hunter, Dan Falconer, and Richard Taylor.

The author would like to thank Jon Landau, Virginia King, Debbie Olshan, Deborah Aaronson,
and Reymundo Perez for their uncompromising support during this fast-paced project.

Design by Christine N. Moog

Library of Congress Cataloging-in-Publication Data

Fitzpatrick, Lisa.
 The art of Avatar : James Cameron's epic adventure / by Lisa Fitzpatrick ;
preface by Peter Jackson ; foreword by Jon Landau.
 p. cm.
 ISBN 978-0-8109-8286-4 (Harry N. Abrams, Inc.)
 1. Avatar (Motion picture) I. Title.
 PN1997.2.A94F58 2009
 791.43'72—dc22
 2009019569

Printed and bound in the United States

10 9 8 7 6 5 4 3 2

Abrams books are available at special discounts when purchased in quantity for premiums and
promotions as well as fundraising or educational use. Special editions can also be created to
specification. For details, contact specialmarkets@abramsbooks.com, or the address below.

THE ART OF BOOKS SINCE 1949

115 West 18th Street
New York, NY 10011
www.abramsbooks.com